BOUND *for* GLORY

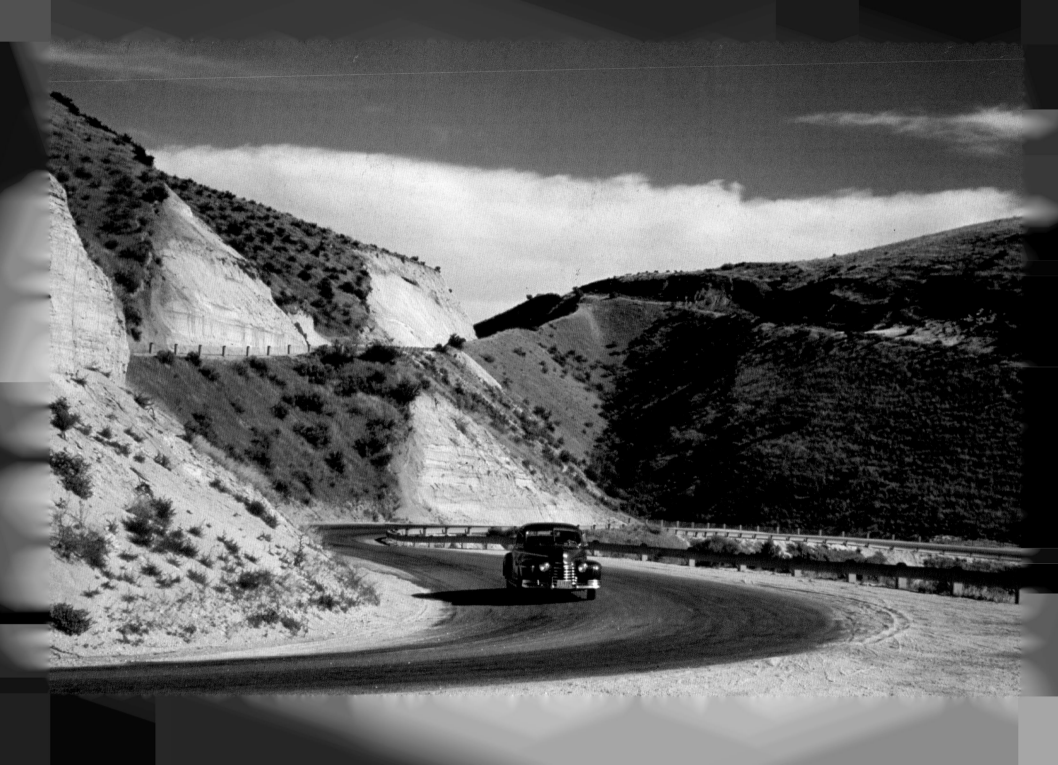

BOUND *for* GLORY

AMERICA IN COLOR 1939-43

INTRODUCTION BY PAUL HENDRICKSON

FSA/OWI COLLECTION, THE LIBRARY OF CONGRESS

HARRY N. ABRAMS, INC., PUBLISHERS IN ASSOCIATION WITH THE LIBRARY OF CONGRESS

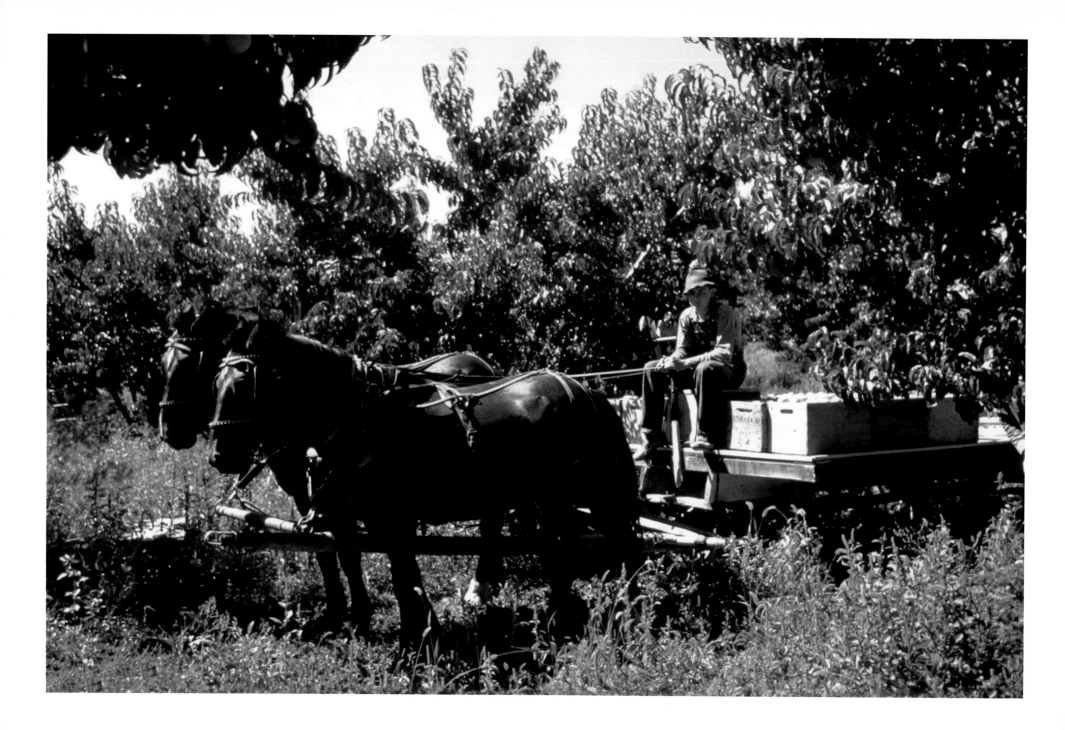

Contents

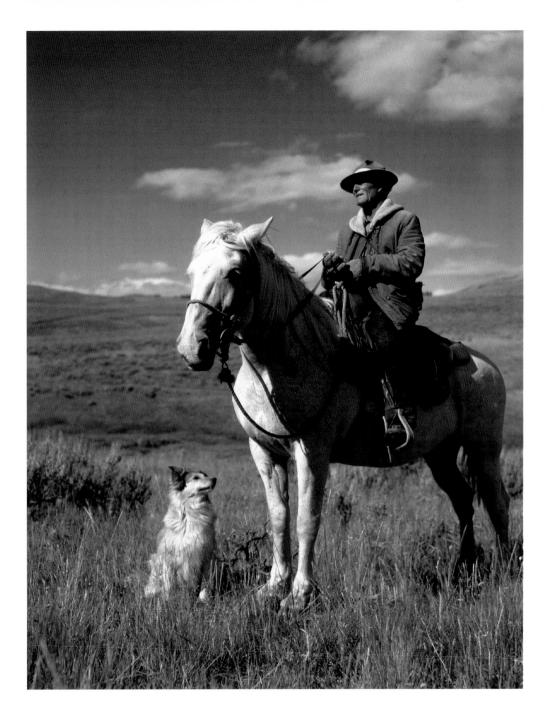

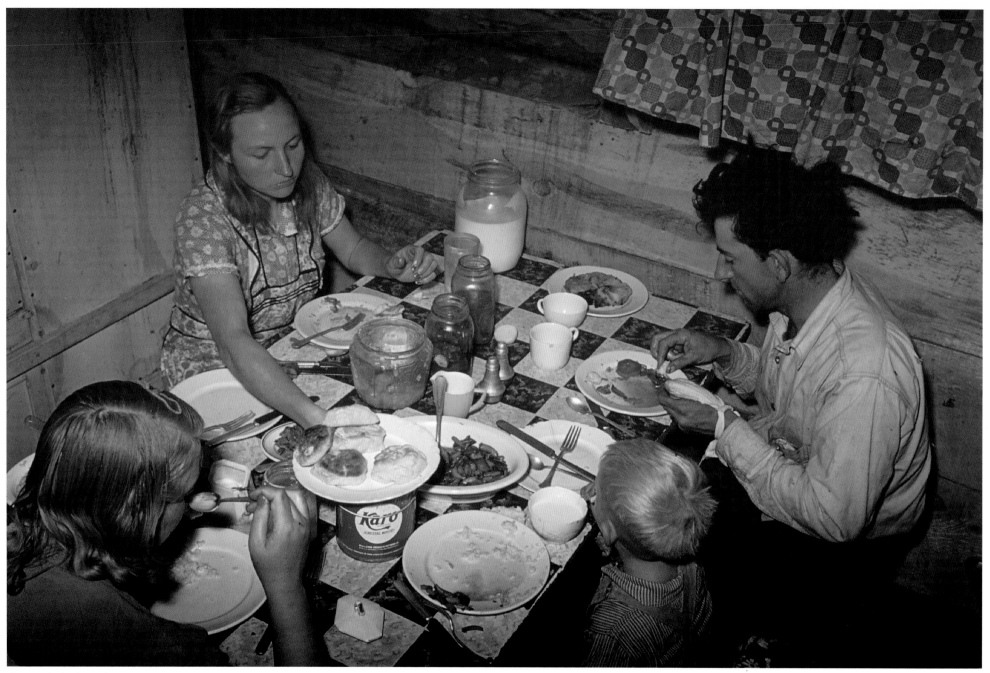

The Caudill family eating dinner in their dugout, Pie Town, New Mexico
Russell Lee 10/1940

The Color of Memory

THERE IS A POWERFUL INCLINATION FOR MANY Americans of a certain age, myself included, to believe that the Great Depression somehow existed in monochrome. The thought flies in the face of reason, but it isn't hard to understand why it persists. So much black-and-white photography, particularly documentary photography, comes out of the 1930s and the prewar forties, an era that's just ahead, incidentally, by about a decade and a half, of when I swam to consciousness (in the fifties, in the middle of the middle of the country, Kankakee, Illinois, "so successfully disguised to myself"—as the writer James Agee once said—"as a child"). Those old gelatin-silver prints, made by a corps of sublimely gifted government photographers working for the New Deal, have become part of our national identity. It's as if they're stored, burned there, behind our collective retina. We see them and understand about them even when we don't see them or know very many specifics about them at all—Walker Evans's sharecroppers in Hale County, Alabama. Dorothea Lange's "Migrant Mother" in Nipomo, California. Russell Lee's square dancers in Pie Town, New Mexico. Marion Post Wolcott's domino players tilted on their wicker-back chairs in the afternoon shade and drowse of a Mississippi drugstore. These pictures amount to a kind of Movietone reel looping through our heads. So much of what we seem to value about ourselves as a nation—pluck, perseverance, individuality, self-reliance, agrarian roots—is encoded in these photographs. To know and love them—and there are about 160,000 such images archived in the collections of the Library of Congress—it isn't necessary to know, or even have heard of, the names Walker Evans or Dorothea Lange or Russell Lee or Marion Post Wolcott. (Depending on how one counts, there were about a dozen photographers, altogether, who worked at various times during the eight-year life of the project.) Much less would it be necessary to understand all about the alphabet-soup federal agencies—the RA, the FSA, the OWI—which authorized and sponsored the picture-taking in the first place.*

In brief: the idea, at least in the beginning, was this: to record through the medium of photography—which felt something like a new art in the thirties—the ravages of the Depression on America's rural population. Why? Not for its own sake, of course, but as a political means, a tool, for spurring Congress and the American public to support government relief and resettlement efforts, which were thought controversial: big brother's intervention on the little guy. But somehow along the way the documenting of hard times turned into something much wider and surprisingly artful. It turned into a pictorial encyclopedia of America herself—a portrait not just of rural life, where so much erosion of land and spirit had taken place, but a portrait of millions of Americans going about their day-to-day living—sometimes joyfully, sometimes desperately—in mill towns and mining towns and mountain towns and huge urban centers. What started narrow—Okie dust bowlers, shanty towns in West Virginia—spread wide, and almost surreptitiously on the part of the documentarians and the far-sighted Washington bureaucrat who had hired them for the project and directed their activities. His name was Roy Emerson Stryker, and he didn't love anything but this country, as one of his photographers once said of him. It was astonishing how much film, and of such wide variety, was

* FSA—where the great bulk of the documenting was done, between the iconic years 1935 and 1942—stands for Farm Security Administration. In 1936–37, the project was officially part of and housed in something called the Resettlement Administration, or RA, which had been chartered in 1935. After the war began, the photographic unit of the FSA—its official title was the "historical section"—got transferred into the newly created Office of War Information, or OWI. By then, the primary focus of the work had shifted to the home front's national defense effort.

being mailed to the Washington office for developing by Stryker's "spies" on the road. By the time America entered the war—really, a good while before that—there were tens of thousands of pictures. But by then the overriding aim of the work was to aid in any way possible to keep Hitler off our doorstep (as Stryker himself liked to say). And so the documenting of a nation had turned far more positive in tone and nature. Essentially the pictures were about America the beautiful, America the productive, America the determined, America the mobilizing. Here was Rosie the Riveter, bent to her task in her B-17 factory in Long Beach. Still, the pictures were by and large wonderful. They were so *American*.

John Vachon—who was nearly as good a writer as he was a squinter through a box, and who started out as a messenger boy for the FSA in the Washington office—once tried to explain in print how the wider, surreptitious lens had come about from the project's original intent: "Through some sublime extension of logic which has never been satisfactorily explained to anyone, Stryker believed that while documenting these mundane activities [government housing loans and federal farm co-ops], his photographers should, along the way, photograph whatever they saw, really saw: people, towns, road signs, railroad stations, barbershops, the weather, or the objects on top of a chest of drawers in Grundy County, Iowa." Ernest Hemingway, who was practicing a different kind of subversive American art in the thirties and forties, once said something similar about literature: "All good books are alike in that they are truer than if they had really happened and after you are finished reading one you will feel that all that happened to you and afterwards it all belongs to you: the good and the bad, the ecstasy, the remorse and sorrow, the people and the places and how the weather was." Substitute the word "photographs" for "books," and I think you have the basis of an explanation of the staying power of these pictures, of the strange way they have burrowed into our walking dreams.

Was the work, right from the beginning, propagandistic? Of course it was, and sometimes in greater than lesser ways. Propaganda is a loaded word. So is another word: politics. As one historian of this period has written, the motive of the FSA photography project was always "political in the best sense of that suspect word." In ways difficult to explain, the propagandizing was always there alongside the artfulness. The two co-joined and the one didn't seem to pollute the other, not most of the time. Later in this essay, I will return to the notion of propagandizing.

But for now suffice it to say that the unlikely artistry that resulted from this tax-supported government relief project seems due in equal parts to the giftedness of the photographers themselves, to Roy Stryker's vision, and, not least, to the times themselves. Or, to put it another way, to what was always there, waiting, on the other side of the lens.

I have known and loved these old black-and-white FSA and OWI rectangles for most of my adult life. As I have said in another place, these images of ordinary, enduring Americans—easily the largest and greatest documentary project of a people in the history of photography—have always seemed most meaningful to me in my own times of stress. Indeed, the pictures epitomize for me the truth of what the great latter-day Swiss-American photographer Robert Frank called "the humanity of the moment." When I look at the struggle coming up out of these pictures, I feel somehow as if I'm combing through my own and the country's ancestral attic with Woody Guthrie and John Steinbeck and maybe the Andrews Sisters and the Great Gildersleve, too, all of us lingering here and there to laugh but more often cry over every broken porcelain doorknob and rusting Dr Pepper sign. This was my own parents' time in America—two scared farm kids out of Kentucky and Ohio, who met and fell in love at a roller rink on the lip of a world war. (They were in a movie theater in a place called Xenia, nine weeks from their wedding, on that Sunday afternoon, December 7, 1941, when the lights went on and the manager delivered the news of what had happened out in Honolulu.) It must be at least a part of why the years between the Depression and World War II seem to exert such a deep, romantic pull on their child; of why the images, for all of their hardship in some cases, strike me as so oddly comforting.

So I would have never guessed that I could fall head over heels, all over again, and in some ways even more deeply this time around, for FSA and OWI *color* work. Shoot, until recently, I barely knew such color documentary work existed—and, as it happens, I am the author of a book (published about a decade ago) about the life of Marion Post Wolcott, one of the greatest photographers, in my view, of that whole crew and era. What we have of FSA-OWI color work amounts, relatively speaking, to a thimbleful of pictures—only about 1,600 images altogether. But let us be grateful for what is, for what survives, for what can be thought of, perhaps, as a new and complementary way of comprehending our national identity.

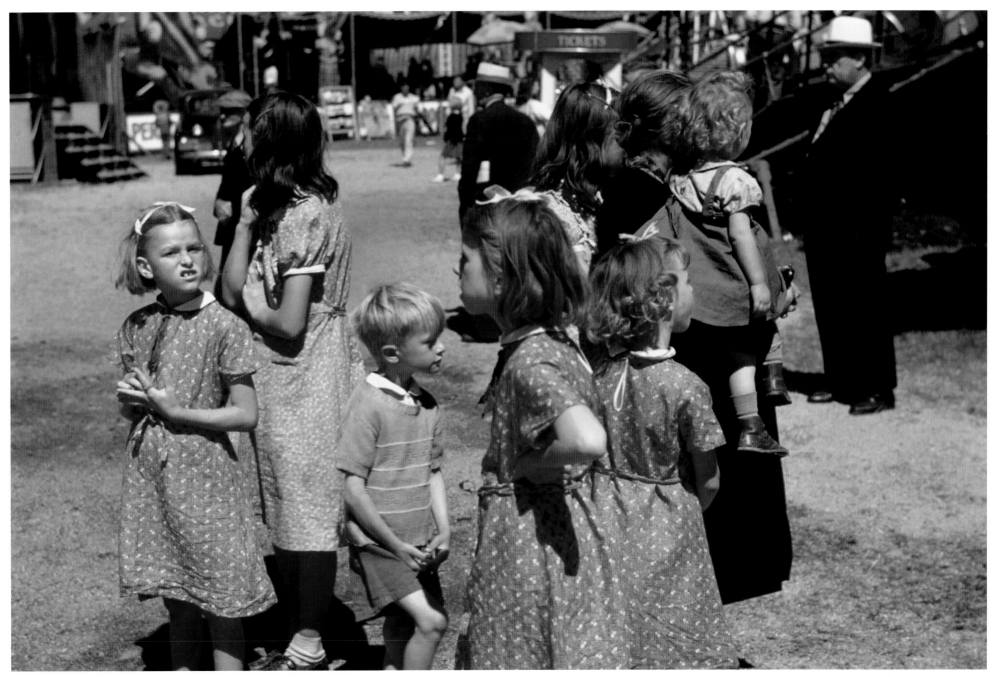

At the state fair, Rutland, Vermont
Jack Delano 9/1941

And let us now praise just one of the 175 color photographs that await your eyes on the following pages of this beautifully produced book. Turn back to page 9. The photograph is entitled "At the state fair, Rutland, Vermont." It was taken in September 1941, by an FSA photographer named Jack Delano. The color is a little washed and faded with time, but *because* it exists in color, I think it can be argued that we are permitted to enter the image more fully, participate more immediately in its emotions and proffered pleasures. I am not trying to make any kind of blanket aesthetic statement here about the efficacy of color vs. black-and-white work. (If I had to choose, I'd probably still always go with black and white.) I am just talking about this photograph, one particular moment, some sixty-three years ago, when time got stopped in a box, when we were given, in perpetuity, so to speak, five slightly dazed and charming and nameless children on their gay New England midway.

There seems something so artlessly artful in the way the children have been captured, although that speaks primarily to the picture's composition. They are dazed, I think, by so many choices before them, all the deliciously assaulting sights and sounds. Actually, there are seven children in the frame, not five, counting the youngest (boy? girl?), over on the right, who's being held by the figure in black, who must be the baby's mother, as she is surely the mother of this whole brood.

There are seven kids in the family, yes, but I am focusing on the five in the foreground—the skinny little boy with his ankles crossed and fingers intertwined, and his four older sisters, almost identically dressed, and three of whom have ribbons in their hair. I have fallen for the girl at the far left of the frame. It's her face, of course. It's always the faces. "Whatever happened to the faces in the old photographs?" is a line from a song by a folksinger named John Stewart, and I can hardly ever look at an FSA photograph without longing to know the same. Hers is the only one we can see fully, and it's the curling lip and the scrunched nose and the house-counting blue eyes and the semi-large ears and the fetching gap in the two front teeth that take me. She seems to be about halfway up the ladder of kids. I love the way she's unconsciously winding the tie-loop of her patterned pink dress around her index digit. She apparently didn't have a rubber band handy or the string on her yo-yo, so she's employing the tie-loop on her dress. She's girlish and tomboyish both. She alone among her siblings is aware that a picture of her family by a stranger is being made, and she's not completely thrilled

about it, either. I'll bet she grew up suffering very few fools gladly. Could she still be alive? If she was, say, ten in 1941, she'd be in her early seventies now, a spring chicken, given the spunk and knowingness that seem to be projecting themselves here.

Because the image is in color, I think I am able to feel something in a deeper way about the very cotton of her dress, of all the dresses here, which I take to be homemade, sewn, each of them, by the same hand. That hand would belong, again, to the figure holding the blond-tressed baby on the right. Well, I don't know for a certainty that the dresses are made of cotton, nor would I have any real notion of whether they would have been store-bought or whether they were crafted from the same pattern and bolt of cloth late at night, on the kitchen table. But if you look closely, you can make out the wrinkles in the fabric, especially down toward the hem of the dresses. This makes me remember how much ironing our mothers always did after we were in bed. I grew up right before polyester.

I once had a ribbed and banded short-sleeved aqua cotton sweater that was a little loose around the neck and that I swear is a near-replica of the aqua sweater on the forelocked little boy. Because of the strange way that memory works, the held baby's scuffed, brown, high-top shoes stir the same kind of buried feelings in me. I can recall their precise, chocolaty texture, the lanolin-soft feel of the leather. Color, too, in this instance, permits me—or so I believe—to get back in touch with the carnival freak-show glories of those state-fair midways. In the Midwest, they were very gaudy and very freaky, irresistible.

Esteemed photographic historian Andy Grundberg, writing some years ago in a magazine called *Portfolio* about the discovery of FSA color work; about how fresh and new some of the pictures seem, including this picture, said: "They remind us of how clothes looked before the artificial spectrum of synthetics took over; they identify a landscape as southern by showing the redness of the earth; they describe the weathering of paint on Nehi signs or the dirt-streaked faces of sharecroppers. Although they seem modern to the eye, they yield a wealth of archaeological information." Grundberg added: "Possible fading aside, the FSA color pictures that have been found show an exemplary early use of color as information rather than decoration. . . . [T]he critical and historical importance of this newly discovered material hinges on its pioneering use of color as an aid in documenting the subject." Recently, preparing to write this essay, I called up Grundberg, to discuss this last point. "The

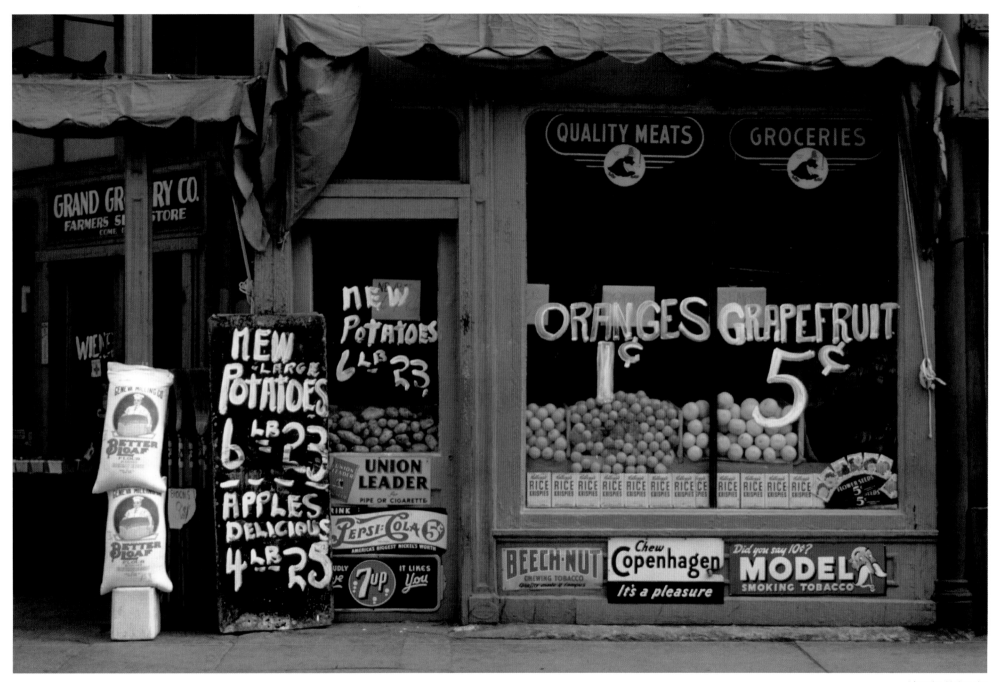

Lincoln, Nebraska
John Vachon 1939–1943

great thing about FSA color is that it's so naturalistic," he said. "I don't think they [the photographers] were naturally disposed to think about how they could use color photography artistically." In other words, they used it organically, authentically. The color wasn't layered atop in a false way. And in not seeking to employ it artistically, they succeeded in creating art. Not every time. But surprisingly often. That, I think, is what this small trove of American documentary work—and the book before you—chiefly wishes to suggest.

SO MUCH OF WHAT WE KNOW ABOUT FSA-OWI COLOR is inconclusive. I am not referring to captions and other identifying information, although that, too.

What we do know is that the Kodak company first marketed the new technology of Kodachrome film in 35mm rolls in America in 1936. In 1938, the company began to return the processed film to photographers with each image individually mounted in a 2 x 2-inch cardboard "Readymount" rather than in uncut strips as they had done previously. This, along with the creation of the color transparency projector in the same year, are largely considered responsible for the boom in interest in 35mm color photography. What we do know is that at least six FSA photographers worked briefly and experimentally in color: Jack Delano, Russell Lee, John Collier, Arthur Rothstein, John Vachon, and Marion Post Wolcott; all are represented in this book. What we have today from the FSA period of the project are 644 images. Most are 35mm Kodachrome slides; a few are color transparencies in sizes up to 4 x 5 inches. Like their black-and-white counterparts, the photographs portray culture in the United States, including Puerto Rico and the Virgin Islands, with a focus on small towns and farm life. What often seems to have happened is that the photographers shot in black and white, and then reloaded, or took up a different camera, to make a few color shots, sometimes of the same scene. Sometimes they returned to the same scene to shoot it in color.

When did the FSA photographers first start using color? The earliest date we know is 1939. It's quite possible, even likely, that color transparency work was done before that. If so, it's lost. We do know that in 1938 Stryker was sending out from his Washington office some "shooting scripts" for color work. (These "scripts," about which much has been written, and much of it false, were really shot-gunned descriptions from the director of what his documentarians should be on the lookout for in a certain area.) The bulk of what we have today of FSA color was shot in 1940 and 1941, and that is what is represented here.

As regards the OWI work, what we do know is that at least twelve photographers shot on and off in color. (Four worked closely with Stryker; some of the others shot in color for the OWI after Stryker had resigned from government service in September 1943 for private industry.) A few OWI-ers had earlier worked for the FSA, including Delano and Vachon, and then made the transfer over with Stryker in late 1942 when the historical section was absorbed by the OWI. Many of the OWI photographers are not nearly as known in photography circles as are the FSA names. And my own view is that OWI color work in general is not as emotionally powerful nor technically accomplished as FSA color work—which was the more pioneering effort. What we have today are 965 color images from the OWI, and they are transparencies in sizes up to 4 x 5 inches. Again, the pictures depict a broad spectrum of culture in the United States, but the focus is more urban than small town and, as noted above, chiefly has to do with war mobilization on the home front: women in factories, railroads, steel plants, munitions, pilots-in-training. The original caption on the photograph of page 13 of this book explains a lot. It's all about resolve. "The kind of man Hitler wishes we didn't have. A bomber pilot, captain in a bombardment squadron, just before he climbs aboard his huge YN-17 bombing plane." It was taken in May 1942, five months after Pearl Harbor, by Alfred T. Palmer.

But I wish to speak more of the earlier work. The discovery of FSA color—that there even was such a thing—is a story in and of itself. This discovery occurred only about twenty-five years ago. The credit belongs to photographic historian and professor on the West Coast named Sally Stein, who did the enterprising thing and started combing the files. For more than three decades, from the middle forties to the late seventies, FSA color remained hidden, anonymous, in the bureaucratic labyrinths of Washington. It's as if everyone, including the men and women who had taken the pictures, had somehow forgotten the work existed. Stein came upon the cache while researching, as part of her dissertation, the development and history of color photography in the thirties, and in the period between the second half of the Depression and the outbreak of war.

One reason this work had so long remained out of sight is almost

comically mundane: filing. No one, apparently, had ever resolved the problem of how to store the 35mm and sheet-film transparencies when they had first come in from the field from the FSA photographers. After the war, in 1946, when the entire documentary output from the defunct FSA and OWI agencies got physically transferred to the archives of the Library of Congress, the FSA color portion of the project was stored along with OWI material. The Kodachrome slides got catalogued and shelved with the OWI pictures. No one sorted it out. There is another point here. In general, it's accurate to say that in the years after the war and through the fifties, America's interest in documentary photography from the Great Depression hadn't yet been stirred. In a sense, *all* of the documentary work from the thirties lay hidden in government drawers. Most historians mark 1962 as the pivotal moment for the revival of interest. That year, Edward Steichen mounted an exhibition entitled *The Bitter Years* at The Museum of Modern Art. It was a black-and-white epiphany.

In 1975, as some then-contemporary American photographers were turning to color, photographer and critic Max Kozloff, in *ArtForum*, did a study of the history of color photography. "Is there even one photograph of the Depression in color?" he asked.

There was, of course, but those nearly 700 FSA color pictures, filed and forgotten, stayed anonymous, languishing, until Stein made her find in 1978. In 1979, she published a seminal piece in *Modern Photography* magazine: "FSA Color: The Forgotten Document." Her research and writing brought the pictures out into the light for the first time, but even so they didn't get a lot of attention among the general public. They were too few in number, perhaps. We were too in love with our black-and-white ideas of the Depression, perhaps. A few years later, Grundberg wrote about FSA color in *Portfolio*: "A Forgotten Experiment." One of his points was that another reason for the long obscurity of FSA color, in addition to the mundane filing problem, was that the work had been masterfully ahead of its time. Color was "outside the mainstream of art photography," or perhaps what was even thought of as good photography. Color was somehow too easy to work in. The false convention and assumption was that the only important photographs were the ones made in black and white. In some ways, that myth persists right to today. In the late 1980s, when I was writing a biography of Marion Post Wolcott, and was making a series of trips to Santa

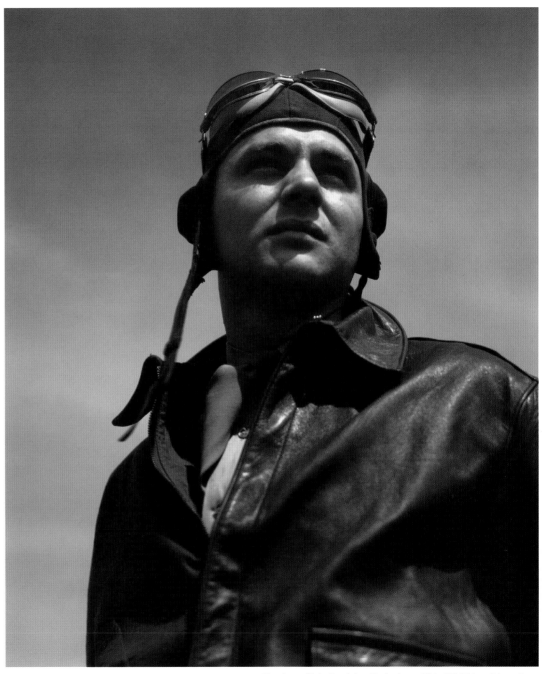

Bomber pilot about to climb aboard his YN-17 bombing plane
Alfred T. Palmer 5/1942

13

Barbara to speak to Wolcott, who was then elderly and infirm, she talked vaguely of her FSA color work. But somehow, it seemed not very important to either of us. In truth, I forgot about it. My own eyes had yet to be opened.

Through the years, galleries and museums in New York and elsewhere have shown samples of FSA and OWI color. (It's accurate to say that the latter, while never misfiled and therefore never "lost," as the FSA work was, still has never been rightly celebrated for its own sake.) In 1983, Light Gallery in New York mounted a small show of FSA color. Two years ago, The Williams College Museum of Art presented: *An American Portrait: Color Photography from the Farm Security Administration*. But even now the color work by the FSA and OWI photographers remains little known and not enough appreciated. This book is being offered as a hopeful corrective.

AND WHY DID THEY SHOOT IN COLOR AT ALL? ONE answer is because it was there. It existed. It was the new technology. The fuller answer is that it helped Roy Stryker's beloved documentary project continue to exist—which is to say to get funded—in the shark-infested waters of New Deal Washington. As I have said elsewhere, Stryker was wonderfully complex—a moralist and a tyrant, a kind of friendly and effervescent tyrant. (John Vachon used that image in a loving portrait in *Harper's Magazine* not long before Stryker died in 1975.) The project director couldn't take a picture of his own for beans; didn't need to, either. He could be garrulous and capricious and generous and cryptic and kind—sometimes in the same letter. He was an old-style Democrat from Colorado whose father had fought in the Civil War and stumped for populism. In 1935, when the documenting of America began, Stryker was a forty-two-year-old irascible man, lately come to FDR's town, with spindly lensed glasses and white hair that stood up in girlish curls on his pale forehead. He turned out to be the antibureaucrat's bureaucrat. He turned out to be the grand compositor. He turned out to be the mind linking the far-flung minds. He was the spymaster at his government-issued desk keeping his temperamental artists just enough off balance to do their finest work.

He recognized that he needed to show results to his superiors and funders, and one way to do it was to get his pictures into public view. As

Sally Stein has written:

> The FSA was most able to defend its existence by placing visual information favorable to the Administration in the popular press. It was Stryker's natural talent as publicist (with one eye forever on the future) that ensured the viability of the FSA's photographic section for eight years. . . . Once the agency had established its reputation for accomplished work, Stryker began to study the market for photography. Magazines such as *Life, Look, Ken* and *Pic* all were conceived with the popular appeal of photography in mind. . . . The photographers who worked longest in the FSA understood the necessity of producing photographs suitable for mass-media distribution. . . . Color was part of Stryker's strategy of anticipating future and radically different requests that would be made upon the FSA file.

There is a famous letter from Stryker to Jack Delano written in September 1940. Delano, who had only recently joined the FSA (he was one of the latecomers, who turned out to be one of the most prolific), was on his first major assignment for the project. From September to January 1941, he and his wife Irene would be almost continuously on the road, documenting the rural and urban Northeast. (Photographers weren't supposed to travel with their spouses, or anyone else, but in this case, as in a few others, Stryker looked the other way.) This missive caught up to Delano in the Finger Lakes region of New York State.

> Please watch for "Autumn" pictures, as calls are beginning to come in for them and we are short. These should be rather the symbol of Autumn, particularly in the Northeast—cornfields, pumpkins, raking leaves, roadside stands with fruits of the land. Emphasize the ideas of abundance—the "horn of plenty" and pour maple syrup over it—you know—mix well with white clouds and put on a sky blue platter. I know your damned photographer's soul writhes, but to hell with it. Do you think I give a damn about a photographer's soul with Hitler at our doorstep? You are nothing but camera fodder to me (except that you are on the other end of the camera).

Was the boss joking? Yes. Was he being dead serious? Yes. In a memoir published a few years ago, *Photographic Memories*, Delano

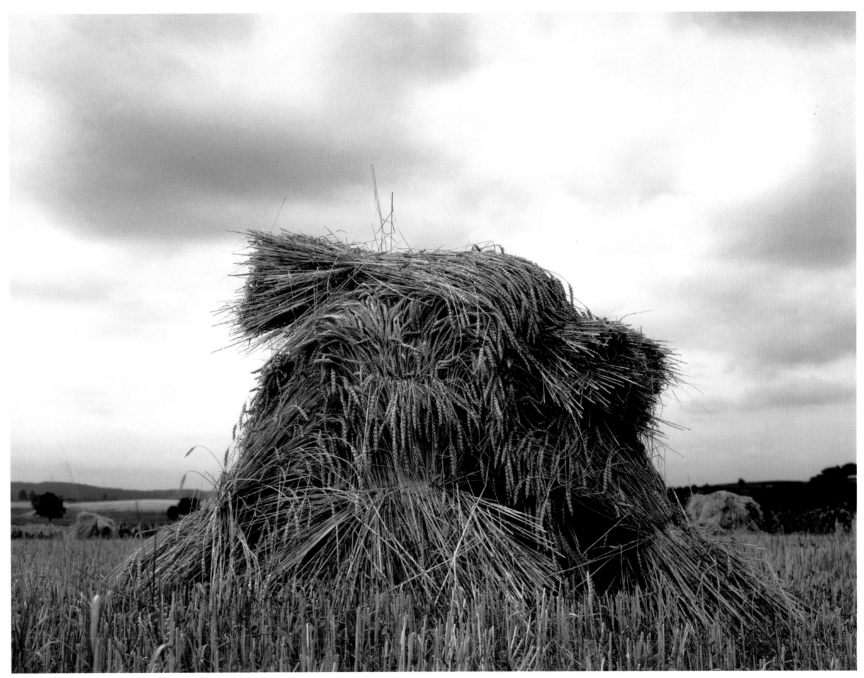

15

Stack of wheat, Pennsylvania
John Collier 7/1943

defended that letter against some who have used it through the years (wrongly) to paint Stryker as both puller of puppet strings and cynical propagandist. He was more a press agent than a propagandist, and he was hardly cynical, and in some ways he always worked wonderfully against himself—so that all the work could get done, get in. "He was engaged in a constant struggle with congressmen and senators in his efforts to keep the agency afloat," wrote Delano. If color work could help get the hay in, stave off those who might close him down, why not? The man was nothing if not an attuned pragmatist, a survivor.

But none of the color work by his photographers actually got used in the publications of the thirties. Much black-and-white work got into newspapers and magazines. This must go to Grundberg's point, as well as to Stein's, that the color pictures were too much ahead of their time to find outlets in periodicals of the day. They were too good, which is to say they weren't escapist or commercial enough. So much of the color work that was being published in the "slicks" of the thirties was flamboyant, inauthentic, decorative rather than indigenous. It was, well, *colorful*. It's funny, really: even today that word can connote such a pejorative idea about creative or even journalistic work. I worked thirty years in daily newspapering as a feature writer, a description I've always loathed. I can still hear editors barking, "Give me color on that story." Color writers were the ones delivering the "soft" news, which is another way of saying the dispensable news. It's as if no one realized that working in "color" might actually be the deeper task in terms of trying to capture life and its complexities.

Stein, on color from the FSA photographers:

Even when the choice of subject conformed to existing ideas about what was especially colorful, the resulting photograph attends to the event as a matter of fact. The unusual occasion or decoration was not magnified out of proportion to its social context. The "colorful" discovered in American life was never exploited as a vehicle for compositional exercises and was rarely romanticized into a painterly image of itself. Clothing, walls, signs—all of which serve decoratively—were recorded as decorative vehicles, without further embellishment.

Why were the photographers able to use such restraint? Again, the answer must have to do with their basic integrity, not to say brilliance,

as well as with the boss's watchful eye. Stryker, a crude man in some ways, was deeply sensitive to the common man. He wasn't going to let an undefended subject get exploited. Stryker has always reminded me of the paradoxes of Harold Ross, the founding editor of the *New Yorker*, a native Westerner with dirty fingernails who put out such an elegant magazine. Walker Evans, arguably the greatest American photographer of the twentieth century, worked fractiously for Stryker and only for a relatively brief period. Evans seems to have had barely disguised contempt for Stryker, regarding him as a philistine, which to Stryker would have almost been a compliment, especially coming from the elitist and fastidious and incomparably gifted Evans.

Whatever it was, the odd alchemy of artists and proletariat boss, the pictures speak for themselves. So here is Delano (page 17), giving us the lonely, late-night glow of a yardmaster sitting in his cone of light in his wainscoted and paper-strewn railroad office in Amarillo, Texas. It's the color, I think, that conveys the powerful and particular amber of this man's loneliness—"amber" as a spiritual quality and state of being almost more than a color. So here is Wolcott (page 23), giving us the slowness and idyll of what must be a Sunday afternoon—an October Sunday afternoon—in 1939 near Belzoni, Mississippi. Sunday, because on any other day of the week, the people in this photograph surely would have been toiling on the nearby cotton plantation to which they were indentured in every sense but a lawful one. Color—the brown of the water, the reddishness of the bank, the dusty greenness of the trees in the background—permits us to feel the reprieve, redemptive stillness, of that Delta afternoon, when almost nothing is wriggling save a worm on a hook. The water may be muddy-brown and ugly, but there are catfish in it. That cane pole is fighting one right now. So here is Wolcott again (page 40), standing across the road from a juke joint and country gas station in Melrose, Louisiana, on a June day in 1940. The image is gaudy, all right, which is precisely what the scene was: she is reporting what she finds. It's what James Agee, who wrote the thirties documentary masterpiece, *Let Us Now Praise Famous Men*, spoke of as "the cruel radiance of what is." And here is Wolcott once more (page 41), showing us another Deep South store plastered with its soft-drink signdom. This time we're in Natchez. There is a kind of patchy, adobe quality to the lime-green walls. I can feel that Mississippi heat, and I think it's because of the sickly color of the walls. Faulkner wrote of these dead, still, hot, lovely afternoons.

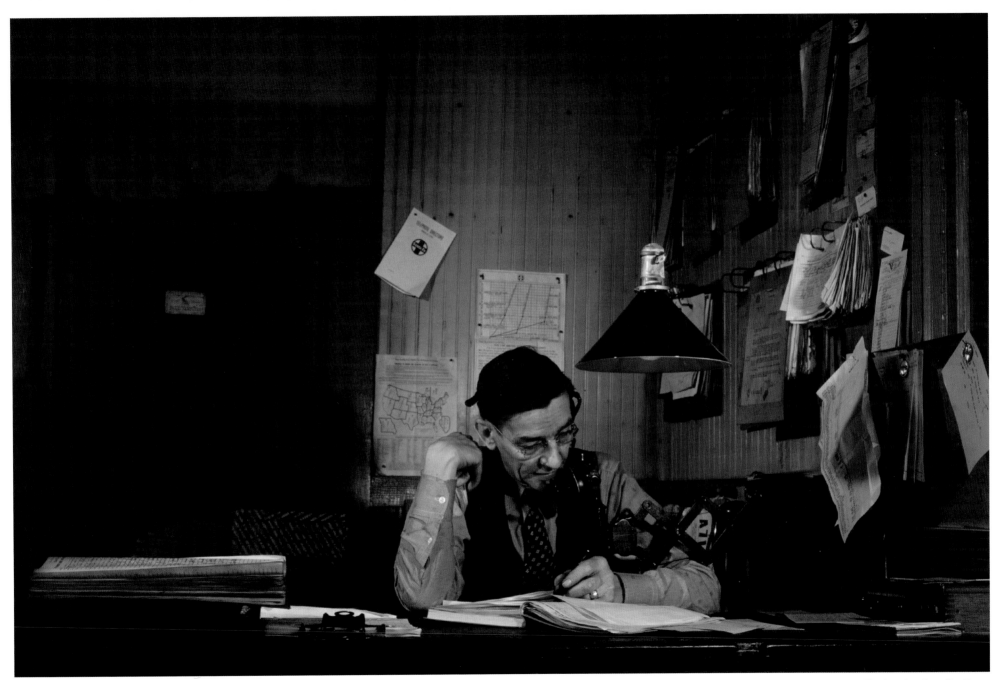

Yardmaster, Amarillo, Texas
Jack Delano 3/1943

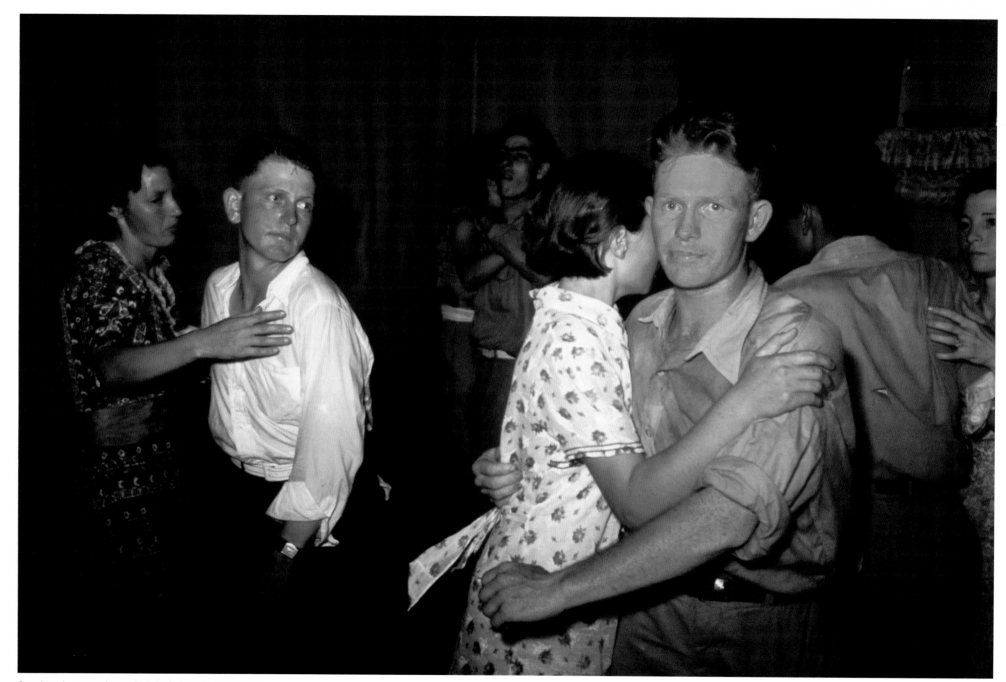

Couples at square dance, McIntosh County, Oklahoma
Russell Lee 1939–1940

18

In the spring of 1940, Russell Lee and his wife, Jean, were on a visit to the FSA regional office in Amarillo when they heard about a little settlement down in New Mexico called Pie Town. How could you resist that name? Pie Town, about a hundred miles southwest of Albuquerque, had been settled by homesteaders from Texas and Oklahoma fleeing the Dust Bowl. It had gotten its name in 1909 when a prospector's wife had opened a store that sold pies to locals. By the time Russ Lee photographed it, the town operated on the principle of self-help and community effort. It was a kind of co-op in the desert. Some members of the community lived in dugout houses and sod shacks. The equipment the photographer carried in the trunk of his car included a 9 x 12cm Linhof Technika; a Speed Graphic; two Contax I 35mm cameras; three flash guns; cases of flashbulbs; many sheets of cut film; cut film holders; cases of 35mm roll film; tripods; plus equipment for field developing the black-and-white work. Some of the pictures Lee got appeared in *U.S. Camera*, in October 1941. His Pie Town series is now considered among the greatest FSA documents in terms of a self-contained essay, showing us what the power of pictures, few words needed, can do.

And yet in a way the color work from Pie Town, not nearly as known, not nearly as many images, recorded in October 1940, shows us even more of that raw Emersonian community. You get the reds of the earth and faces; the soft sages of the brushland and clothing; the interiors of the dimly lit dwellings. Study some of the ones reproduced in this book—on pages 50–66. It's a little Technicolor movie of a lost American place, of lost American families named Whinery and Caudill. In 1983, in *American Photographer* magazine, FSA historian F. Jack Hurley presented some of Lee's Pie Town work, both the color and the black and white. He described how Lee had to master the new technology on the short bounce. Color required mobility and spontaneity, using a clunky on-camera flash for 35mm slides. The flashes were big blue flashbulbs (carried in suitcases) to help balance color temperature and emulsions so sensitive to heat. As Hurley wrote, "The use of color intrigued [Lee] and it seemed important to capture the ruddy orange of sunburned faces and the incredible blue of the sky. Those slides have held their color surprisingly well, and serve today to remind us

[that] . . . life during the late Depression was not as colorless as memory."

As colorless as memory. That's the whole point here, isn't it—or the point to argue against? Life has always been a colored thing. I wish to speak for inclusivity. I love the black-and-white thirties photography of Lee and Wolcott and Vachon and Delano and all the others—but I now love their color work as well. There is a photographic and cultural historian named Michael Lesy to whom I have been indebted for many years. Two years ago he published a book called *Long Time Coming*. His point, which we already knew but were glad to be reminded of, was that the FSA collection amounts to a kind of Homeric narrative of America. The photographers saw everything in their viewfinders, not just misery and the pluck and the breadlines and the grapes of wrath.

They saw rawboned, sleeve-rolled, Friday-night, communal happiness at a square dance in McIntosh County, Oklahoma (page 18). They saw hard-pressed people joyfully greeting each other in the parking lot at the Pie Town fair (page 58). Three generations of Western women are in the frame—little girls, moms, a calico-clad granny. And yet, when you look again, perhaps your eye and emotion will drift away from this female joy, over toward the little boy, with his head down, with his hands pocketed, standing alone, as if somehow shamed. But why? It would be impossible to know now. What remains are our feelings from gazing at the image—confused, deep, lingering, rich. There is a poet I love and tend to read late at night, Richard Hugo. He titled one of his books and best poems: *What Thou Lovest Well Remains American*.

All of it, every bit, that's what Stryker's photographers saw and sealed inside their boxes. "I want people to look again, and think again, and to realize that things were both worse than you can imagine and better than you can imagine," Michael Lesy has said of that period from the middle of the Depression into the first years of war. Yes. They saw misery, they saw the joy, they saw decency and the pity and the shame, and there wasn't a color on the palette left out.

The too-long-ignored color photographs in this volume, I think, can only add to, not detract from, the black-and-white Movietone reel that's long been running in your head.

— PAUL HENDRICKSON

Tenant's home beside the Mississippi River levee, near Lake Providence, Louisiana
Marion Post Wolcott 6/1940

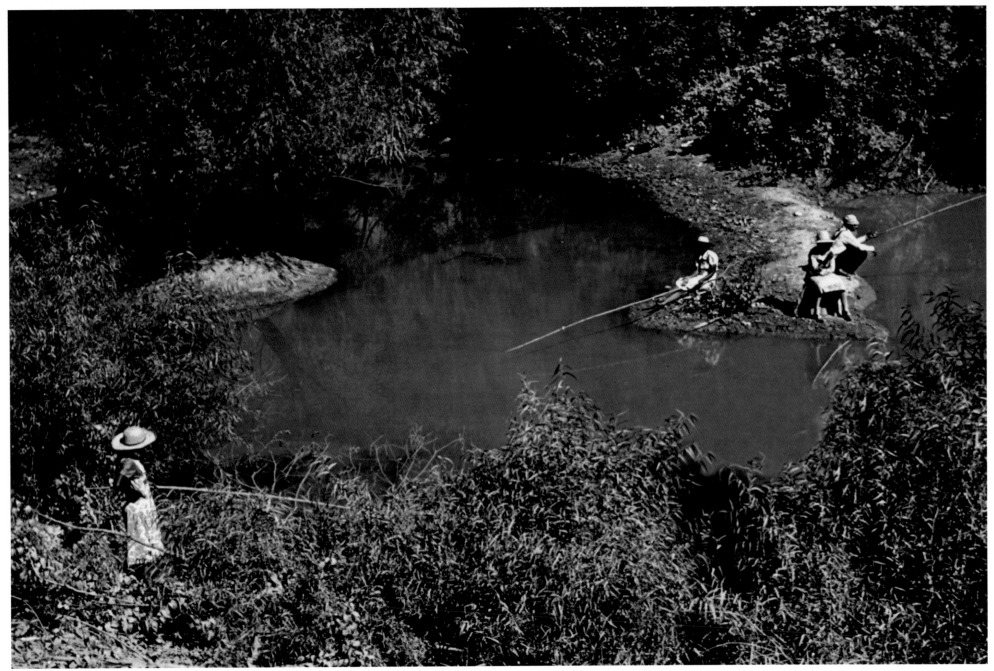

Fishing in a creek near cotton plantations outside Belzoni, Mississippi
Marion Post Wolcott 10/1939

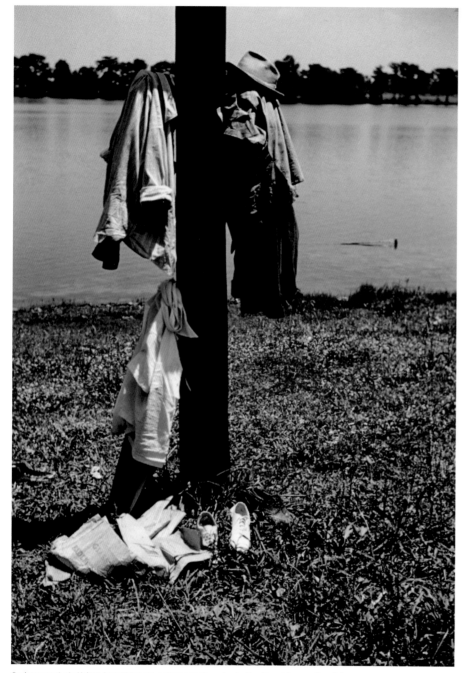

Swimmers' clothing hanging on a telegraph pole, Lake Providence, Louisiana
Marion Post Wolcott 6/1940

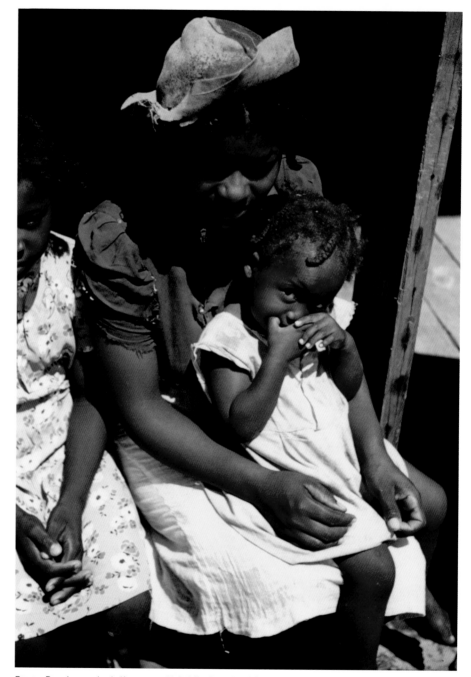

Bayou Bourbeau plantation, near Natchitoches, Louisiana
Marion Post Wolcott 8/1940

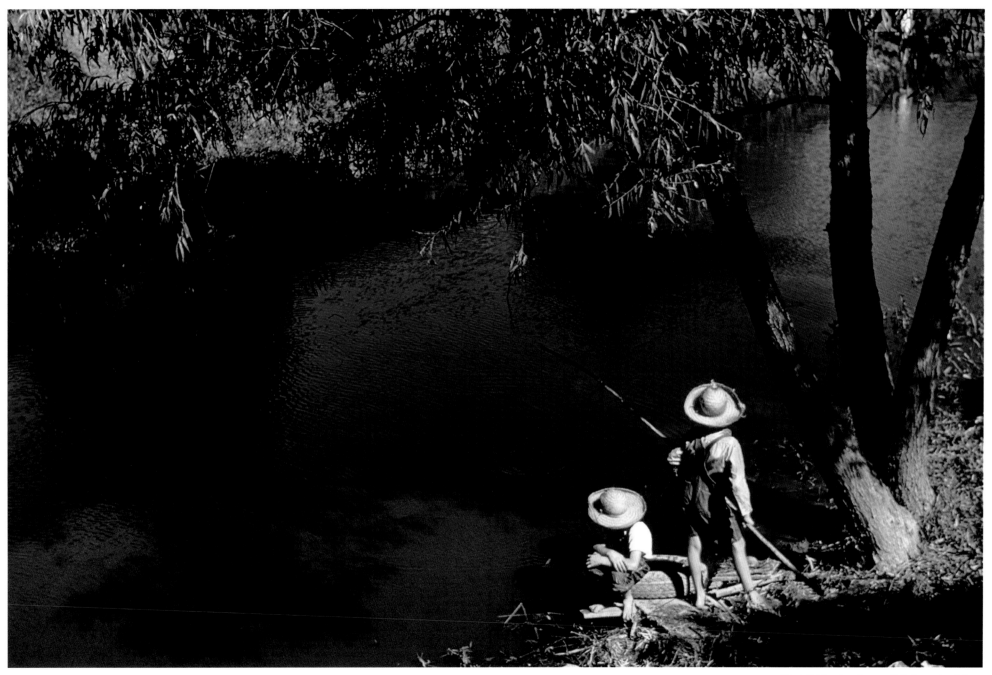

Boys fishing in a bayou, Schriever, Louisiana
Marion Post Wolcott 6/1940

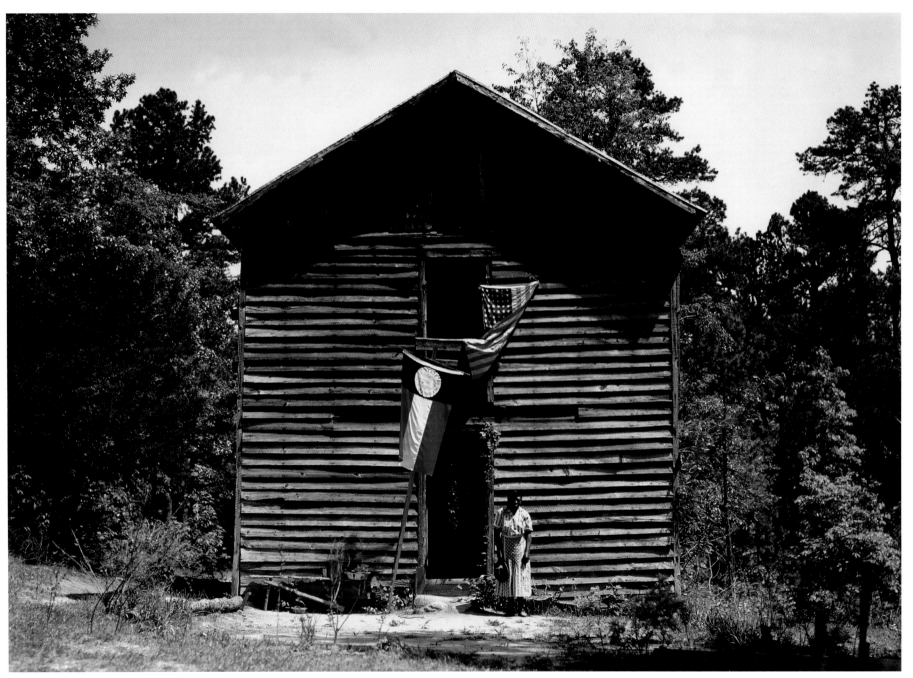

Building with Georgia state and United States flags. Possibly near White Plains, Georgia
Jack Delano [possibly Marion Post Wolcott] c. 1941

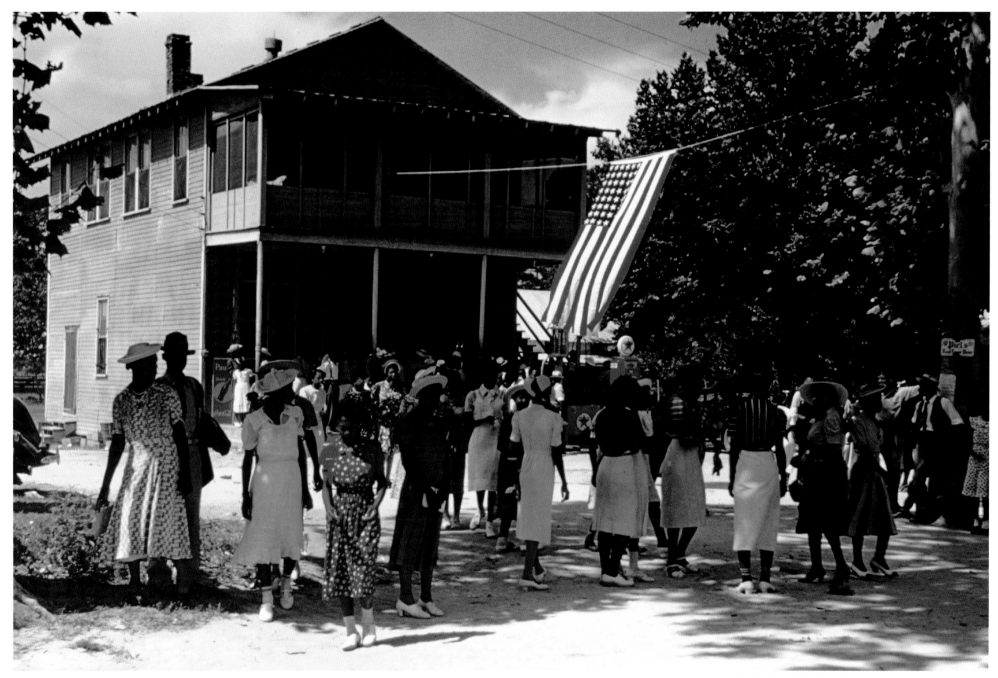

A Fourth of July celebration, St. Helena Island, South Carolina
Marion Post Wolcott 1939

27

Going to town on Saturday afternoon, Greene County, Georgia
Jack Delano 5/1941

Possibly a Georgia oat field (identification based on similar images in the FSA archives)
Marion Post Wolcott c. 1940

30

Day laborers picking cotton near Clarksdale, Mississippi
Marion Post Wolcott 11/1940

Chopping cotton on rented land near White Plains, Greene County, Georgia
Jack Delano 6/1941

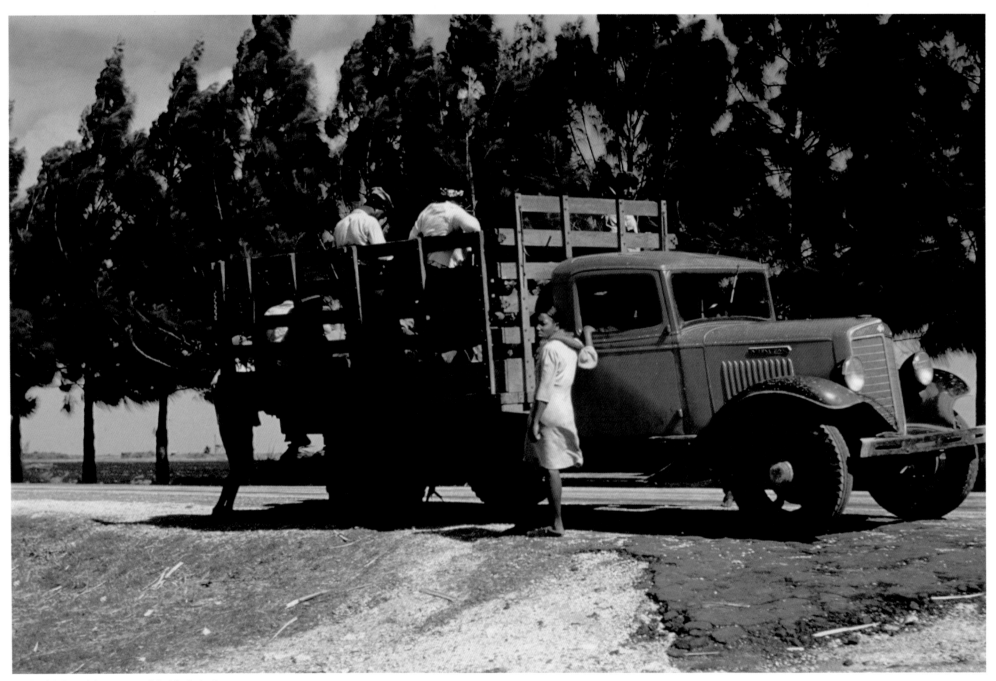

Truck with farm laborers, possibly Mississippi
Marion Post Wolcott c. 1940

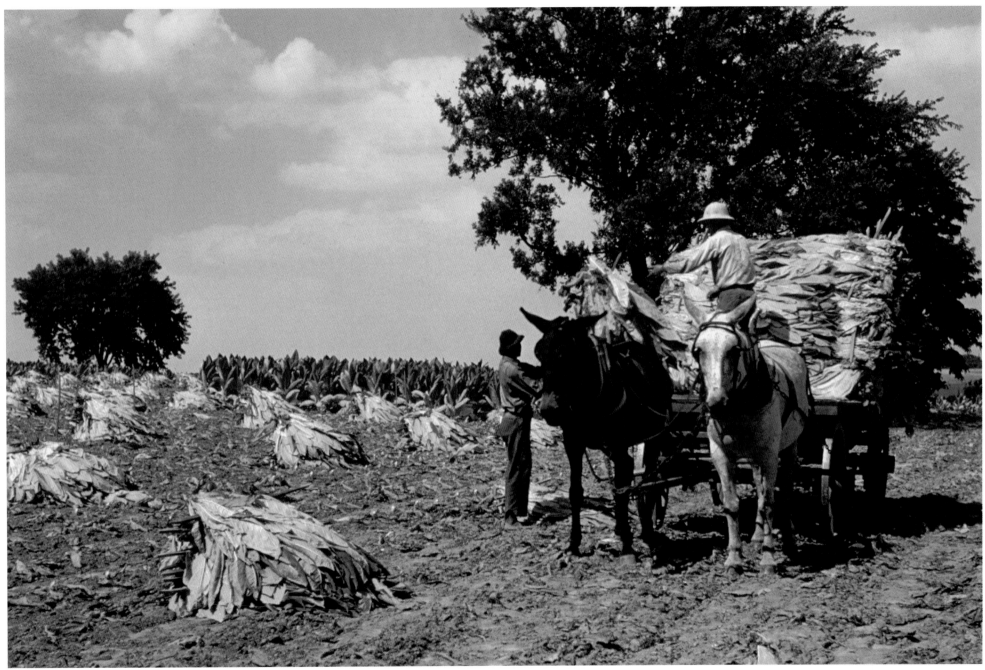

33

Taking tobacco in from the fields, Russell Spears's farm near Lexington, Kentucky
Marion Post Wolcott 9/1940

Boy who brought lunch to his father, sugarcane fields, near Rio Piedras, Puerto Rico
Jack Delano 1/1942

La Vallee, St. Croix, Virgin Islands
Jack Delano 12/1941

34

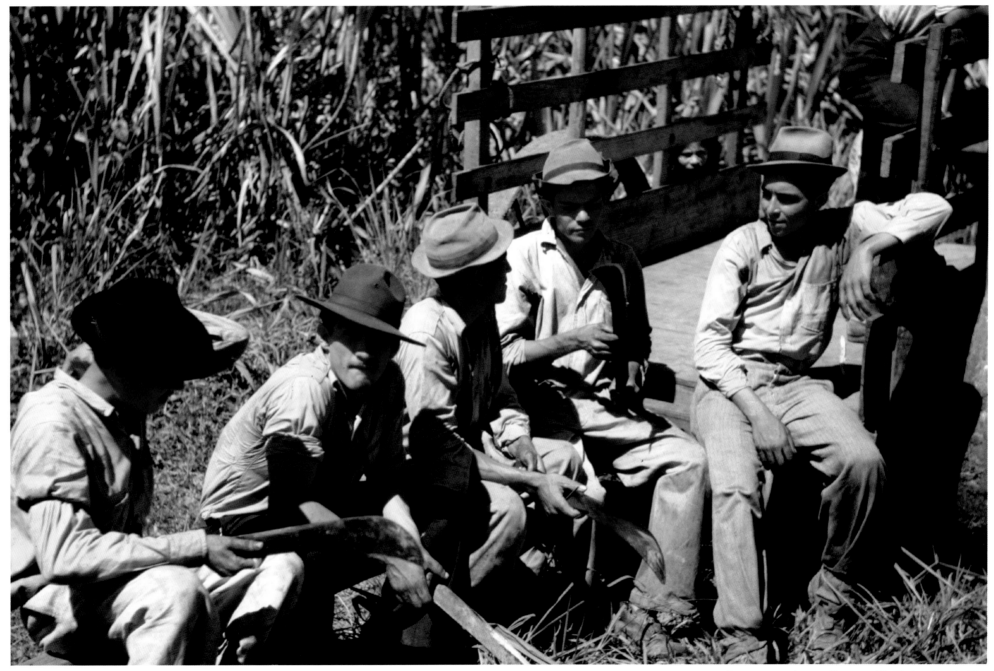

Sugarcane workers resting, near Rio Piedras, Puerto Rico
Jack Delano 12/1941

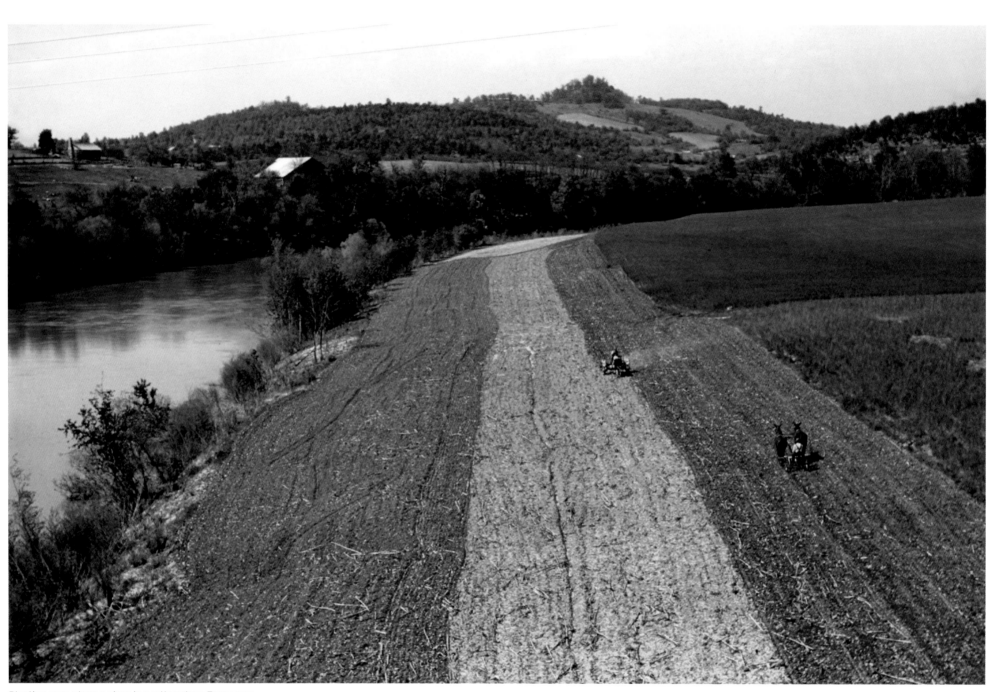

Planting corn along a river in northeastern Tennessee
Marion Post Wolcott 5/1940

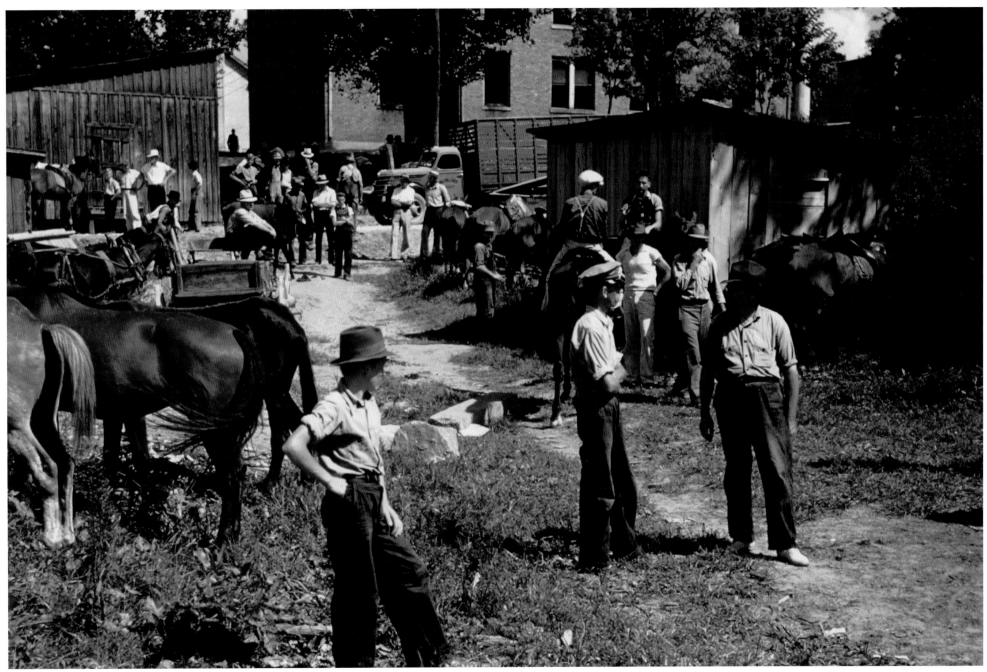

Mountaineers and farmers trading mules and horses, Campton, Wolfe County, Kentucky
Marion Post Wolcott 9/1940

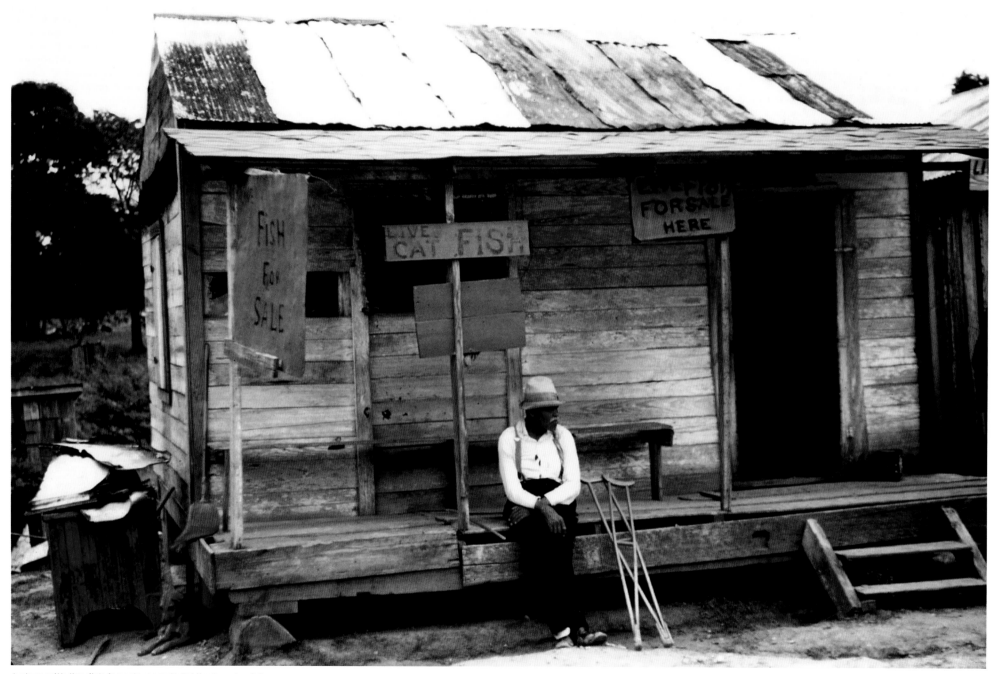

A store with live fish for sale, near Natchitoches, Louisiana
Marion Post Wolcott 6/1940

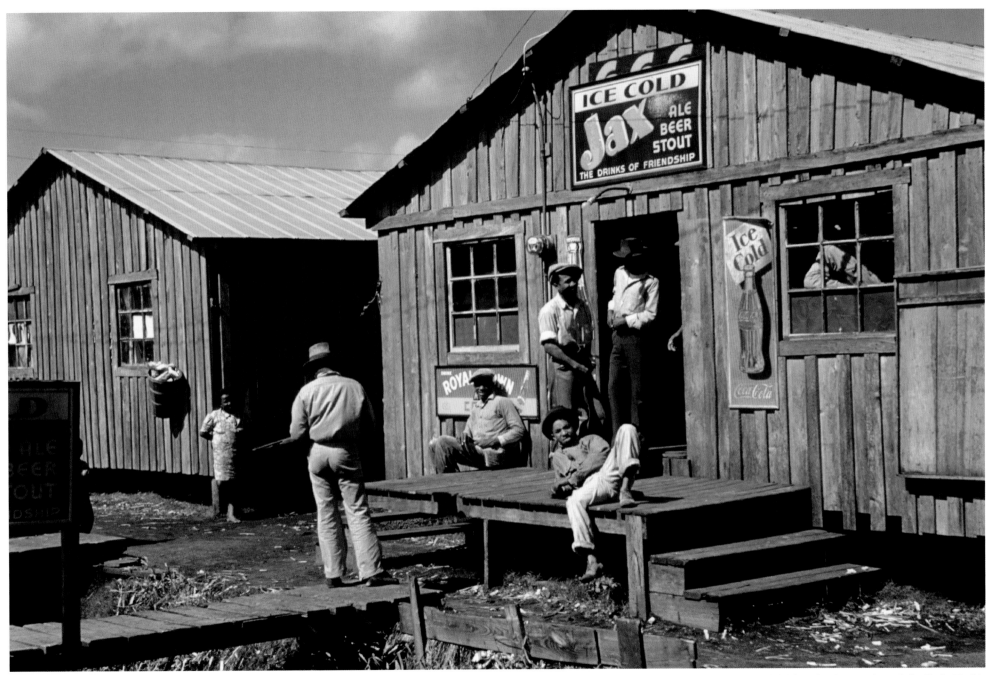

39

Living quarters and juke joint for migratory workers, Belle Glade, Florida
Marion Post Wolcott 2/1941

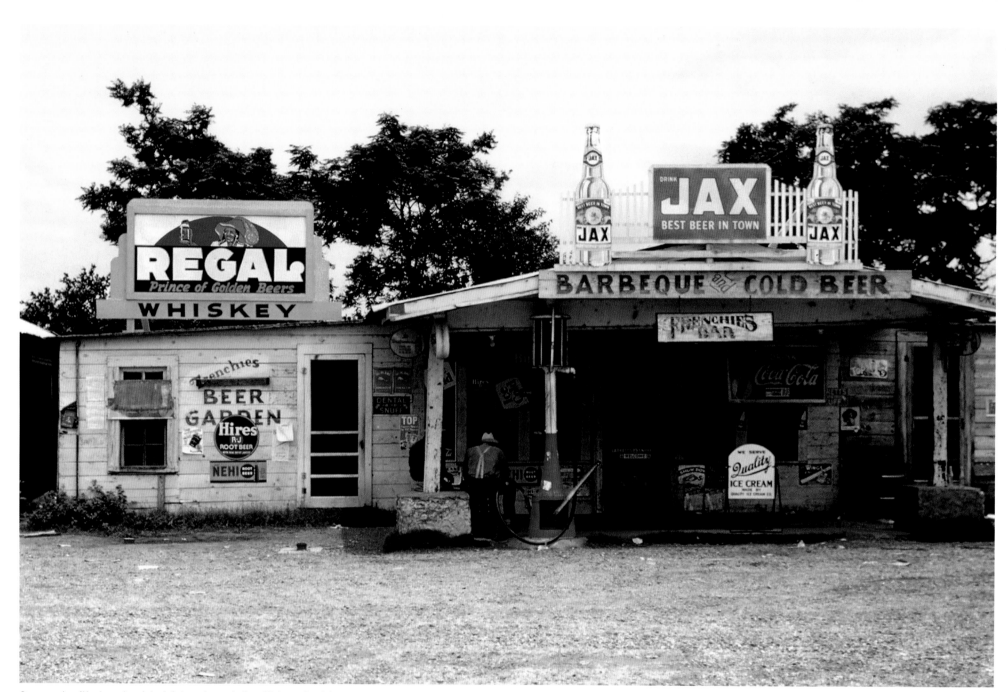

40

Crossroads with store, bar, juke joint, and gas station, Melrose, Louisiana
Marion Post Wolcott 6/1940

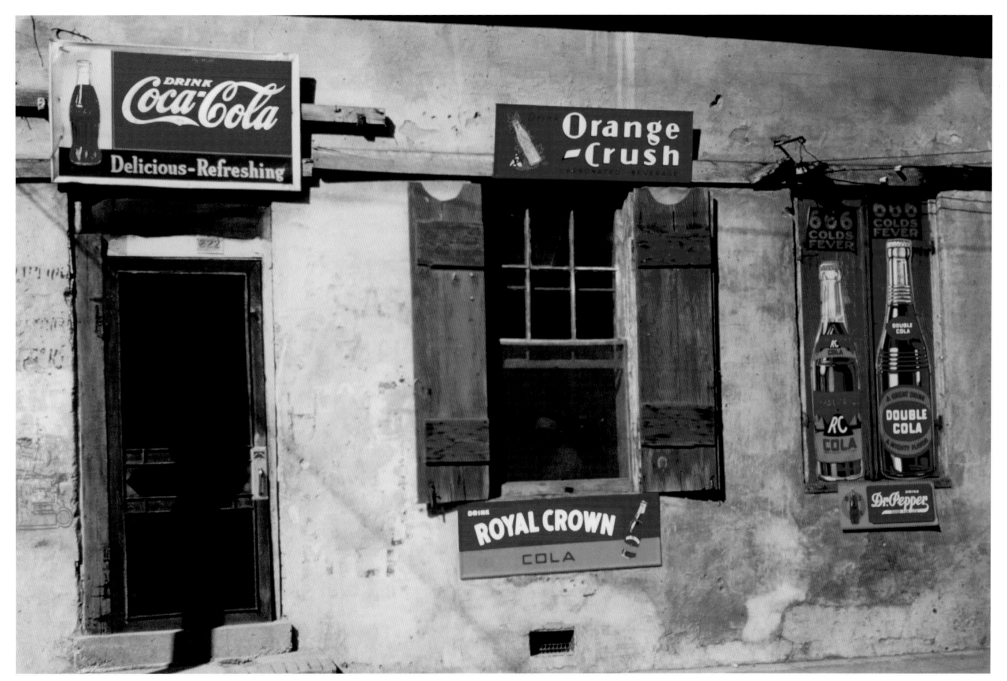

Natchez, Mississippi
Marion Post Wolcott 8/1940

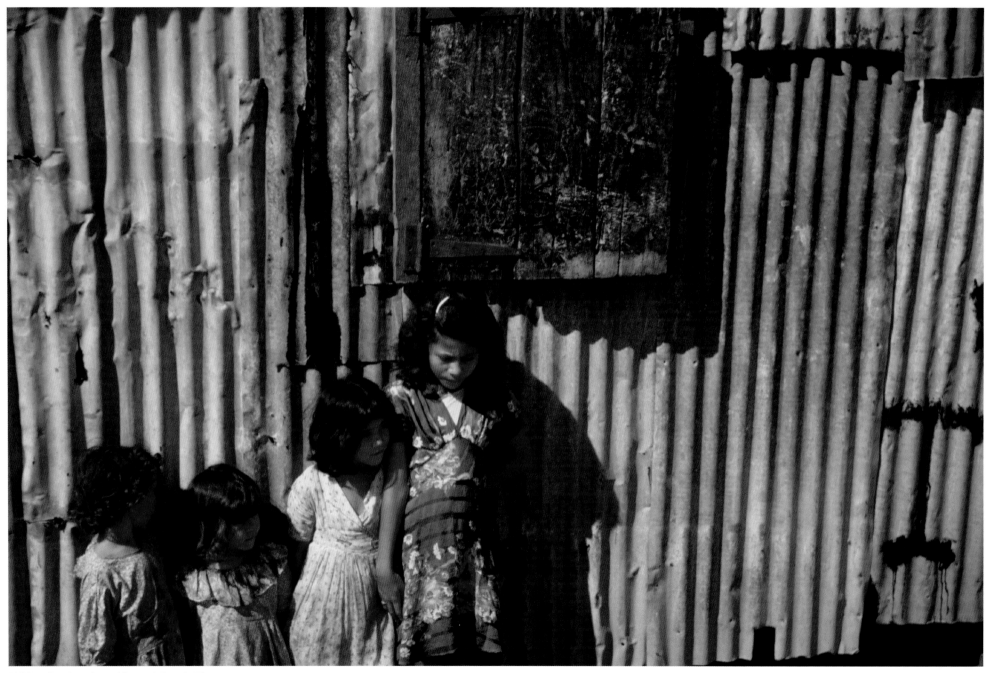

42

Children in a housing settlement, Puerto Rico
Jack Delano 12/1941

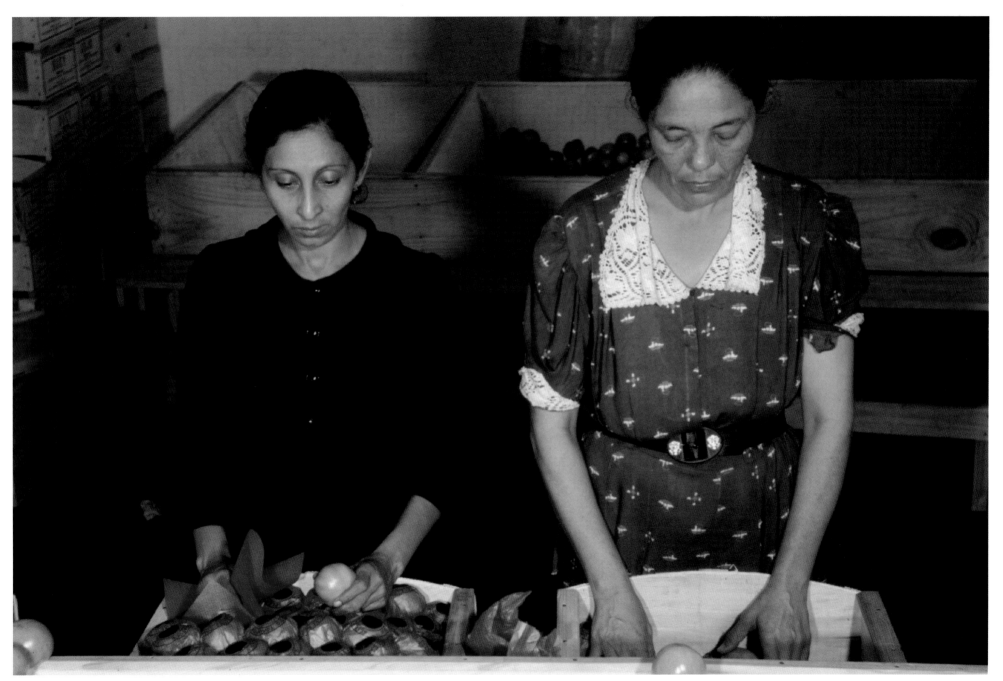

Sorting and packing tomatoes at the Yauco Cooperative Tomato Growers Association, Puerto Rico
Jack Delano 1/1942

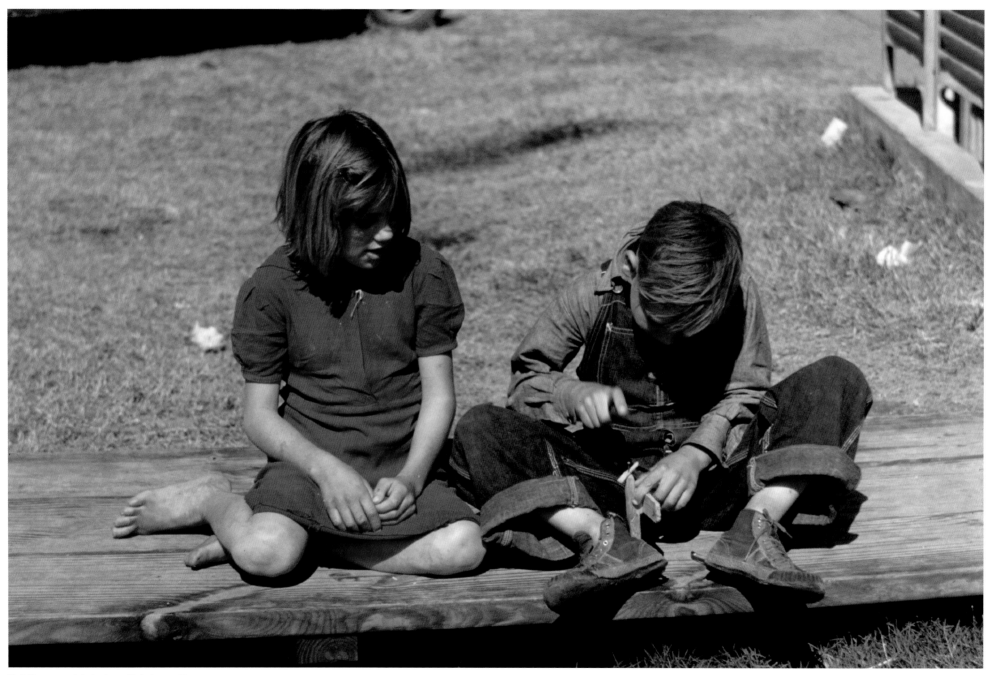

Building a model airplane, Robstown, Texas
Arthur Rothstein 1/1942

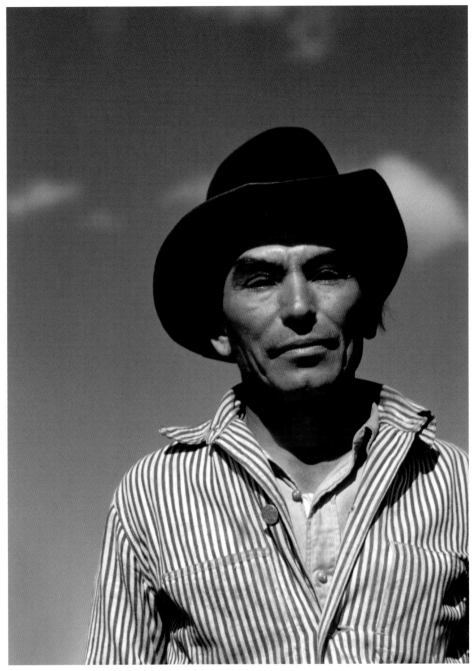

Migratory worker, Robstown, Texas
Arthur Rothstein 1/1942

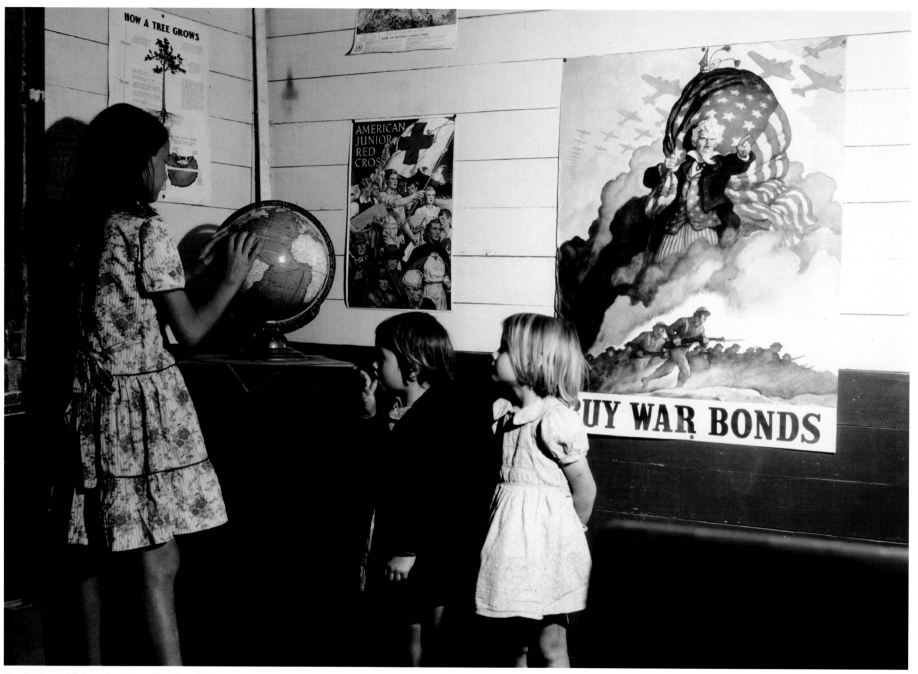

Rural school children, San Augustine County, Texas
John Vachon 4/1943

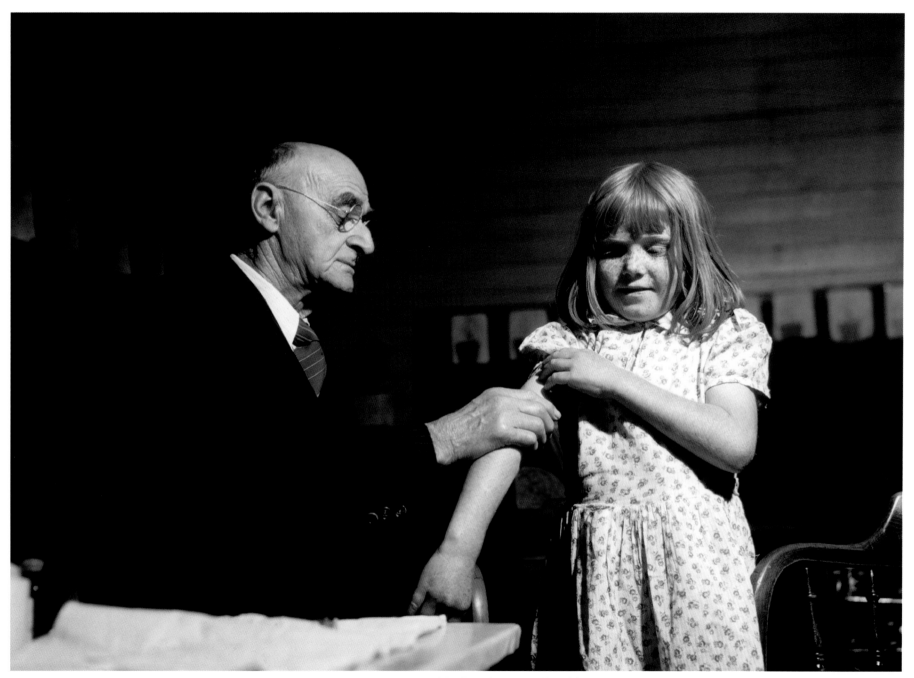

Dr. Schreiber of San Augustine giving a typhoid inoculation at a rural school, San Augustine County, Texas
John Vachon 4/1943

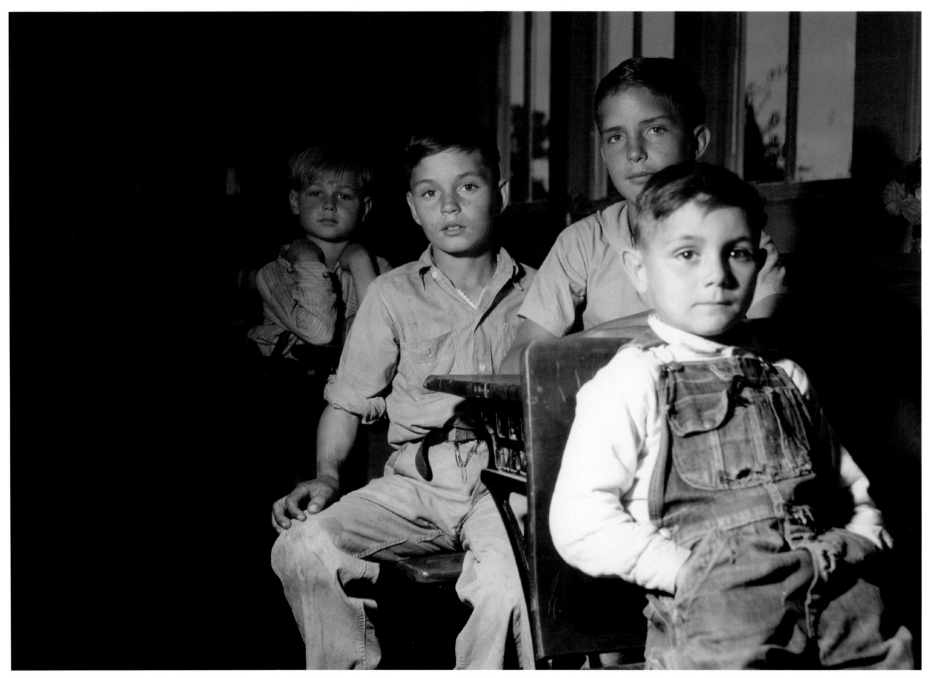

48

Rural school children, San Augustine County, Texas
John Vachon 4/1943

49

Houston, Texas
Photographer unknown 1943

50

Faro and Doris Caudill, homesteaders, Pie Town, New Mexico
Russell Lee 10/1940

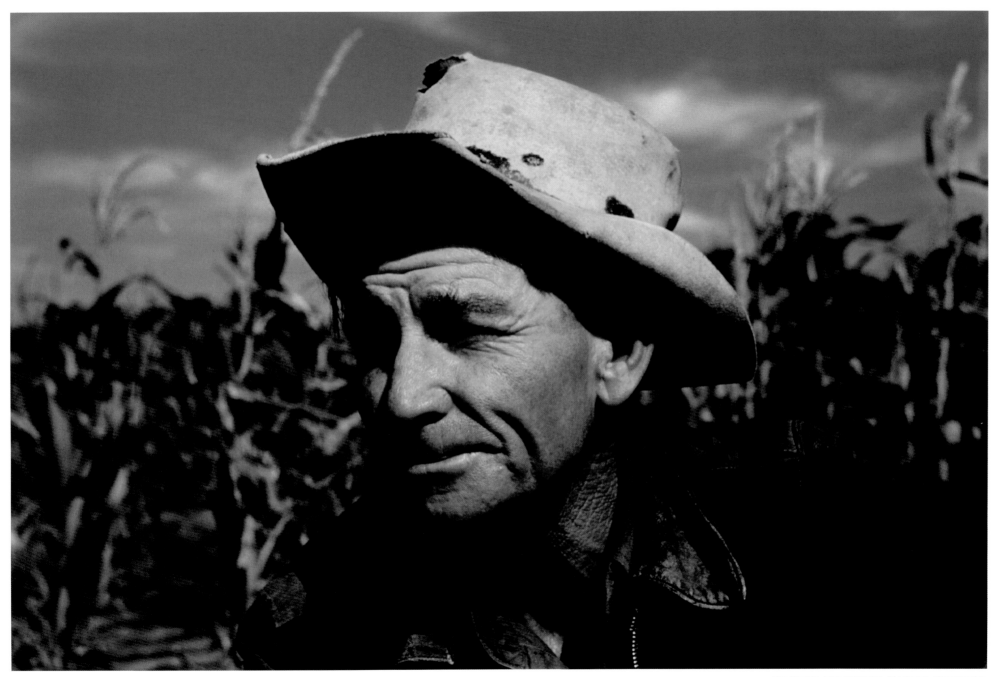

51

Jim Norris, homesteader, Pie Town, New Mexico
Russell Lee 10/1940

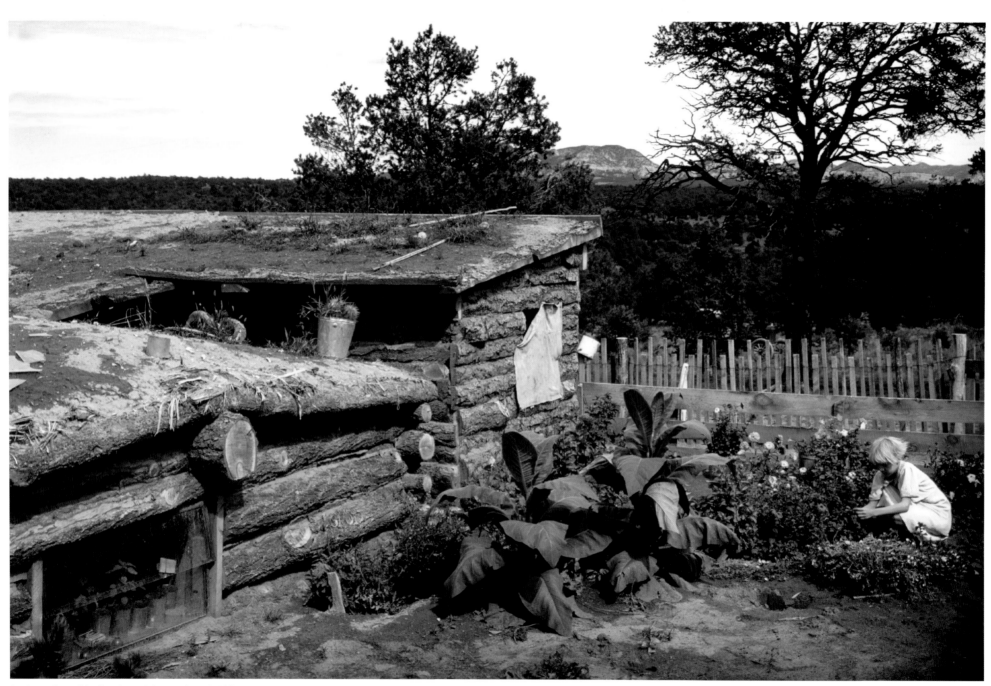

52

Garden adjacent to the dugout home of Jack Whinery, homesteader, Pie Town, New Mexico
Russell Lee 9/1940

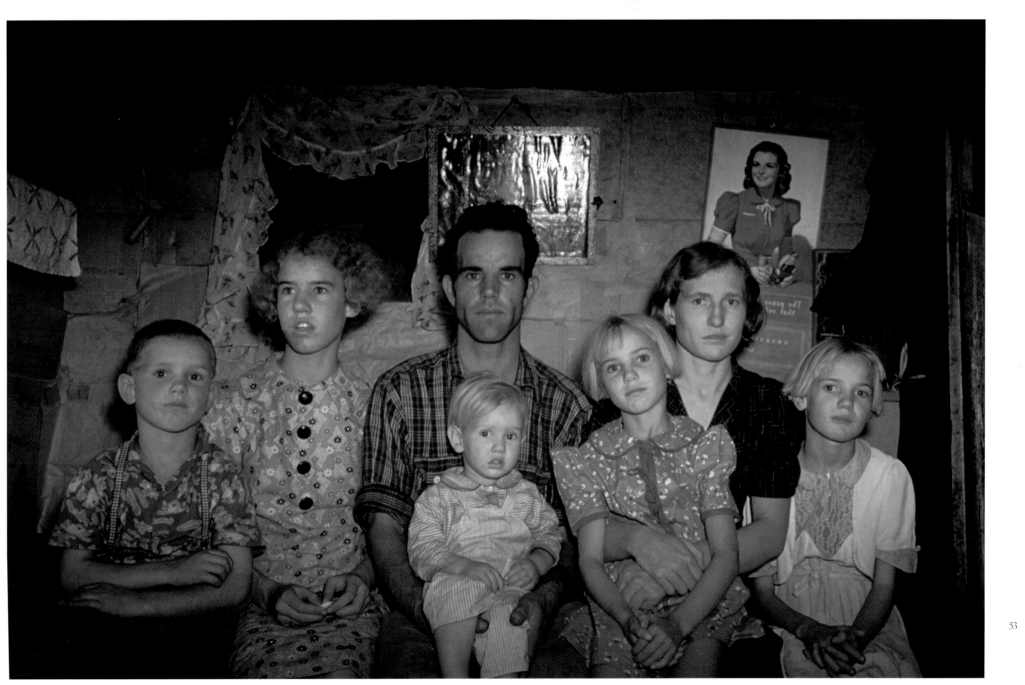

53

Jack Whinery, homesteader, and his family, Pie Town, New Mexico
Russell Lee 10/1940

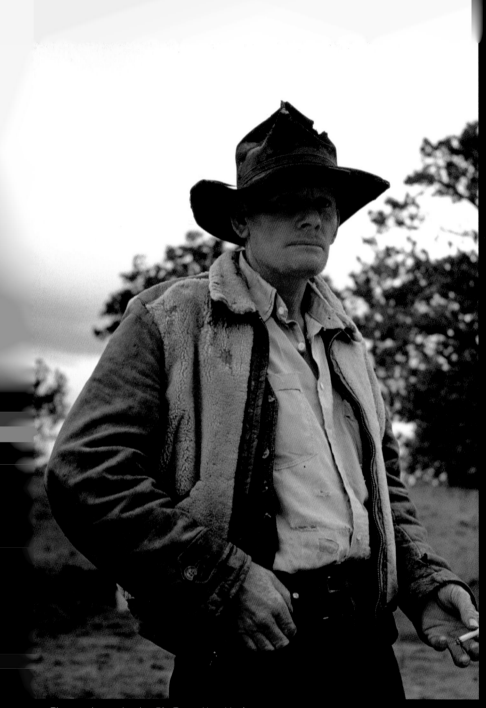

es Thomas, homesteader, Pie Town, New Mexico

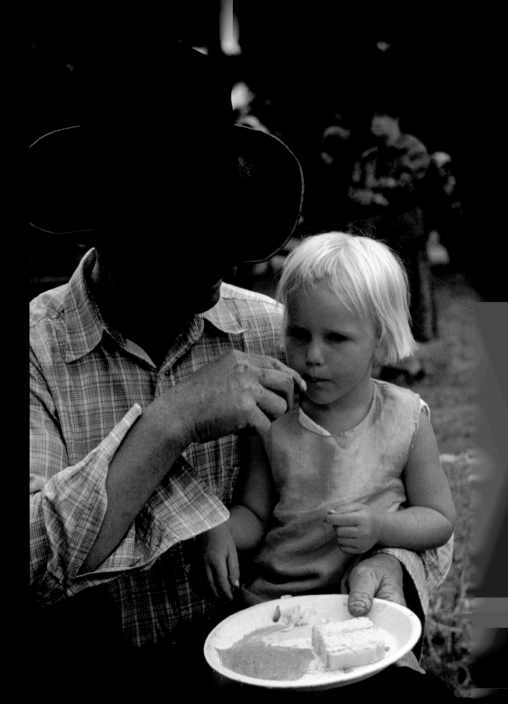

Homesteader feeding his daughter barbeque at the fair, Pie Town, New Mexico

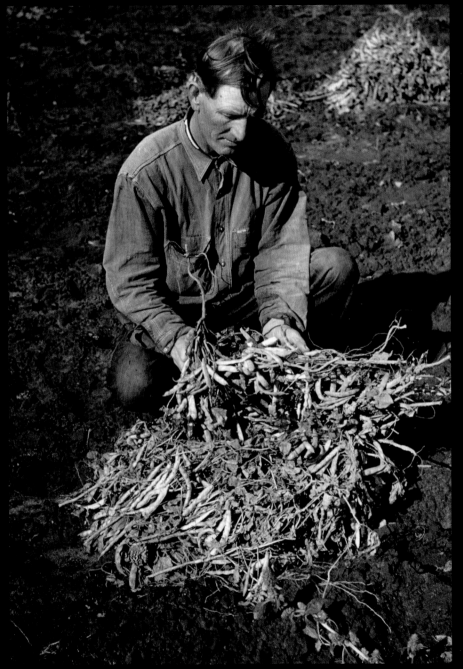

Bill Stagg, homesteader, with pinto beans, Pie Town, New Mexico
Russell Lee 10/1940

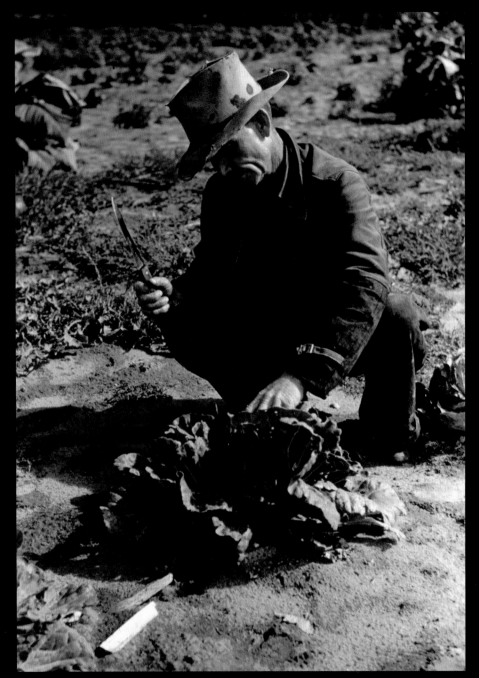

Jim Norris, homesteader, cutting a head of cabbage, Pie Town, New Mexico
Russell Lee 10/1940

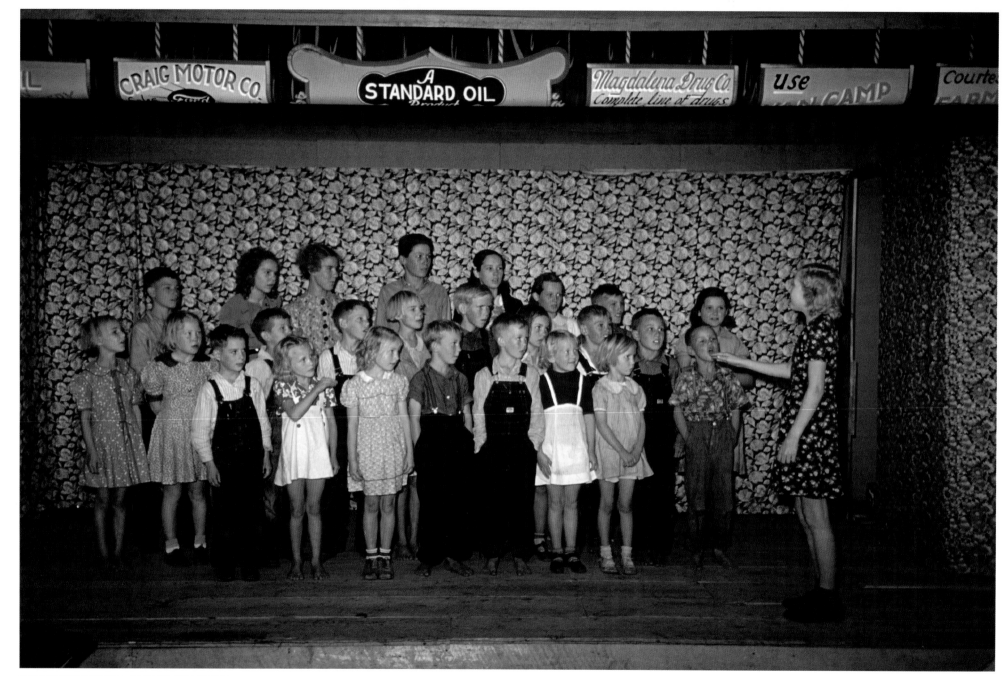

Schoolchildren singing, Pie Town, New Mexico
Russell Lee 10/1940

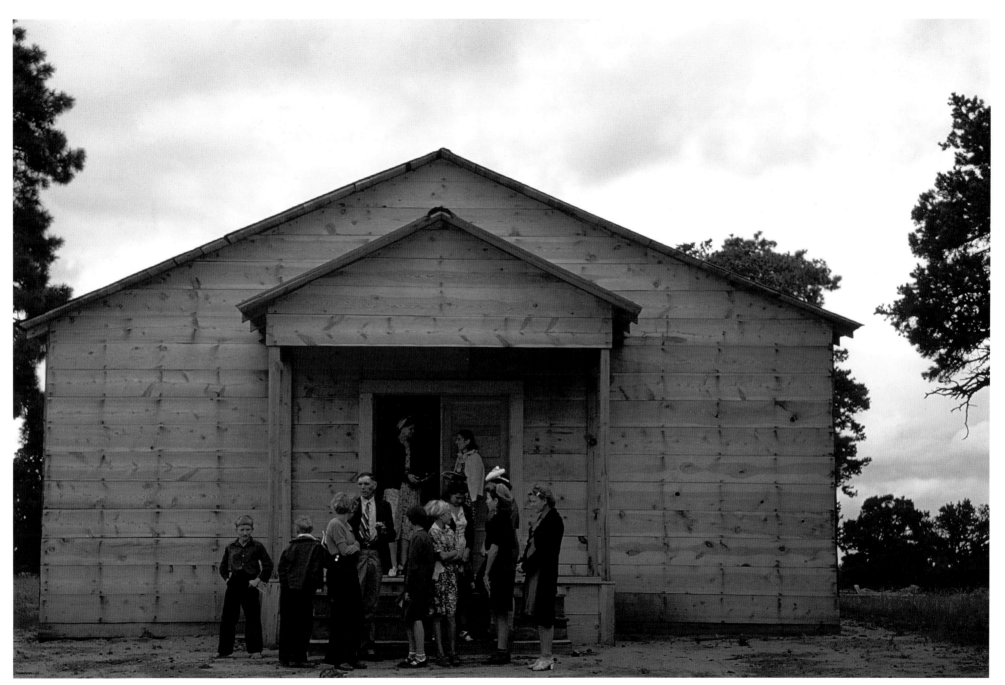

Church, Pie Town, New Mexico
Russell Lee 10/1940

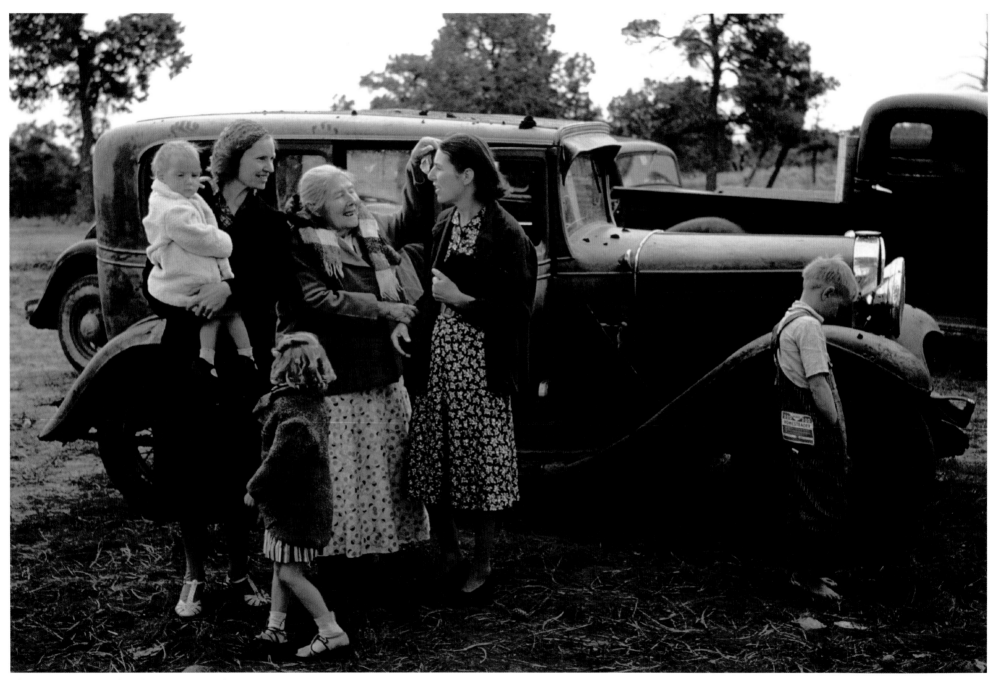

Friends meeting at the fair, Pie Town, New Mexico
Russell Lee 10/1940

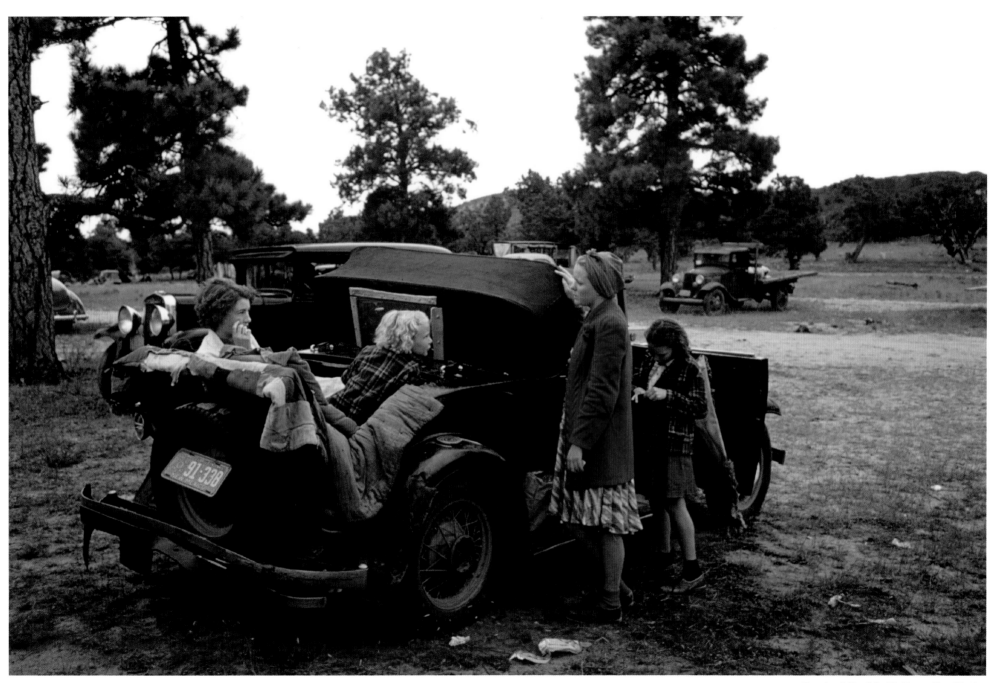

People at the fair, Pie Town, New Mexico
Russell Lee 10/1940

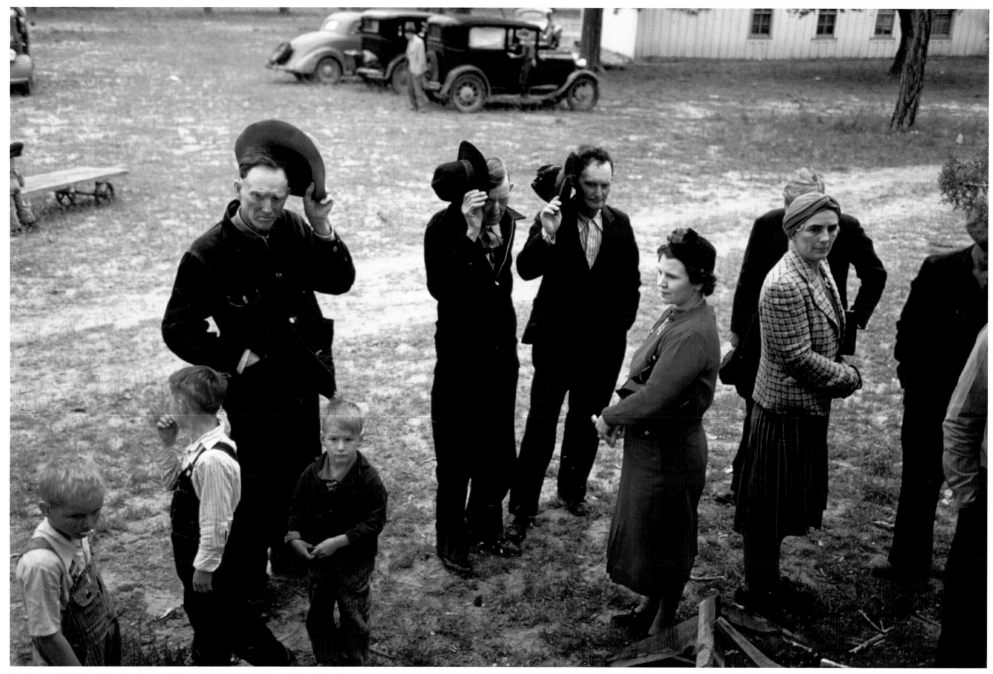

Saying grace before the barbeque dinner at the fair, Pie Town, New Mexico
Russell Lee 10/1940

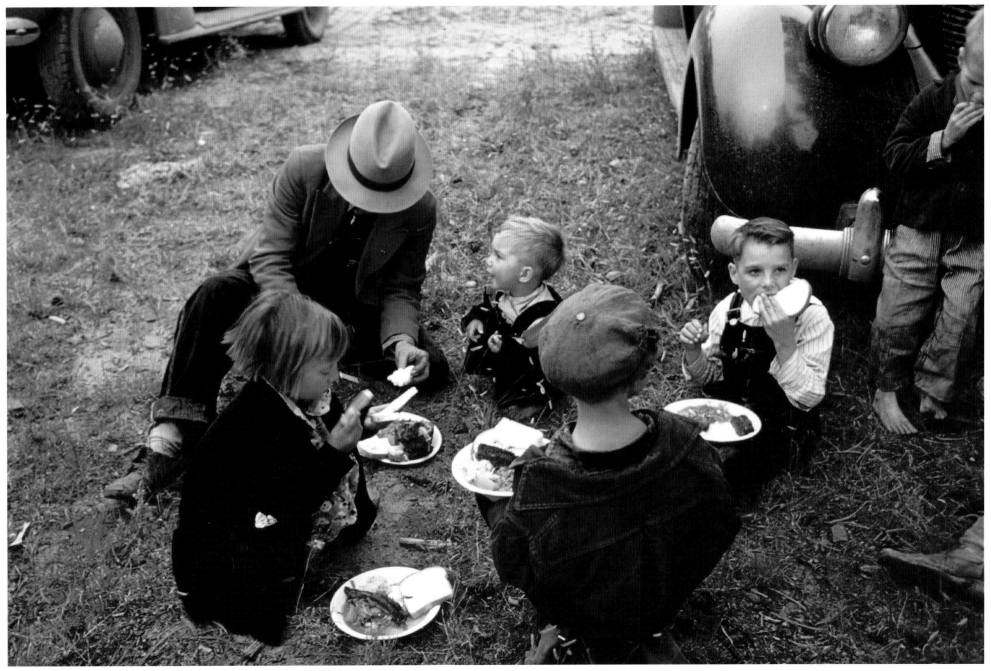

61

Homesteader and his children eating barbeque at the fair, Pie Town, New Mexico
Russell Lee 10/1940

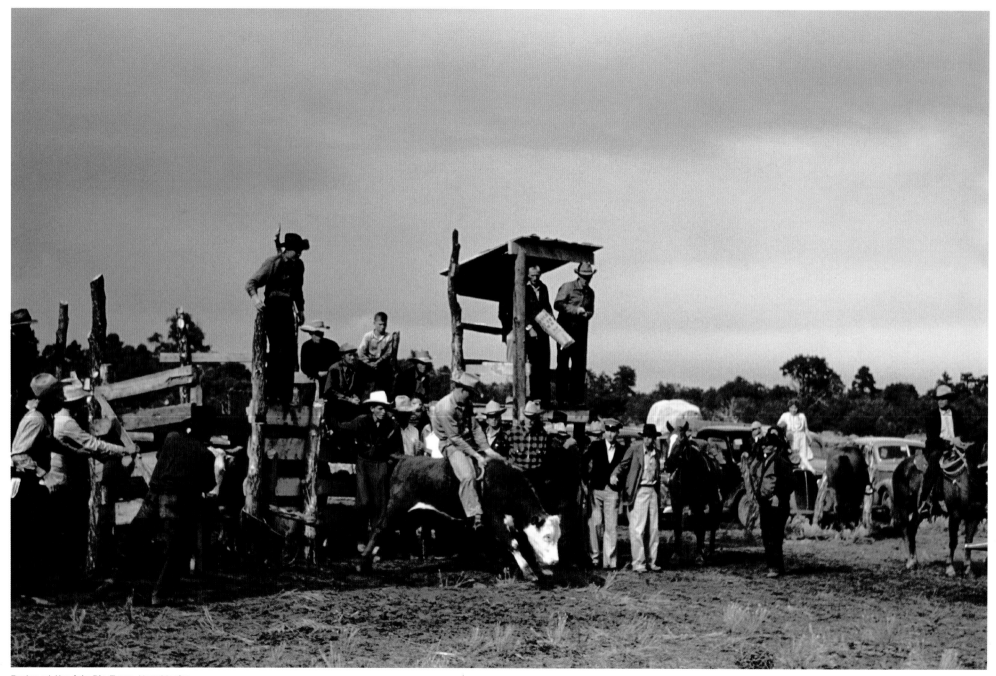

Rodeo at the fair, Pie Town, New Mexico
Russell Lee 10/1940

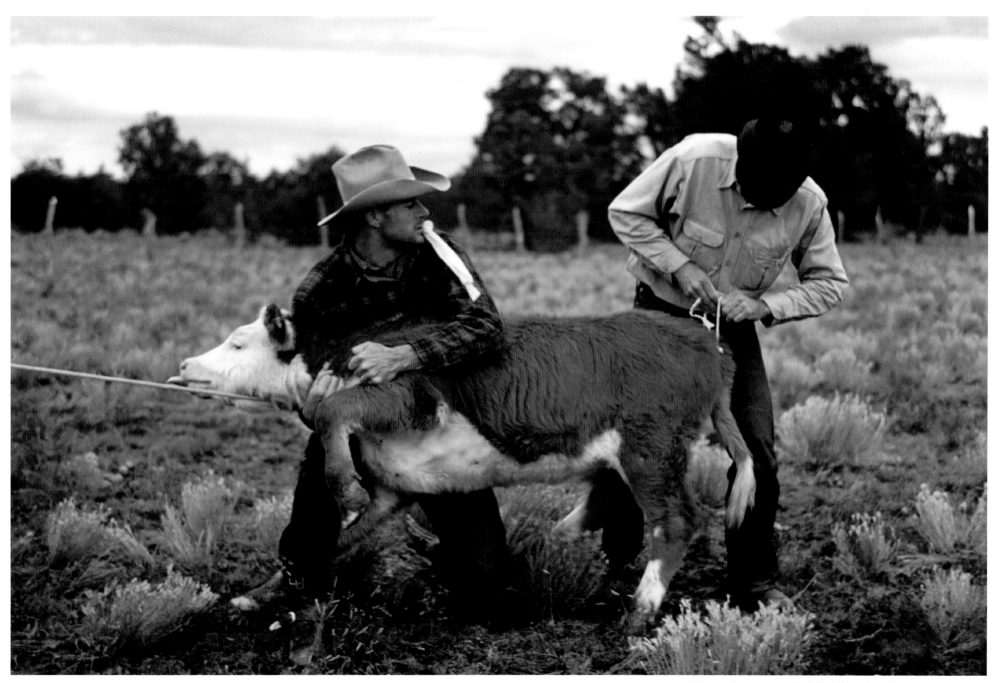

Tying a ribbon on a calf's tail at the rodeo, Pie Town, New Mexico
Russell Lee 10/1940

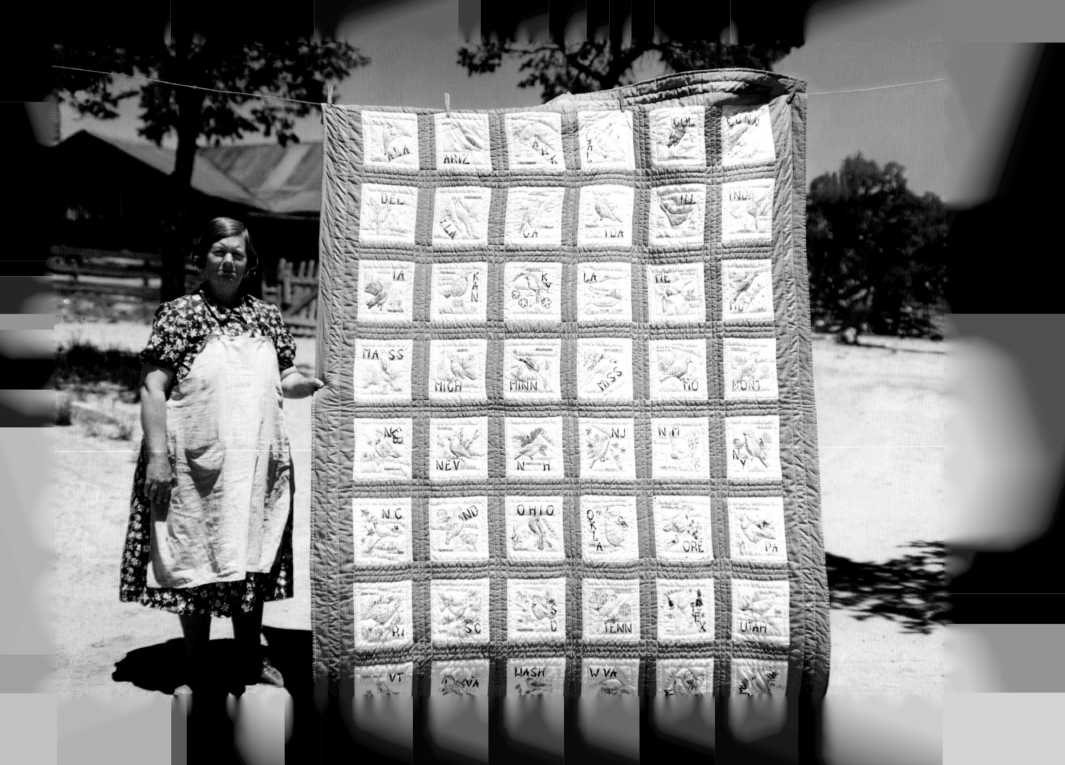

Mrs. Bill Stagg with a quilt that she made, Pie Town, New Mexico
Russell Lee 10/1940

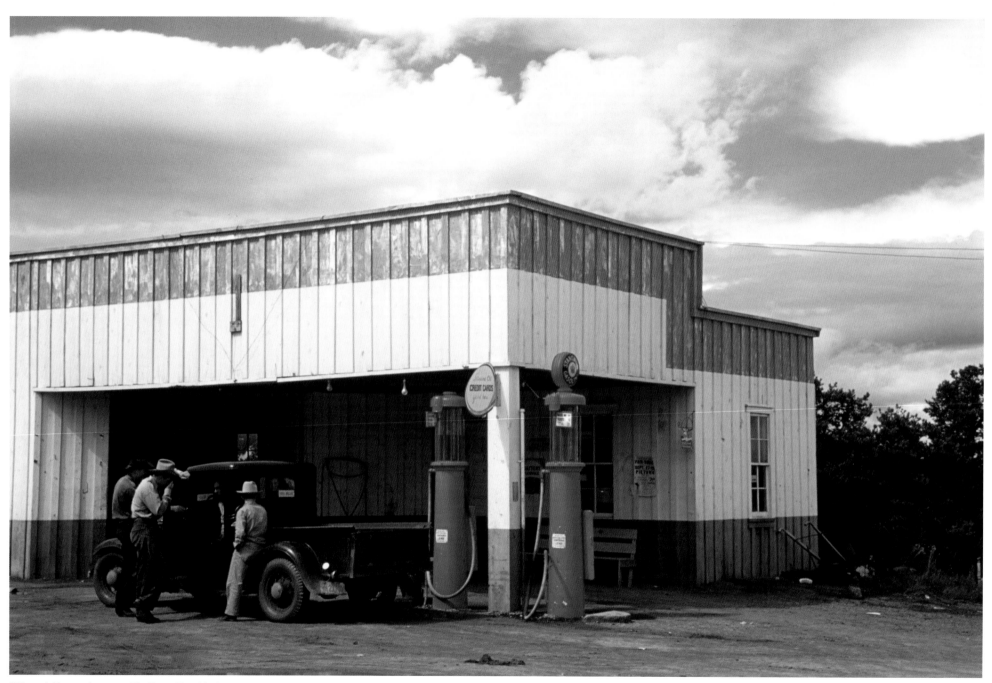

Filling station and garage, Pie Town, New Mexico
Russell Lee 10/1940

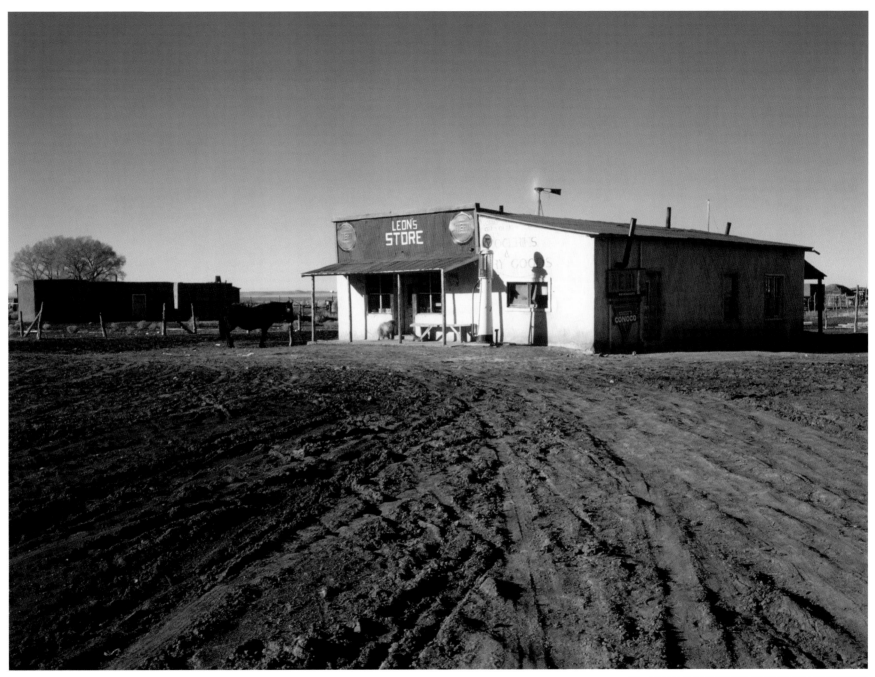

General store near Questa, Taos County, New Mexico
John Collier Spring 1943

67

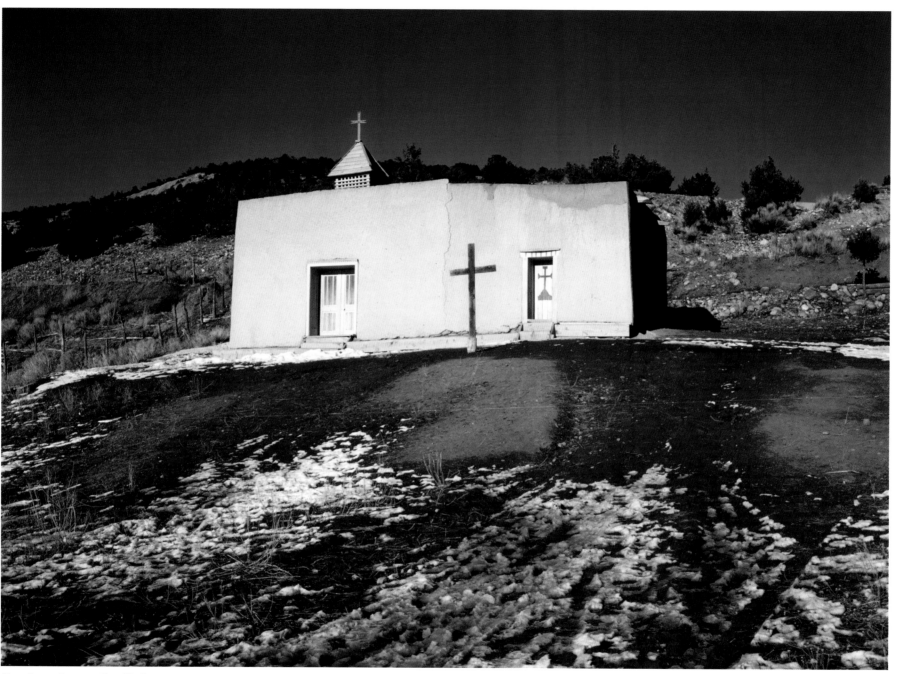

68

Chapel near Penasco, New Mexico
John Collier Spring 1943

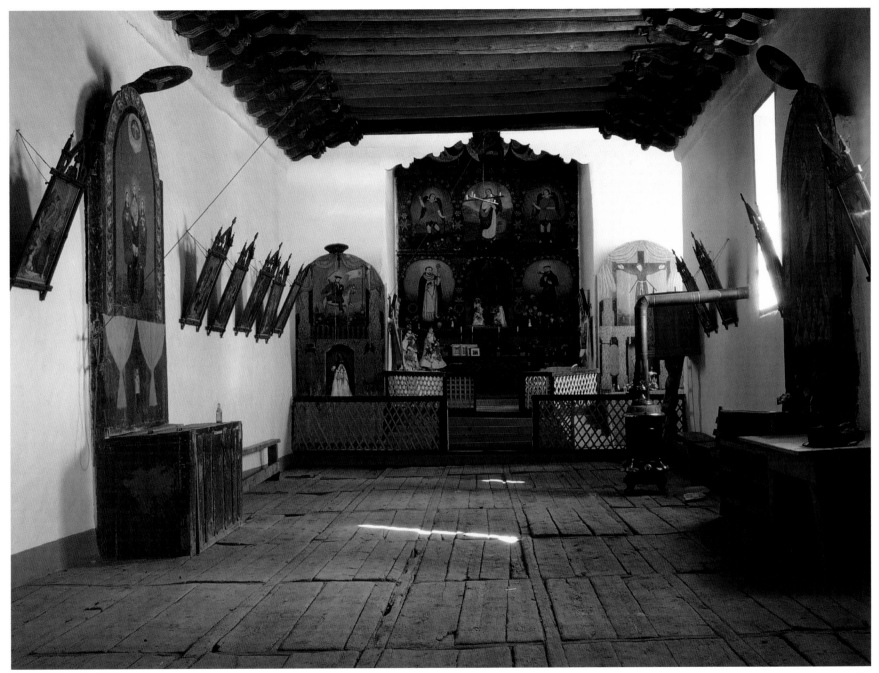

Church, Trampas, Taos County, New Mexico
John Collier Spring 1943

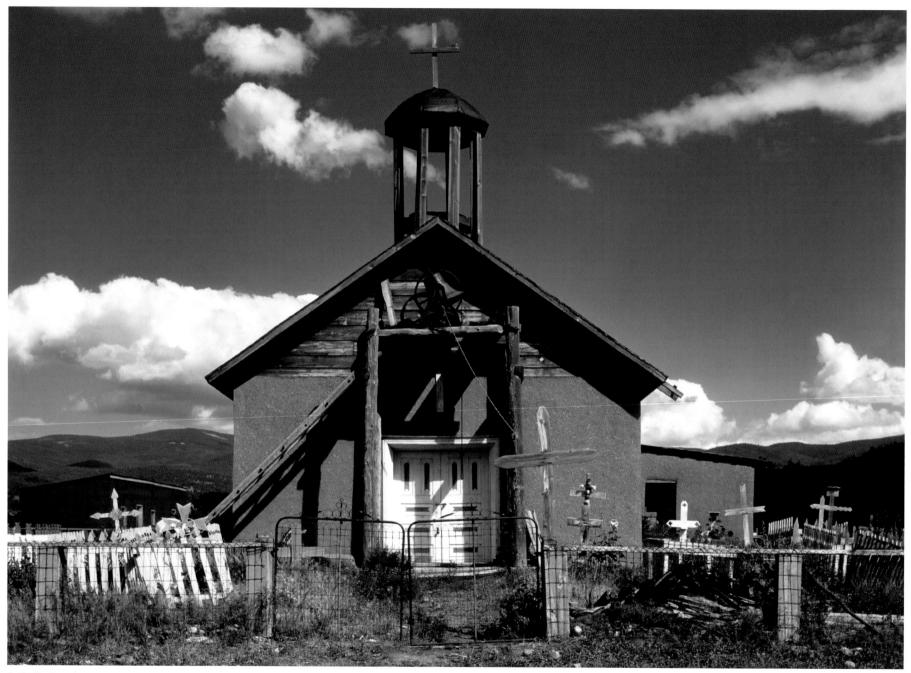

70

Catholic Church, Llano de San Juan, New Mexico
Russell Lee 1940

71

Cerros del Rio, near Costilla, New Mexico
John Collier Spring 1943

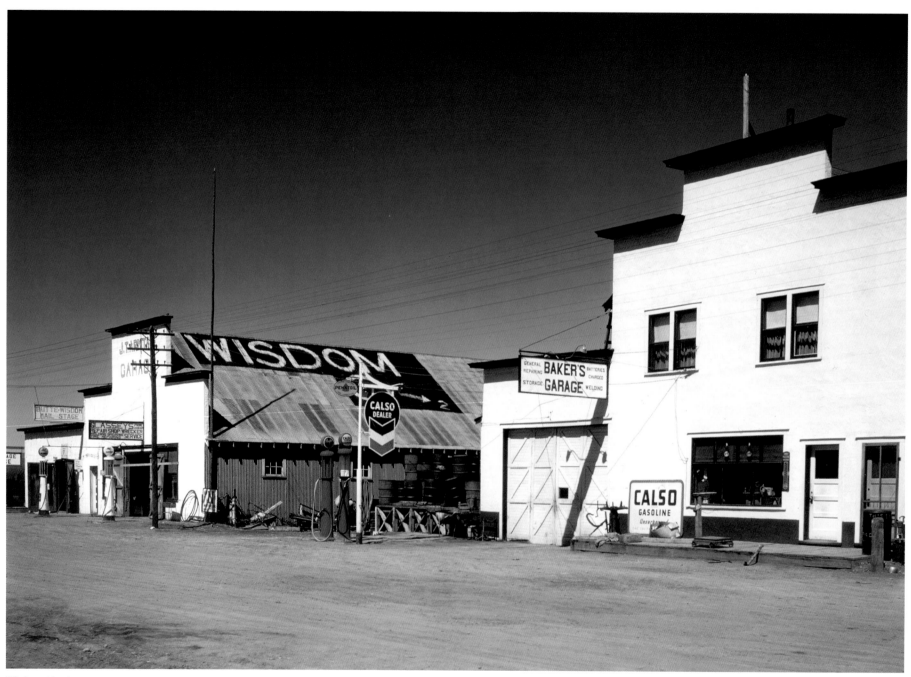

Wisdom, Montana
John Vachon 4/1942

Cattle corrals, Beaverhead County, Montana
Russell Lee 9/1942

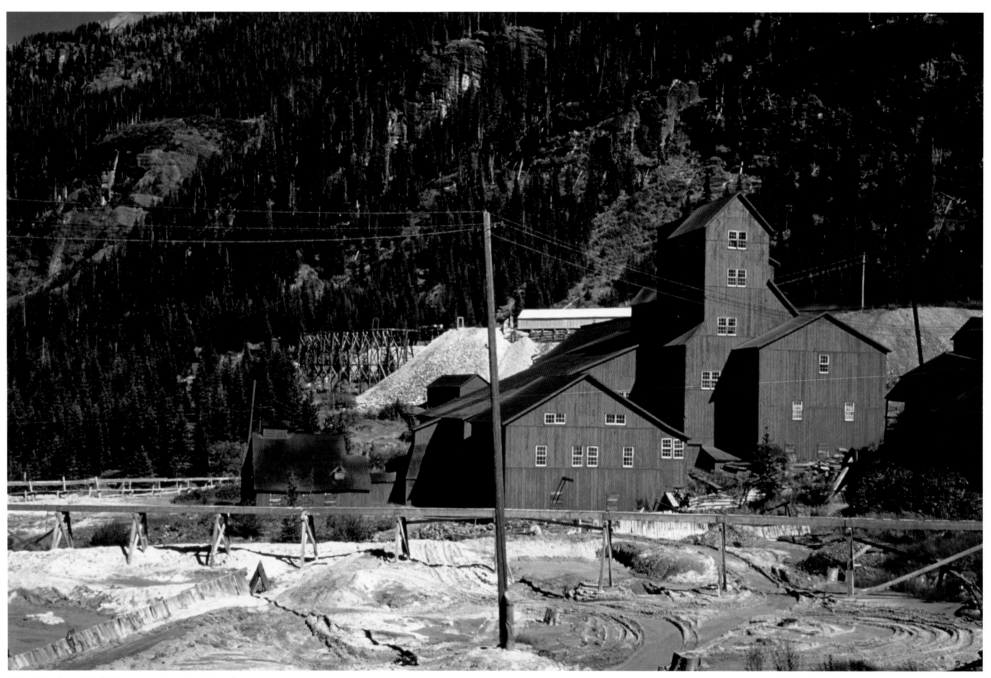

74

Mill at the Camp Bird Mine, Ouray County, Colorado
Russell Lee 10/1940

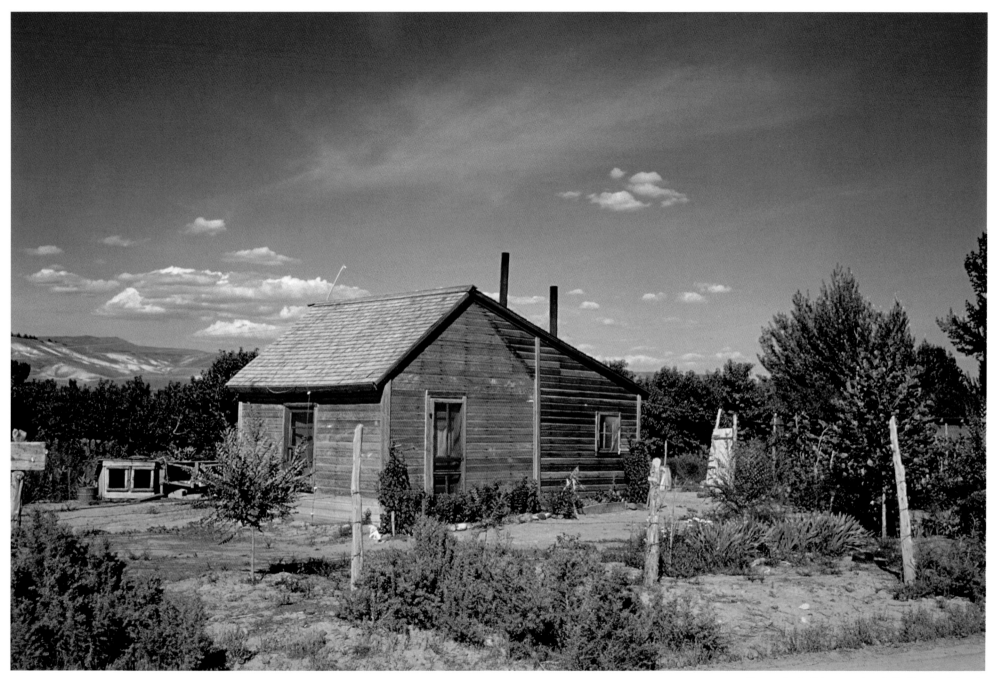

Home of a fruit tree rancher, Delta County, Colorado
Russell Lee 10/1940

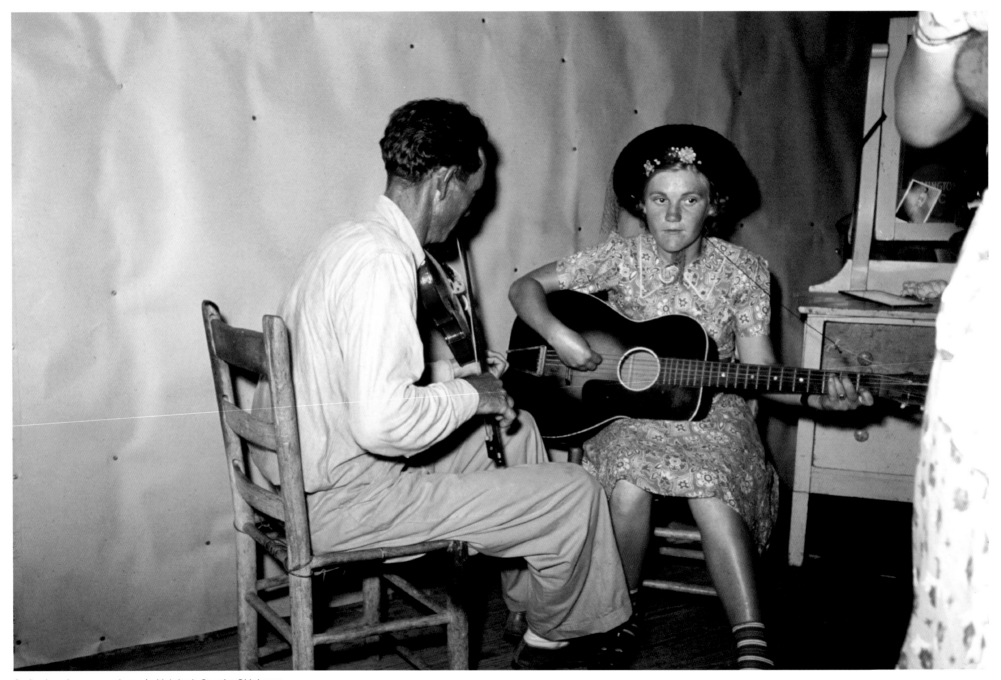

Orchestra at a square dance in McIntosh County, Oklahoma
Russell Lee 1939–1940

Children sleep through the square dance, McIntosh County, Oklahoma
Russell Lee 1939–1940

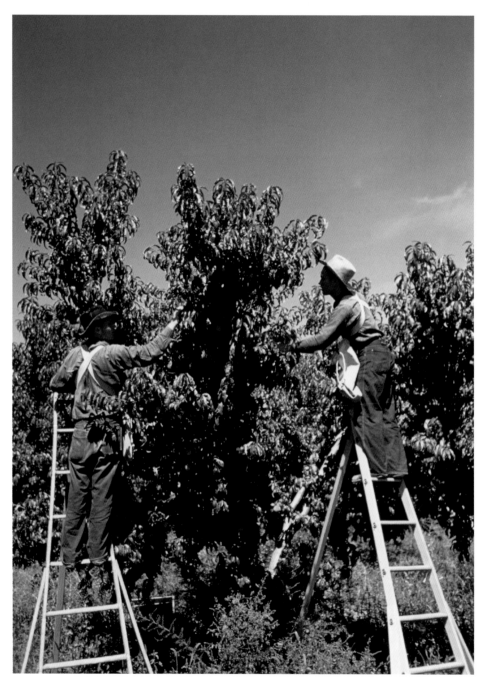

Pickers in a peach orchard, Delta County, Colorado
Russell Lee 9/1940

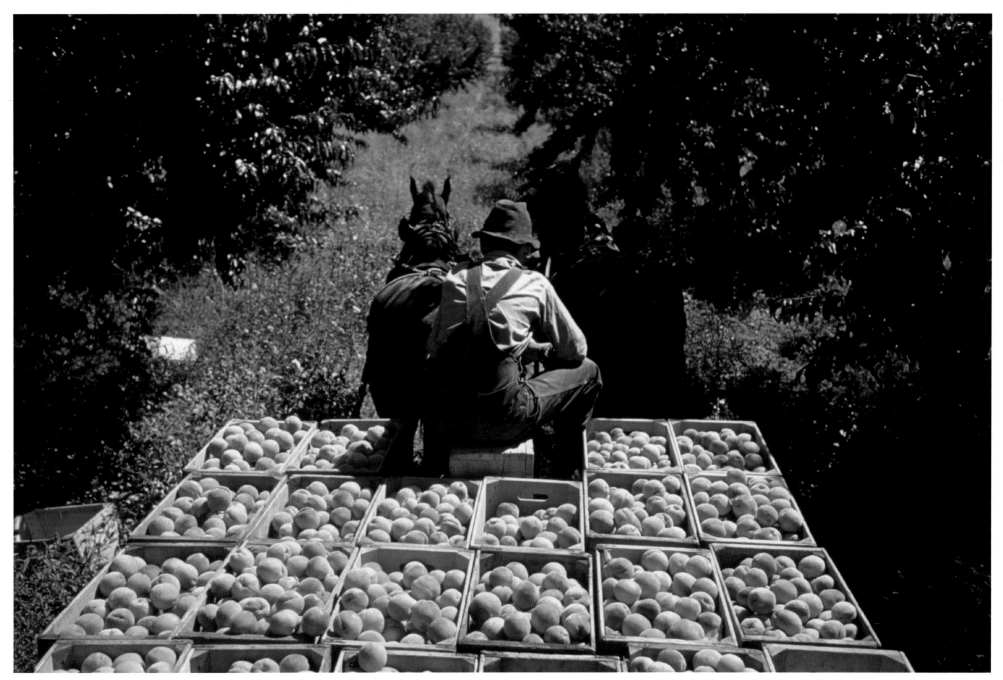

Hauling crates of peaches, Delta County, Colorado
Russell Lee 9/1940

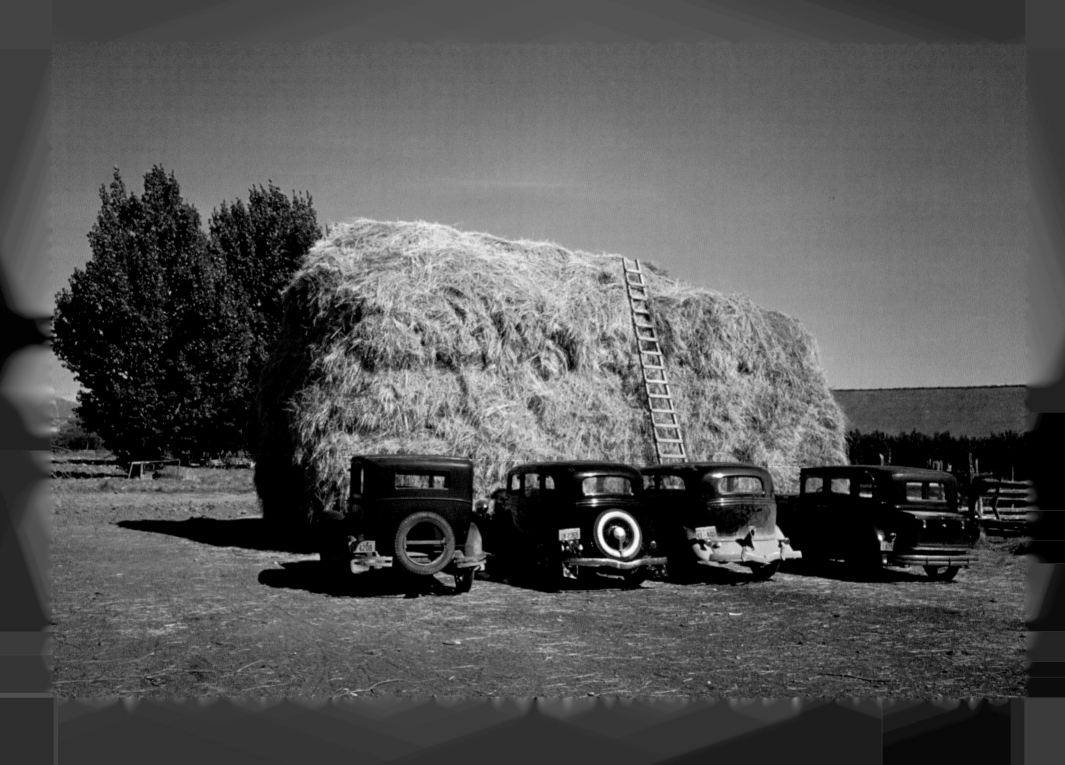

Haystack and peach pickers' automobiles, Delta County, Colorado
Russell Lee 1940

Delta County Fair, Colorado
Russell Lee 10/1940

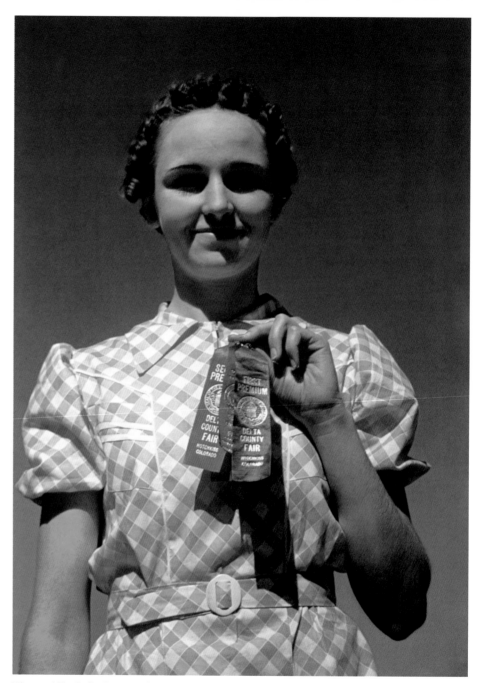

Winner at the Delta County Fair, Colorado
Russell Lee 10/1940

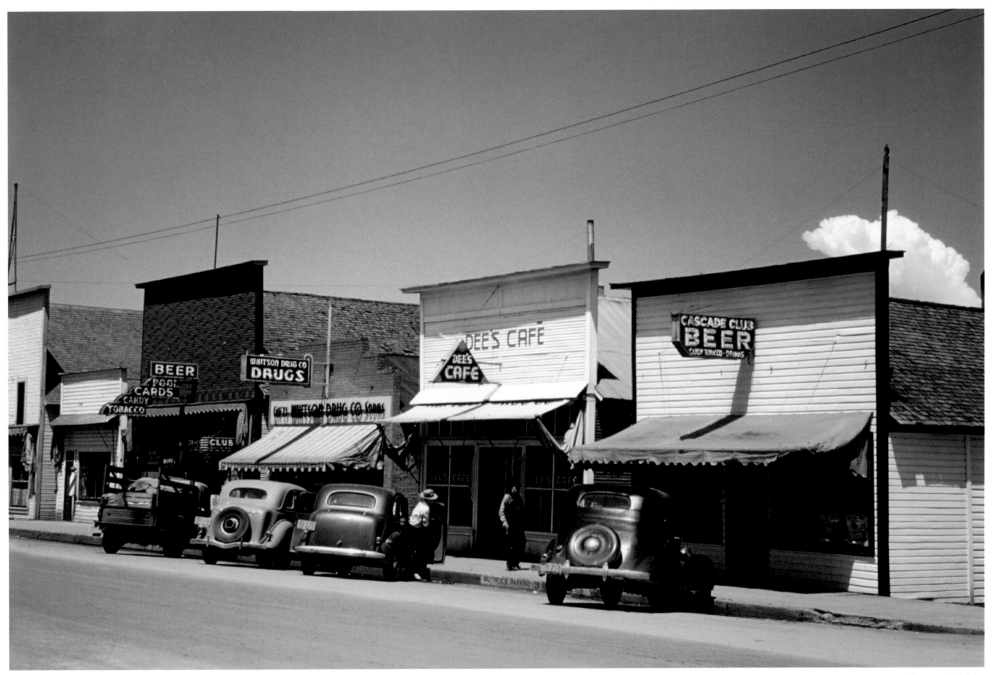

On the main street of Cascade, Idaho
Russell Lee 7/1941

83

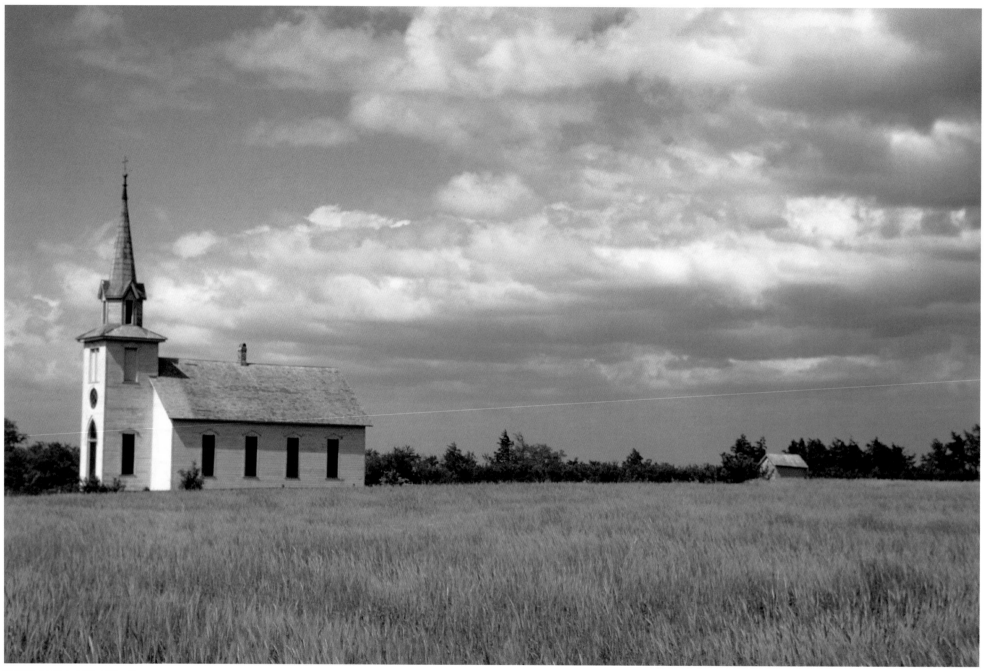

84

Church near Junction City, Kansas
John Vachon 1939–1943

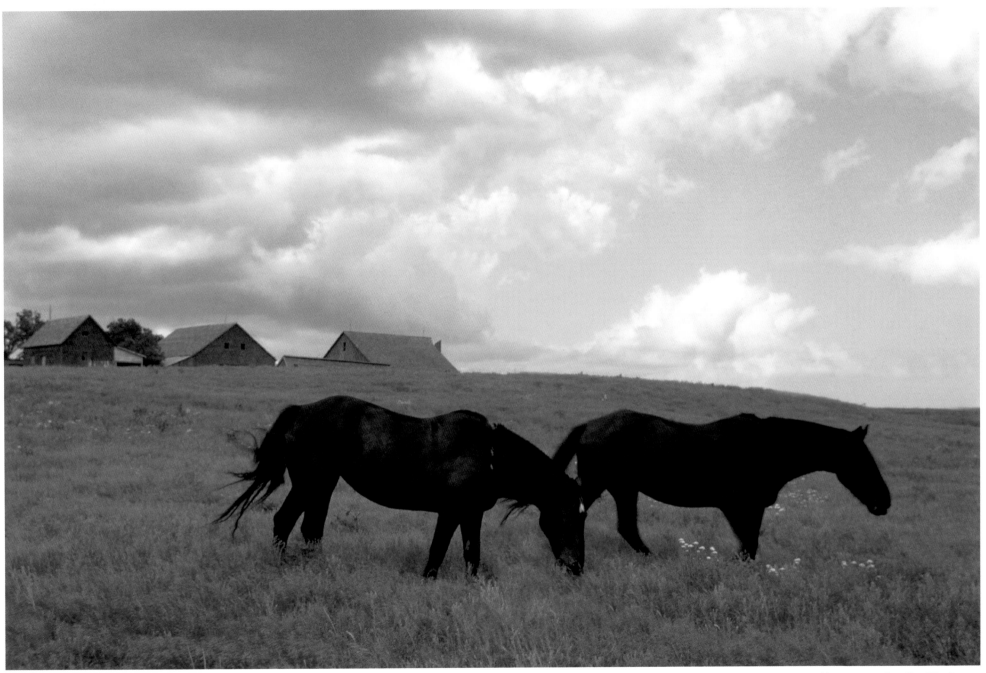

Workhorses near Junction City, Kansas
John Vachon 1939–1943

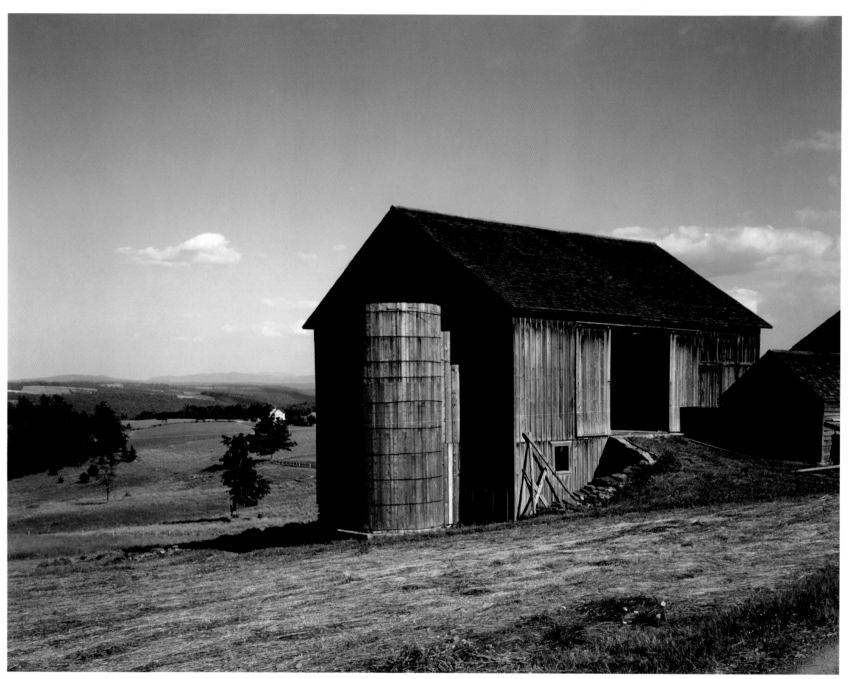

Farmland in the Catskills, New York
John Collier 6/1943

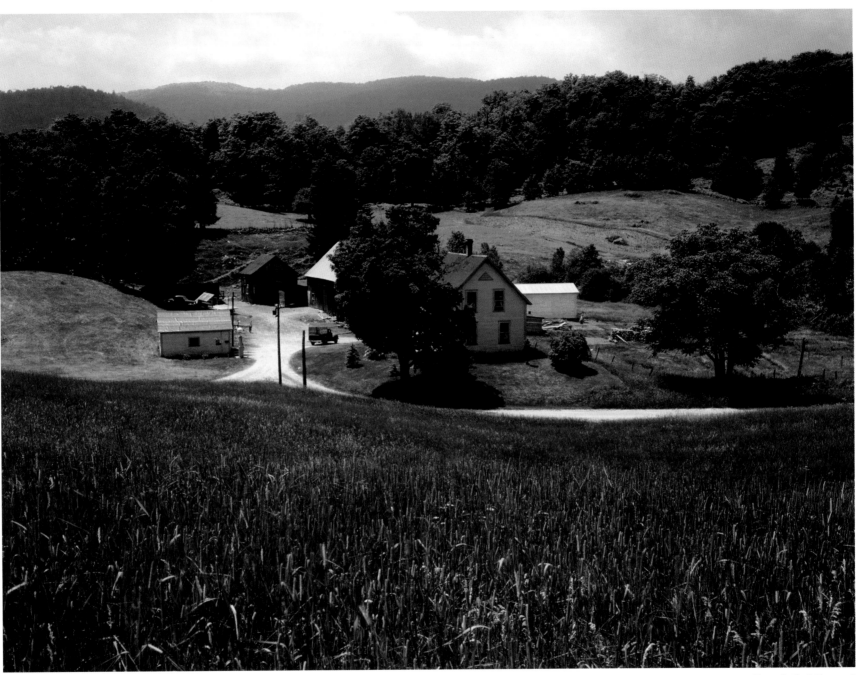

87

Farm, Bethel, Vermont
John Collier 6/1943

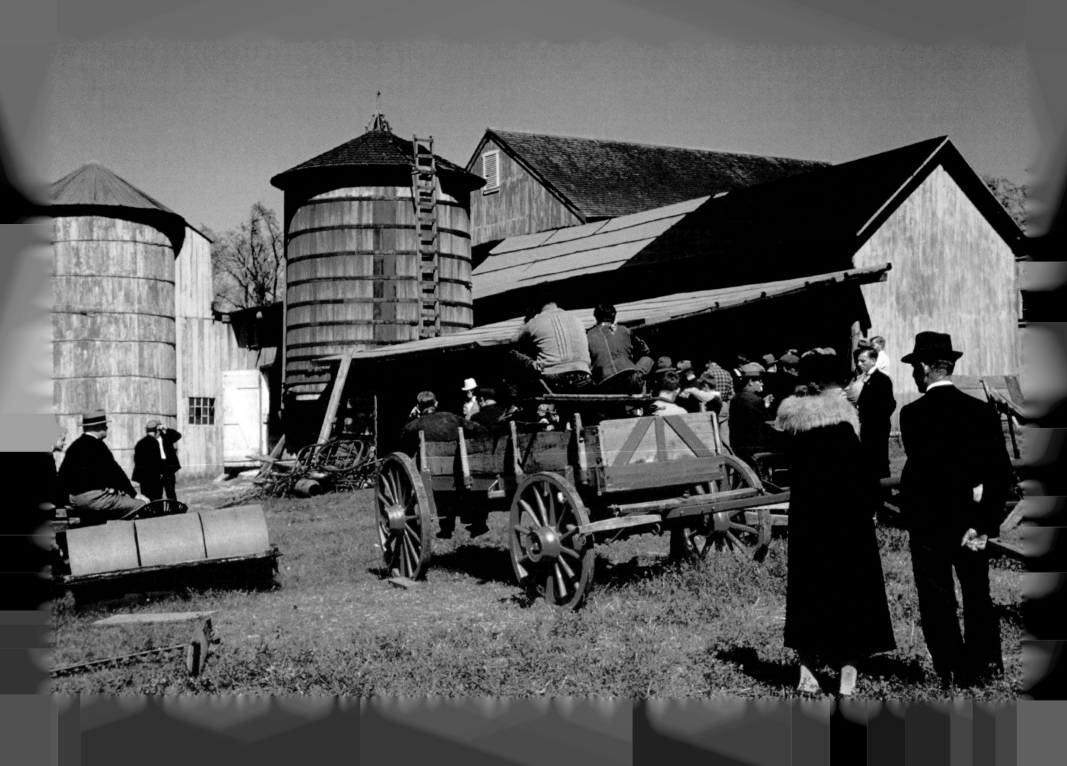

Farm auction, Derby, Connecticut
Jack Delano 9/1940

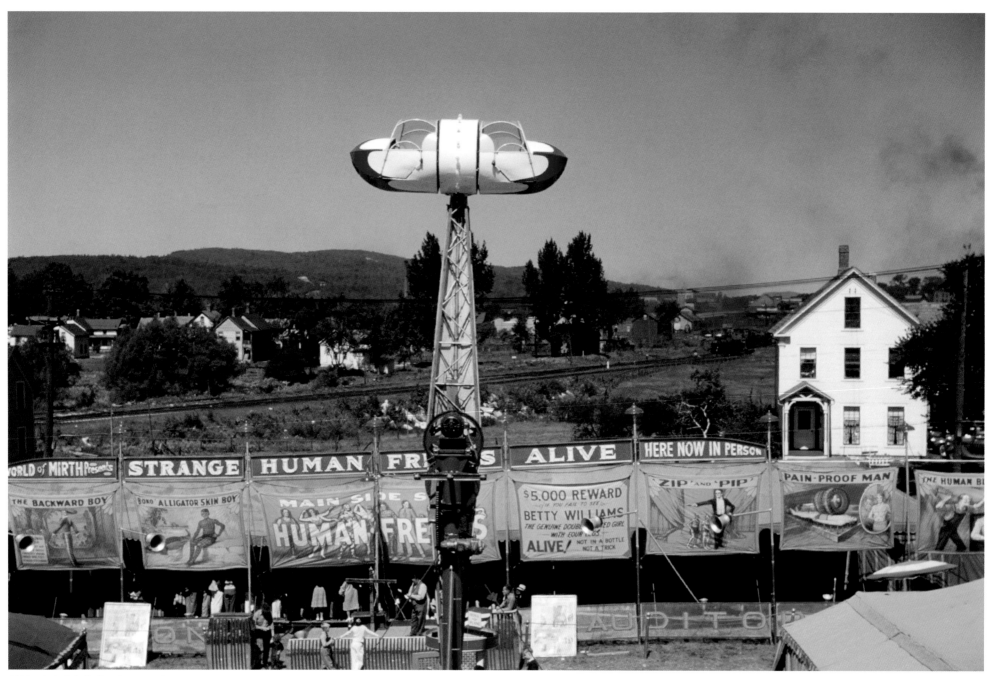

At the state fair, Rutland, Vermont
Jack Delano 9/1941

91

At the state fair, Rutland, Vermont
Jack Delano 9/1941

Barker on the grounds of the state fair, Rutland, Vermont
Jack Delano 9/1941

93

At the state fair, Rutland, Vermont
Jack Delano 9/1941

Backstage at the "girlie" show at the state fair, Rutland, Vermont
Jack Delano 9/1941

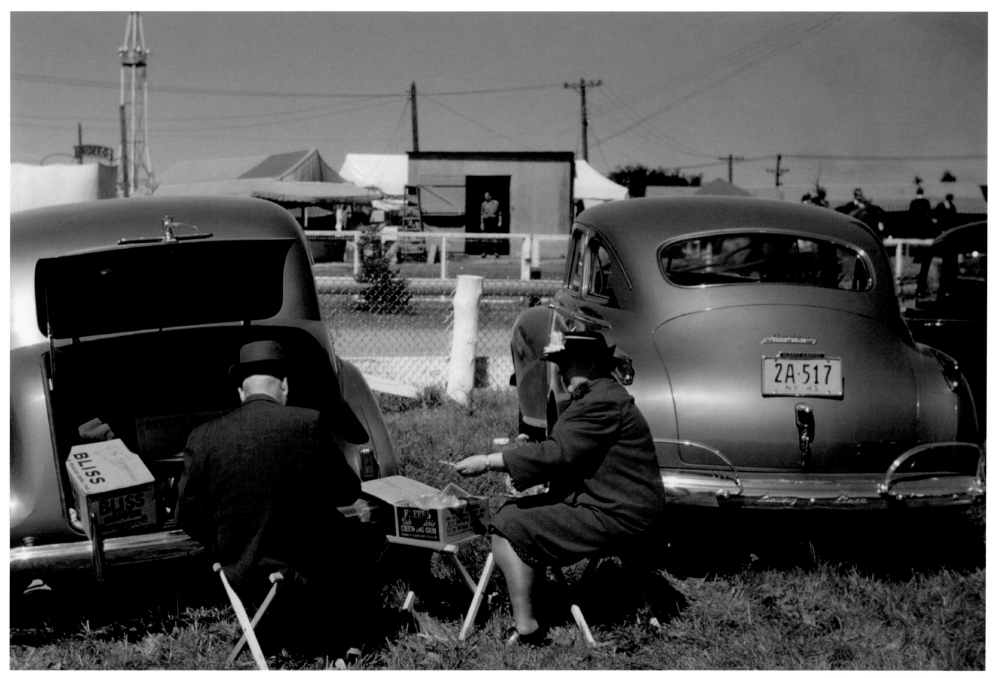

95

At the state fair, Rutland, Vermont
Jack Delano 9/1941

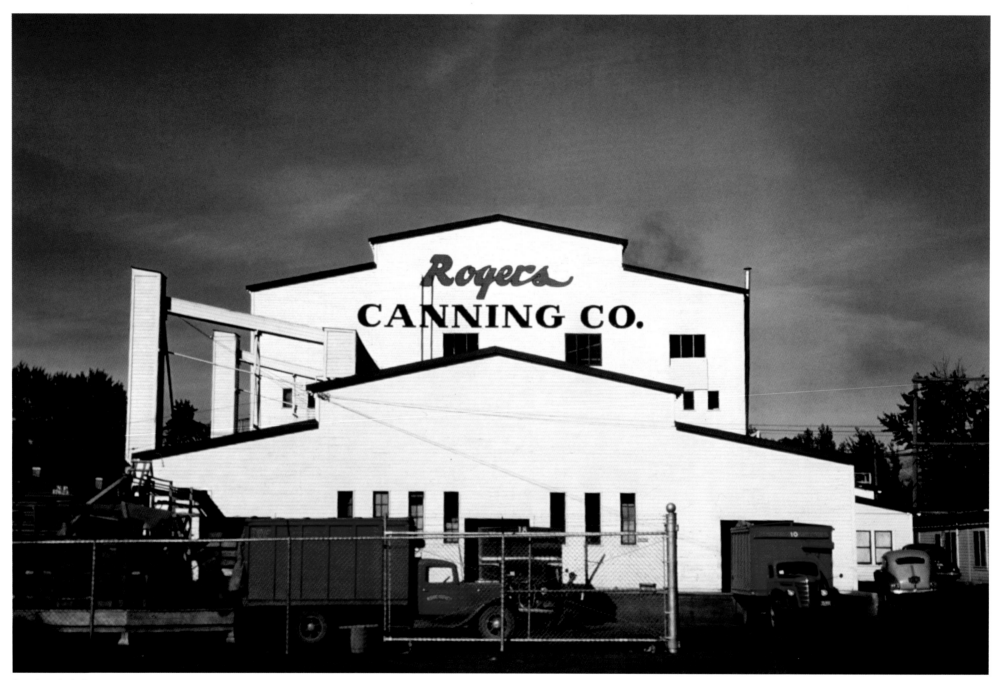

Canning plant, Oregon
Russell Lee 7/1941

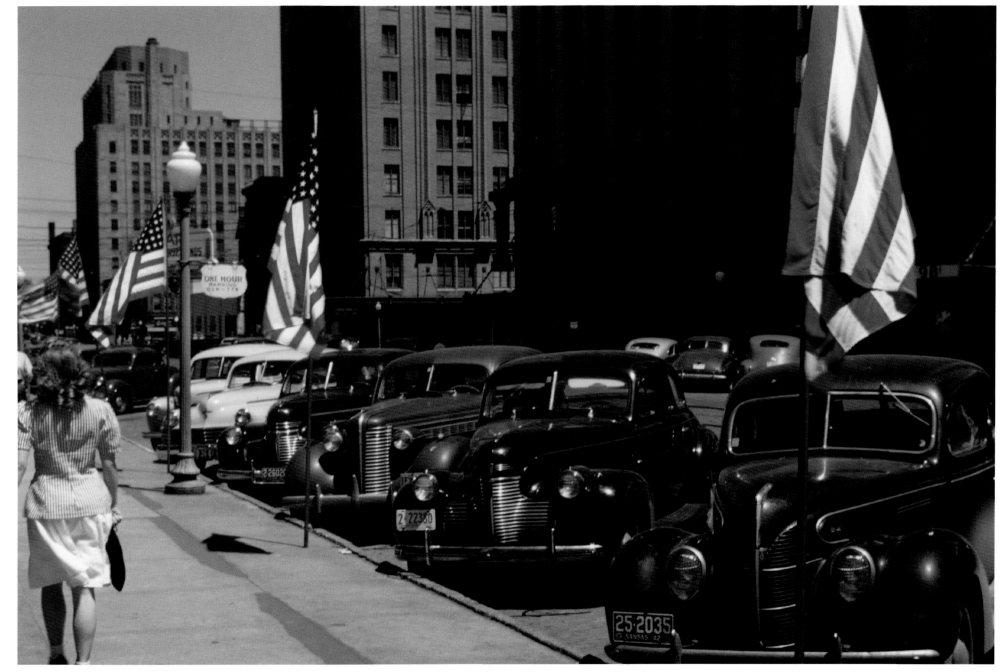

Lincoln, Nebraska
John Vachon 1939−1943

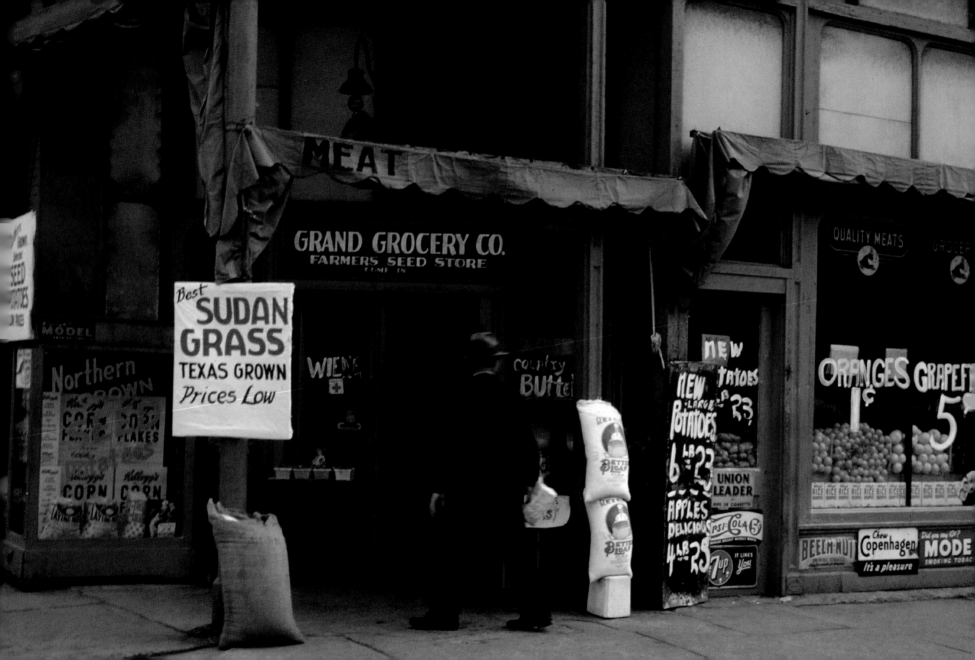

Seed and feed store, Lincoln, Nebraska
John Vachon 1939–1943

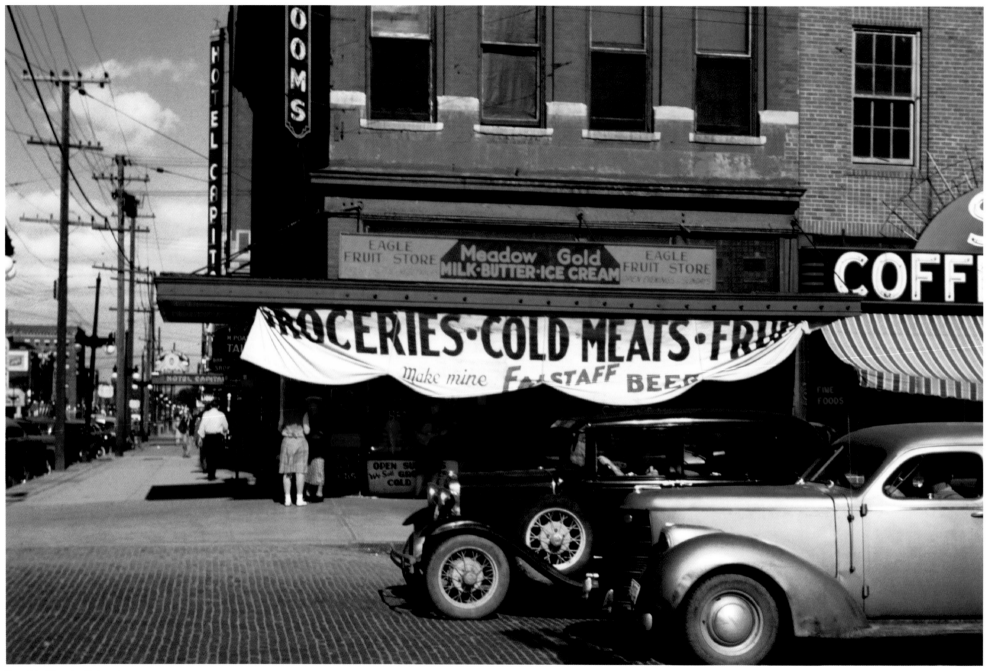

Possibly Lincoln, Nebraska
John Vachon 1939–1943

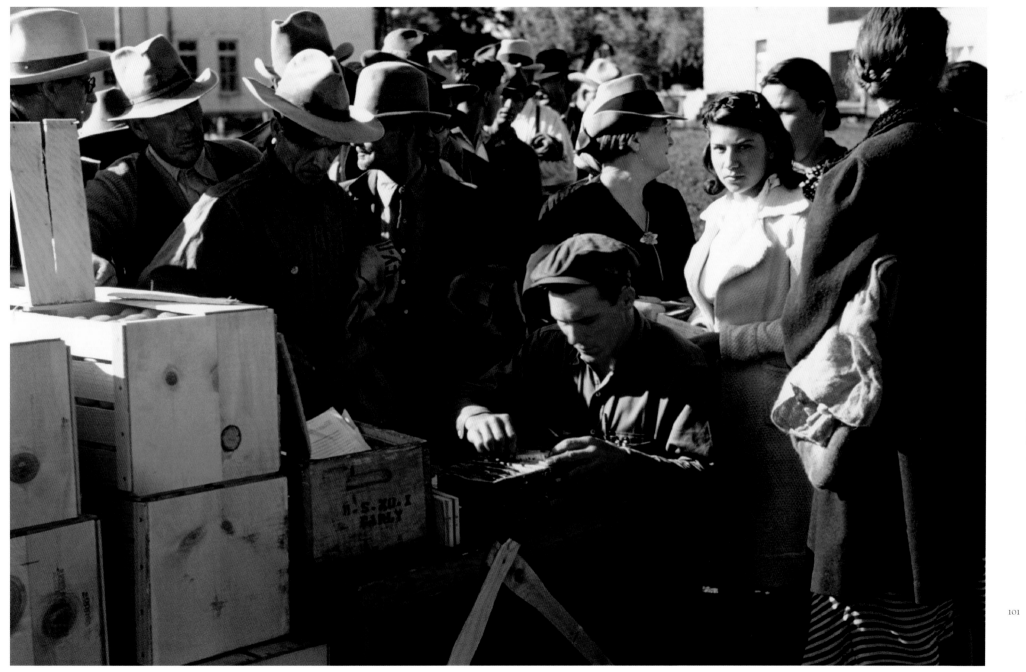

Distributing surplus commodities, St. Johns, Arizona
Russell Lee 10/1940

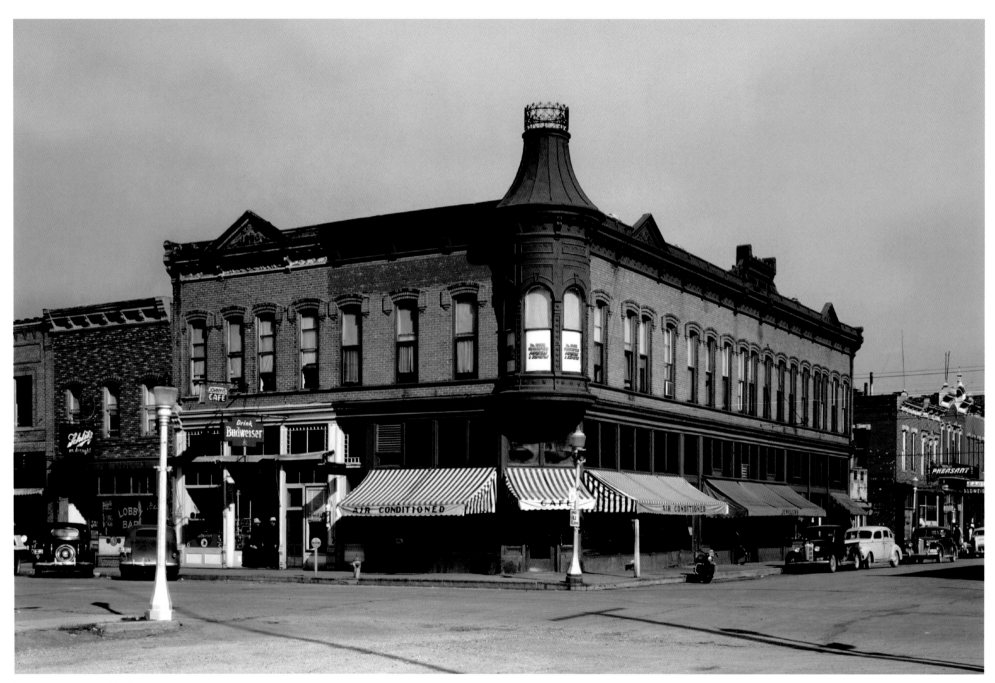

Street corner, Dillon, Montana
Russell Lee 8/1942

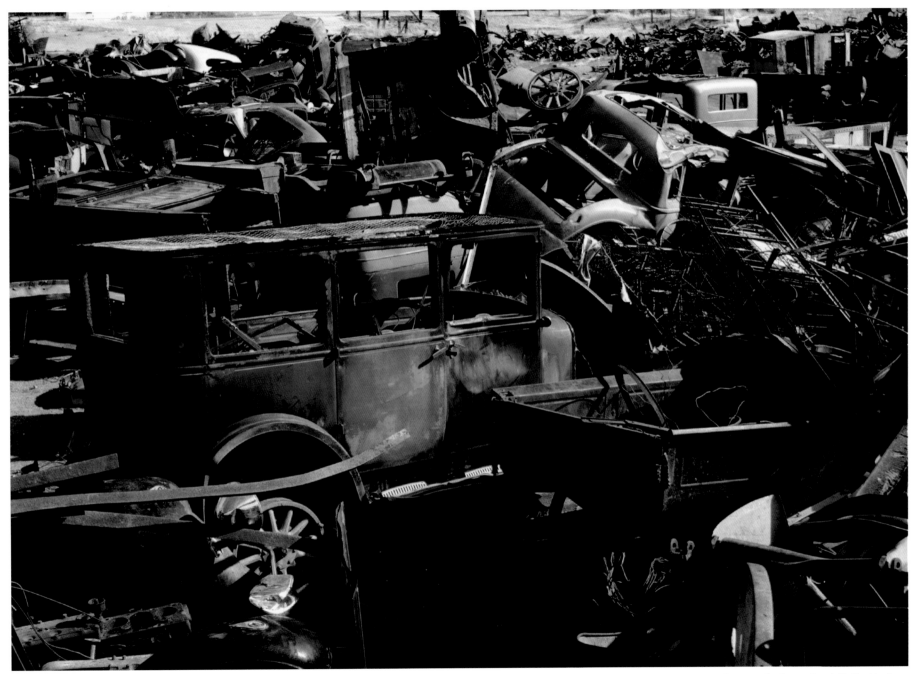

Scrap and salvage depot, Butte, Montana
Russell Lee 10/1942

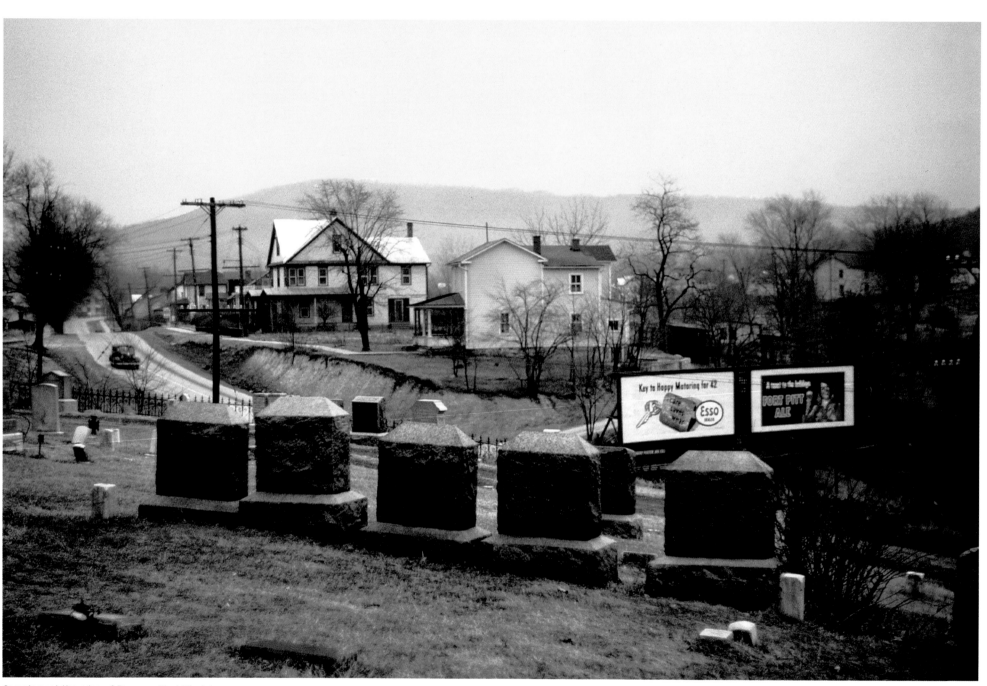

Cemetery at the edge of Romney, West Virginia
John Vachon 1939–1943

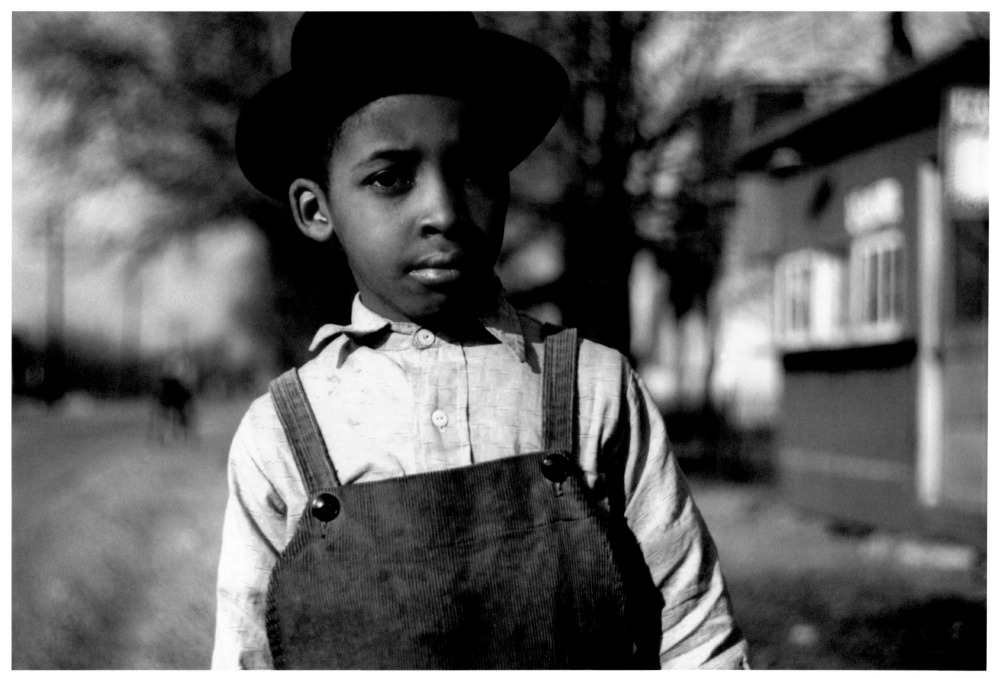

Boy near Cincinnati, Ohio
John Vachon 1939–1943

Stonington, Connecticut
Jack Delano 11/1940

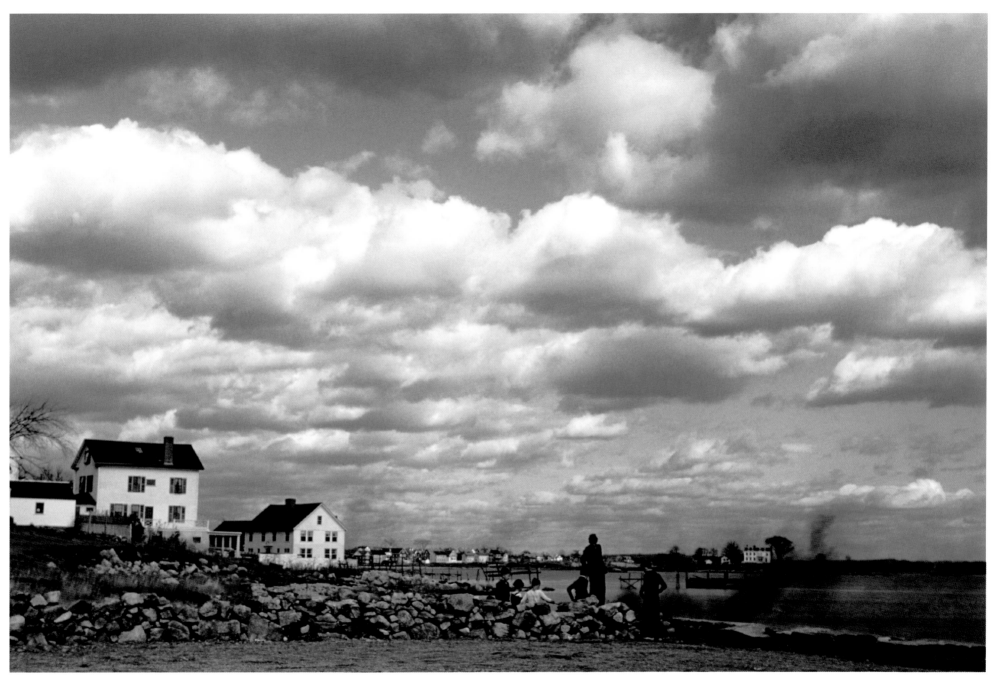

Town on the sea, probably Stonington, Connecticut
Jack Delano 11/1940

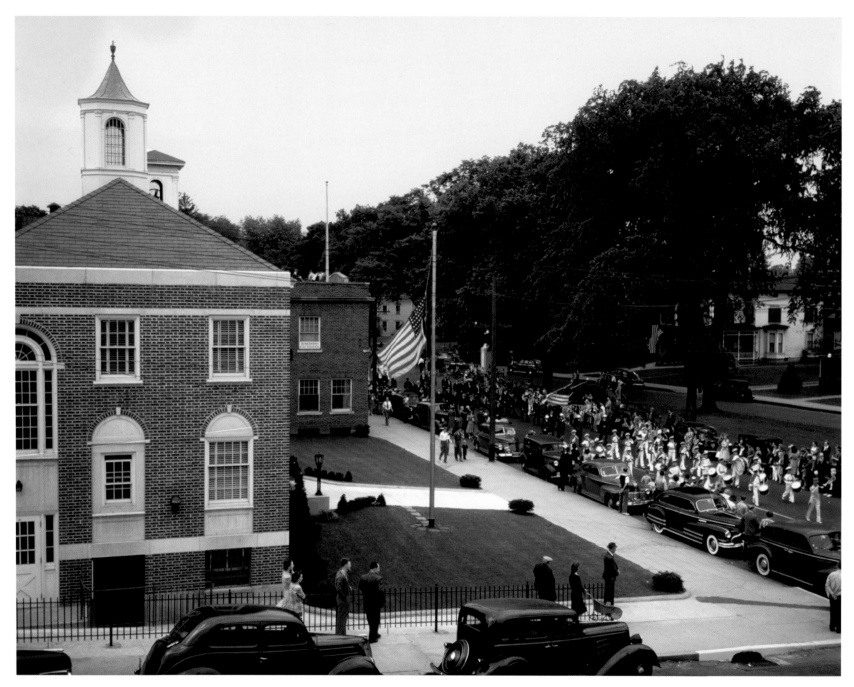

108

Memorial Day parade, Southington, Connecticut
Fenno Jacobs 5/1942

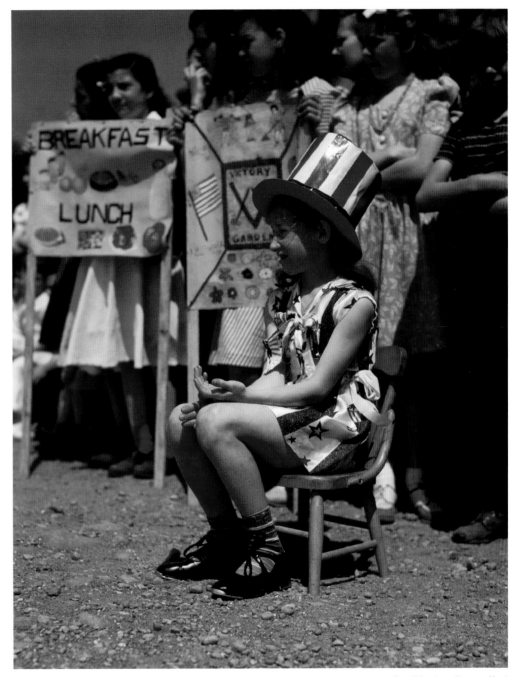

109

Southington, Connecticut
Fenno Jacobs 5/1942

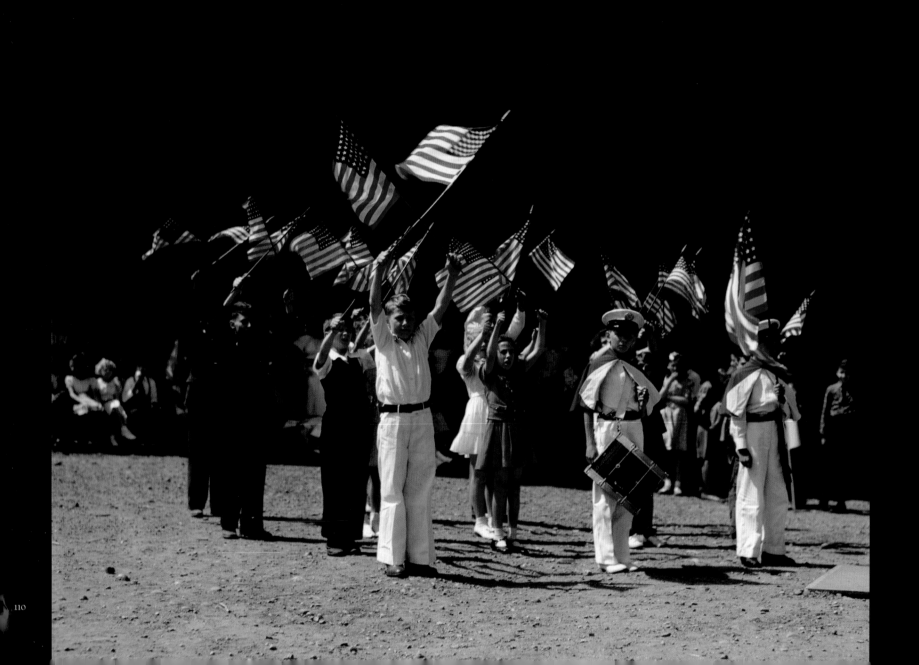

Children stage a patriotic demonstration, Southington, Connecticut
Fenno Jacobs 5/1942

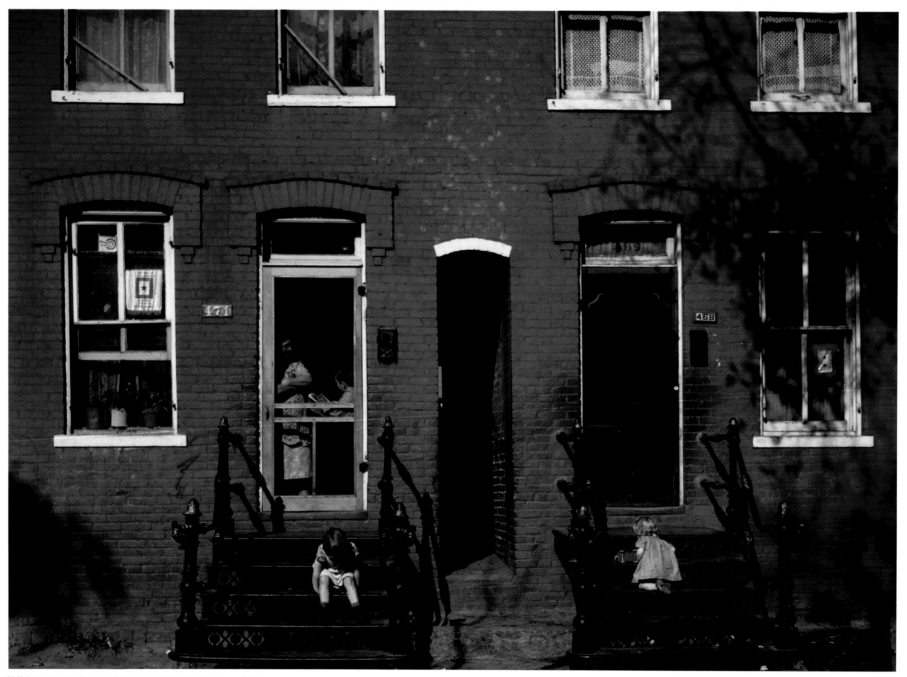

Children on row-house steps, probably Washington, D.C.
Louise Rosskam 1941–1942

112

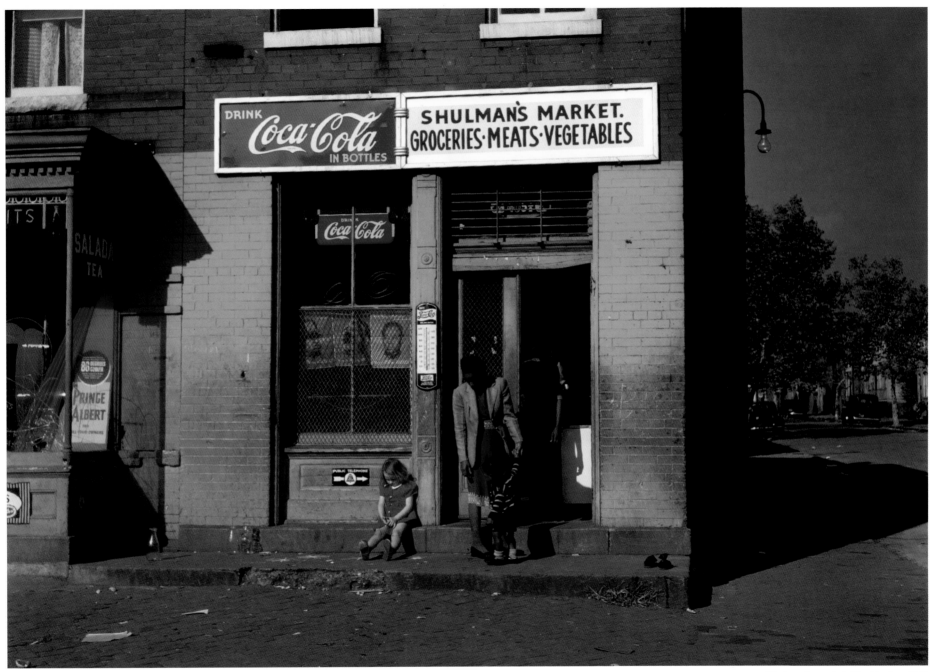

113

Shulman's market, Washington, D.C.
Louise Rosskam 1941–1942

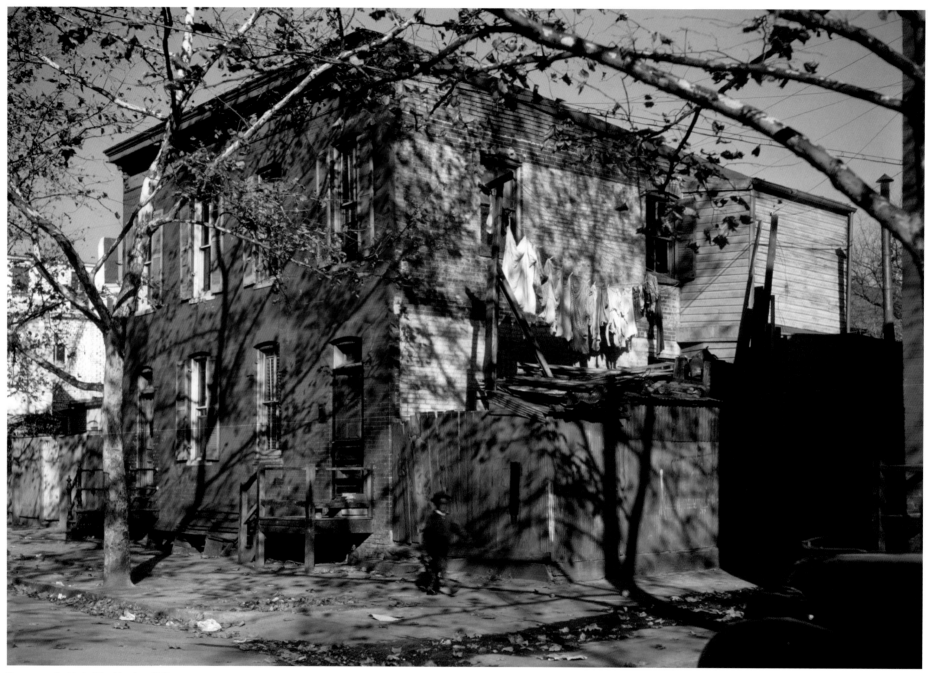

114

House, probably in Washington, D.C.
Louise Rosskam 1941–1942

Laundry, barbershop, and stores, probably in Washington, D.C.
Lousie Rosskam 1941–1942

115

116

Near the waterfront, New Bedford, Massachusetts
Jack Delano 1/1941

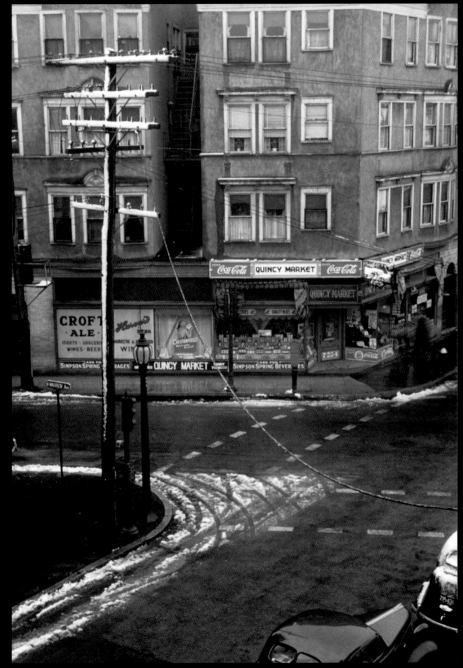

Street corner, Brockton, Massachusetts
Jack Delano 1/1941

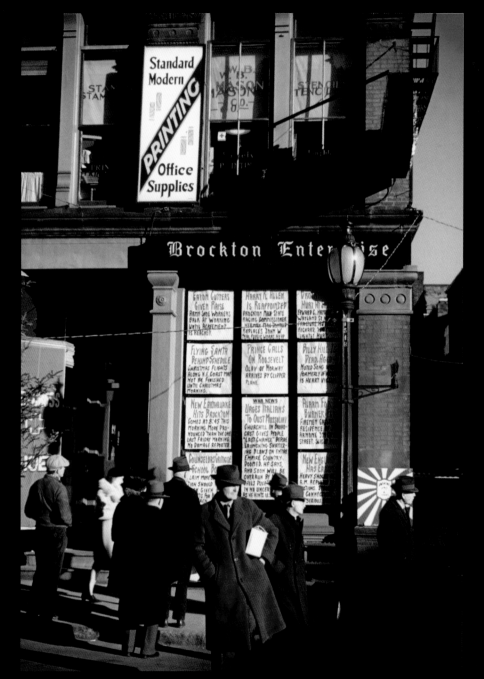

Newspaper office, Brockton, Massachusetts
Jack Delano 12/1940

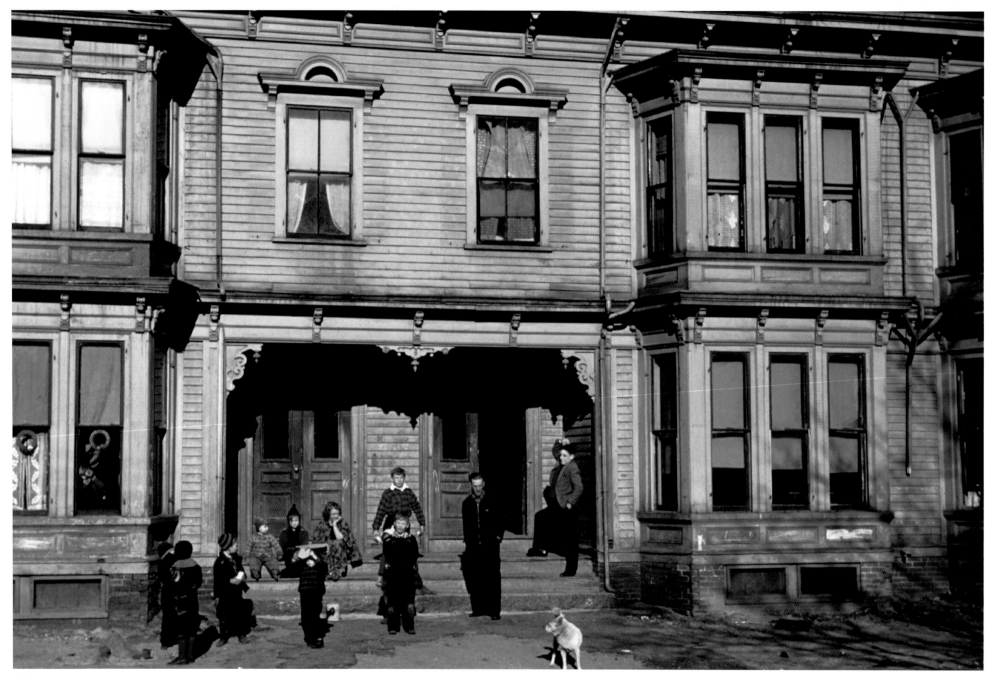

Children in the tenement district, probably Brockton, Massachusetts
Jack Delano 12/1940

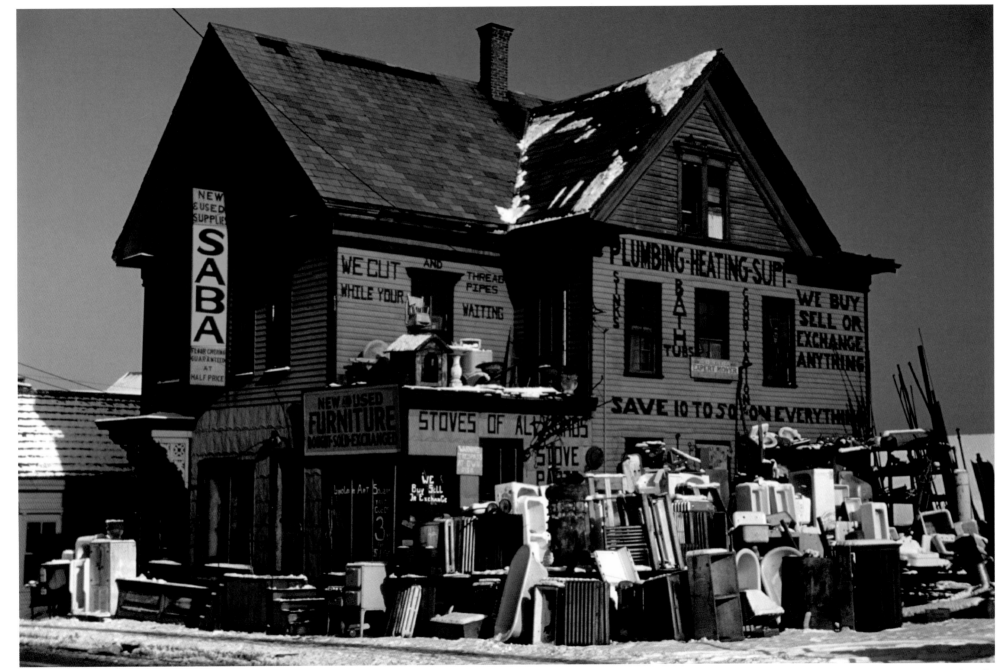

Second-hand plumbing store, Brockton, Massachusetts
Jack Delano 12/1940

119

Railroad cars and factory buildings, Lawrence, Massachusetts
Jack Delano Early 1941

Commuters waiting for the bus to go home, Lowell, Massachusetts
Jack Delano 1/1941

121

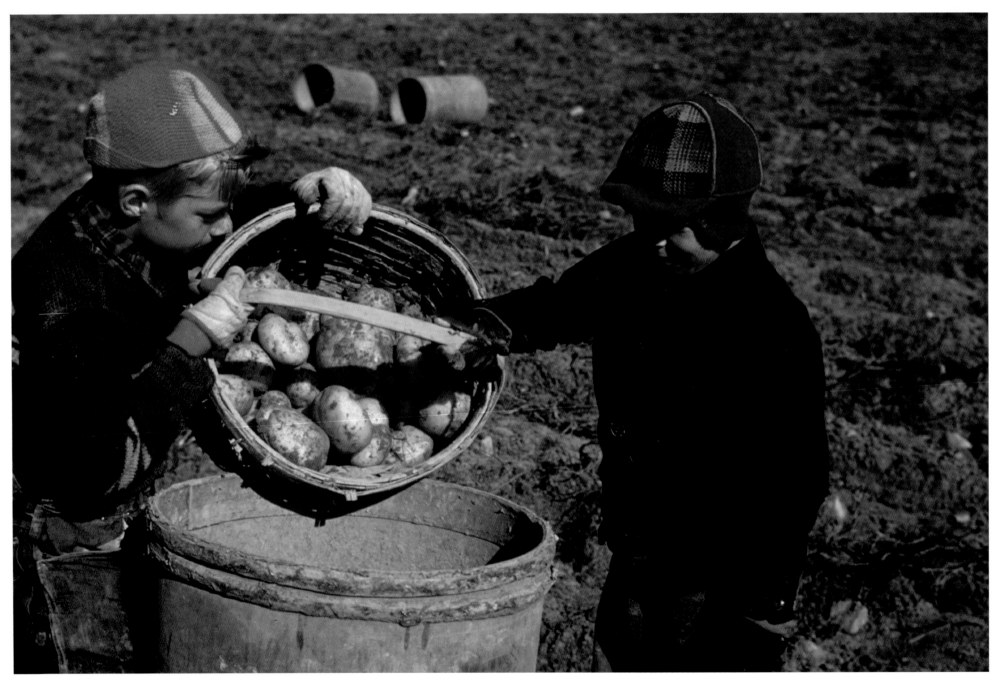

Children gathering potatoes on a farm near Caribou, Aroostook County, Maine
Jack Delano 10/1940

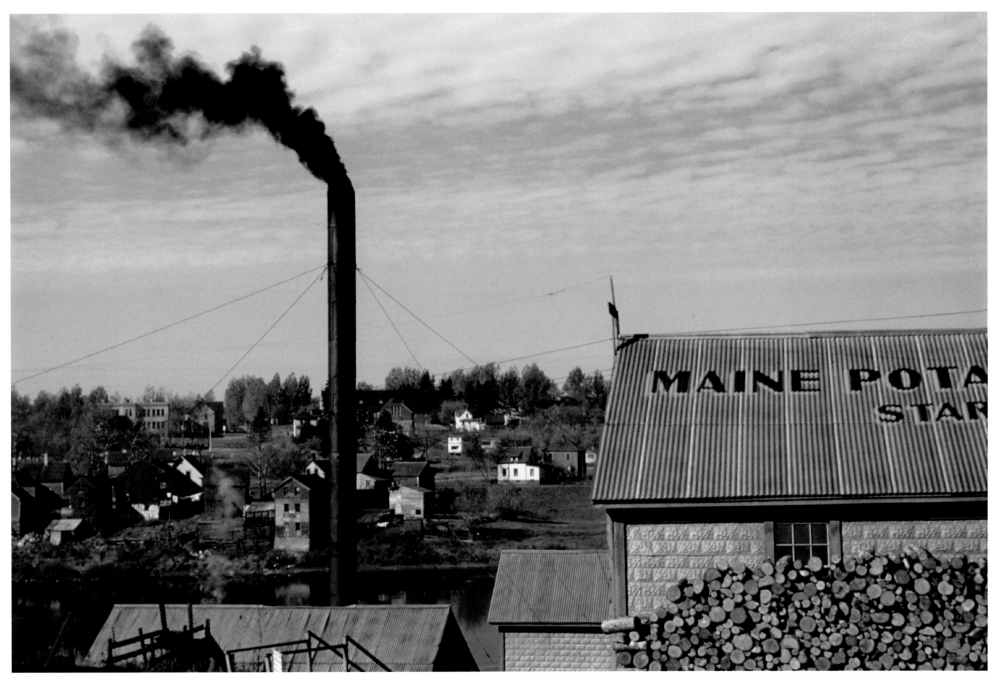

A starch factory along the Aroostook River, Caribou, Aroostook County, Maine

Jack Delano 10/1940

Trucks outside of a starch factory, Caribou, Aroostook County, Maine
Jack Delano 10/1940

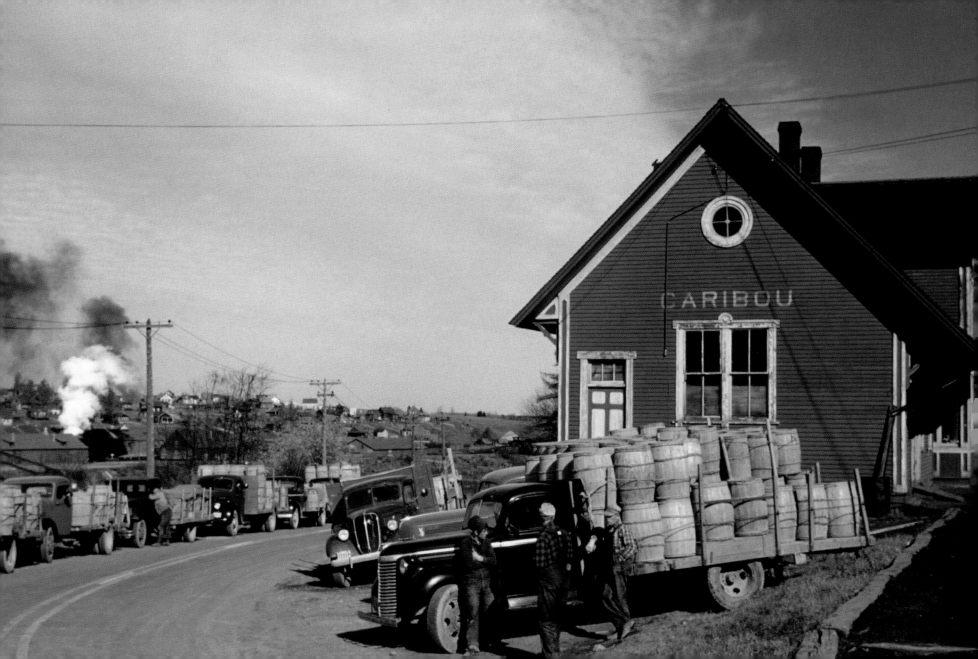

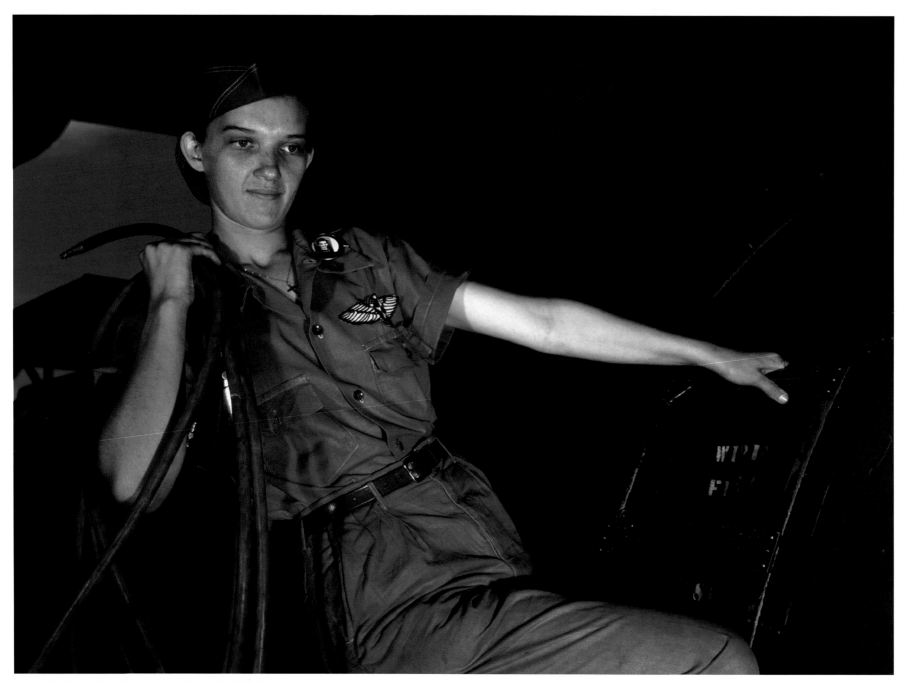

Lorena Craig, employed as a cowler, Corpus Christie, Texas
Howard R. Hollem 8/1942

127

Workers leaving Pennsylvania shipyards, Beaumont, Texas
John Vachon 6/1943

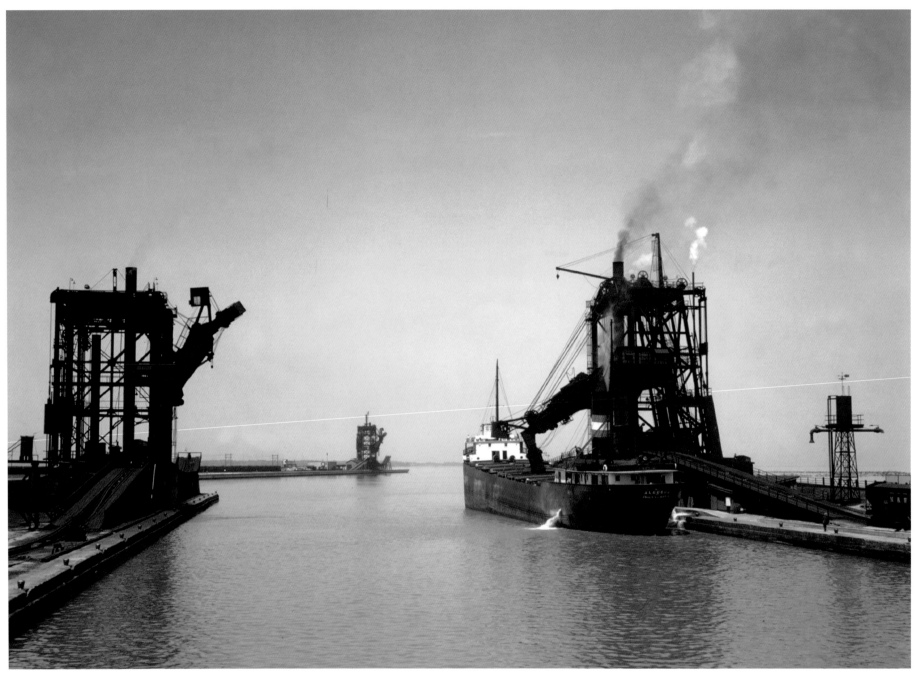

128

Loading a freighter with coal, Pennsylvania Railroad coal docks, Sandusky, Ohio
Jack Delano 5/1943

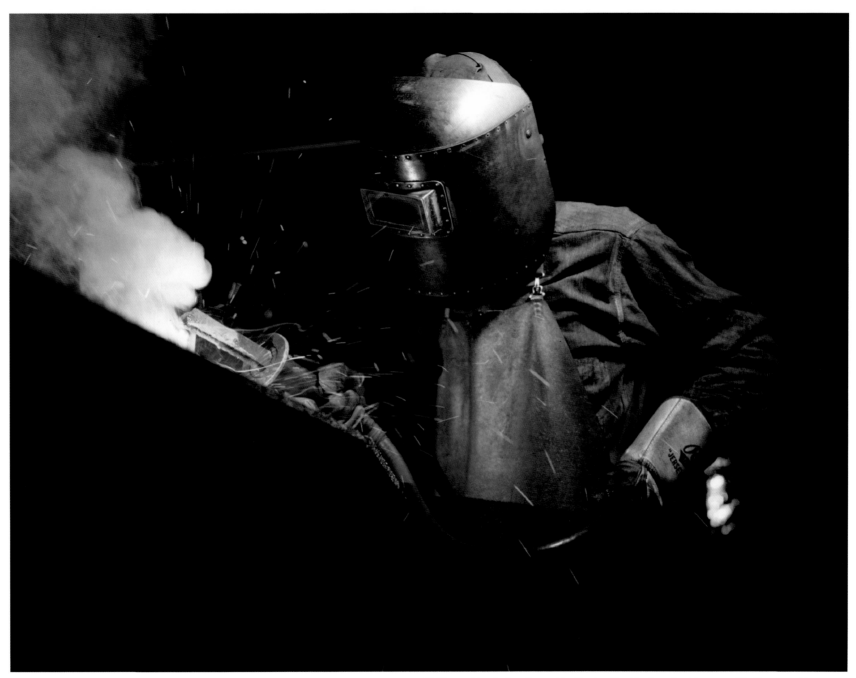

Welder making boilers for a ship, Combustion Engineering Company, Chattanooga, Tennessee
Alfred T. Palmer 6/1942

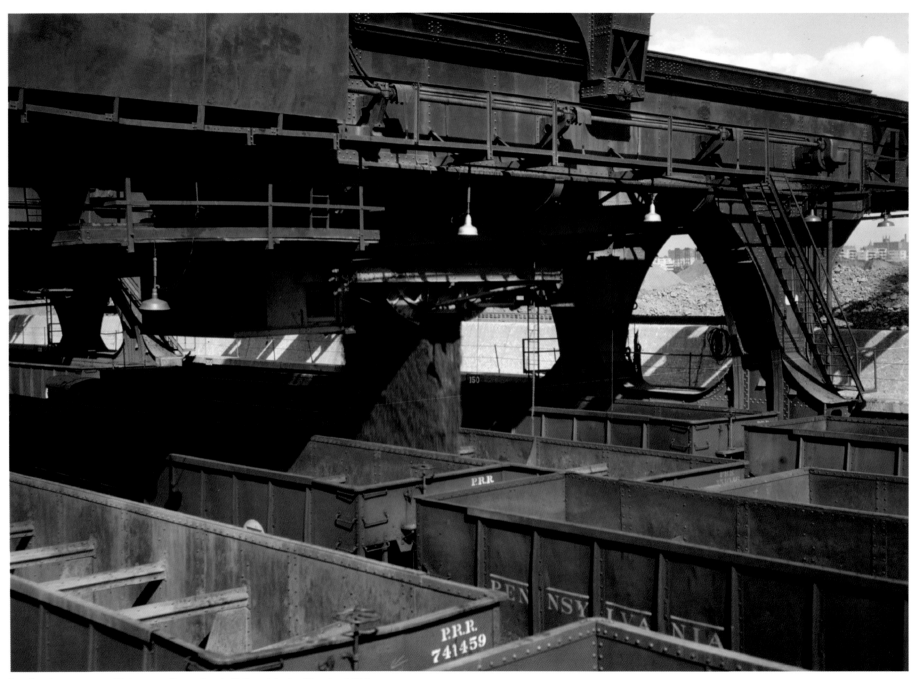

130

Loading hopper cars with iron ore, Pennsylvania Railroad docks, Cleveland, Ohio
Jack Delano 5/1943

131

Furnaces of the Great Lakes Steel Corporation, Detroit, Michigan
Arthur Siegel 11/1942

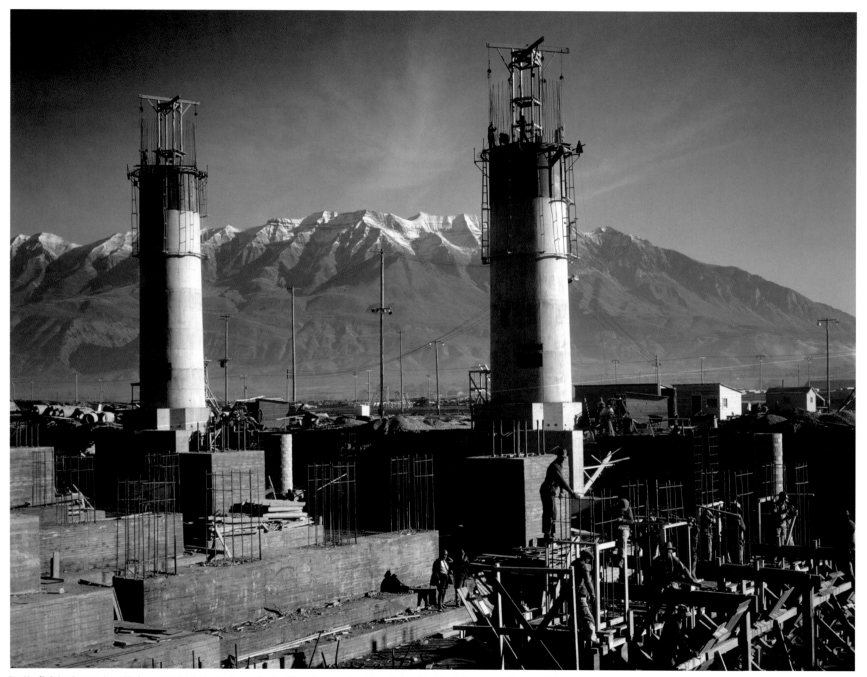

132

Partly finished open-hearth furnaces and stacks for a steel mill under construction, Columbia Steel Company, Geneva, Utah
Andreas Feininger 11/1942

Servicing floodlights for a new steel plant, Columbia Steel Company, Geneva, Utah
Andreas Feininger 11/1942

133

View of Carr Fork Canyon from "G" bridge, Bingham Copper Mine, Utah
Andreas Feininger 11/1942

Electric power transmission lines from a Tennessee Valley Authority (TVA) dam's hydroelectric plant, Tennessee
Alfred T. Palmer 6/1942

Insulators and transmission wires in the switchyard of the TVA's Chickamauga Dam, near Chattanooga, Tennessee
Alfred T. Palmer 6/1942

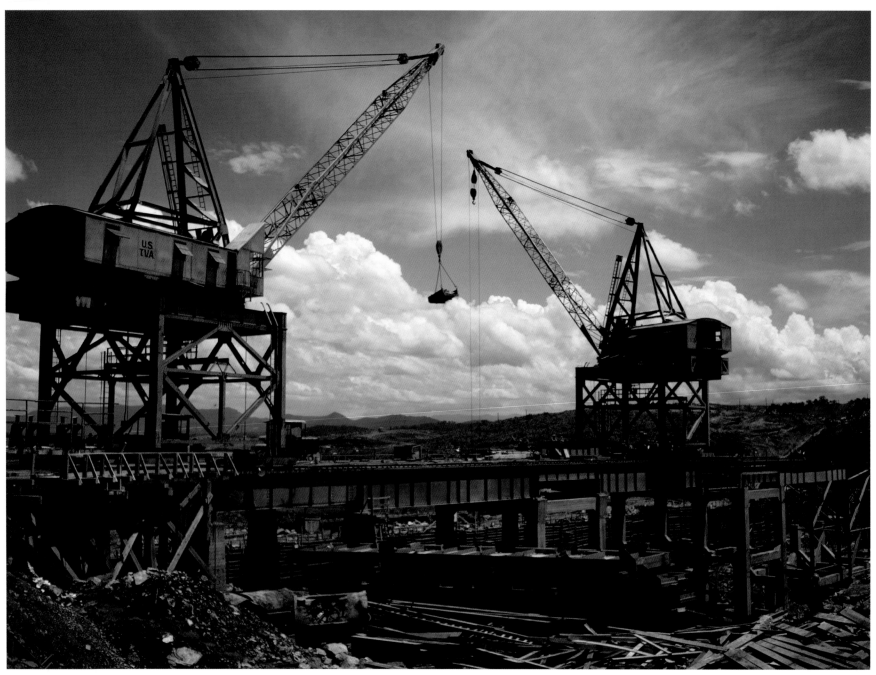

Construction work at the TVA's Douglas Dam, Tennessee
Alfred T. Palmer 6/1942

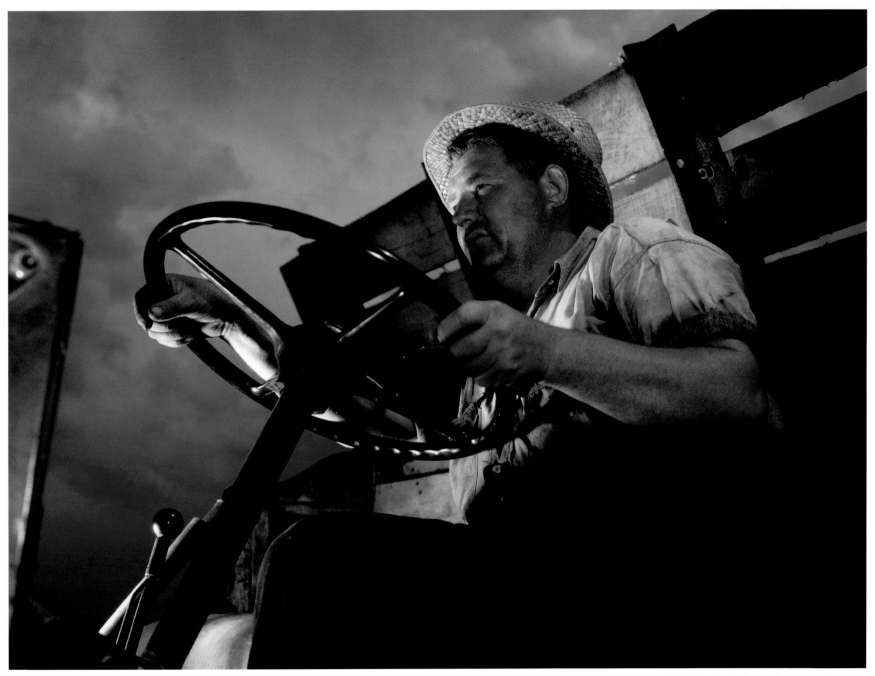

Truck driver at TVA's Douglas Dam, Tennessee
Alfred T. Palmer 6/1942

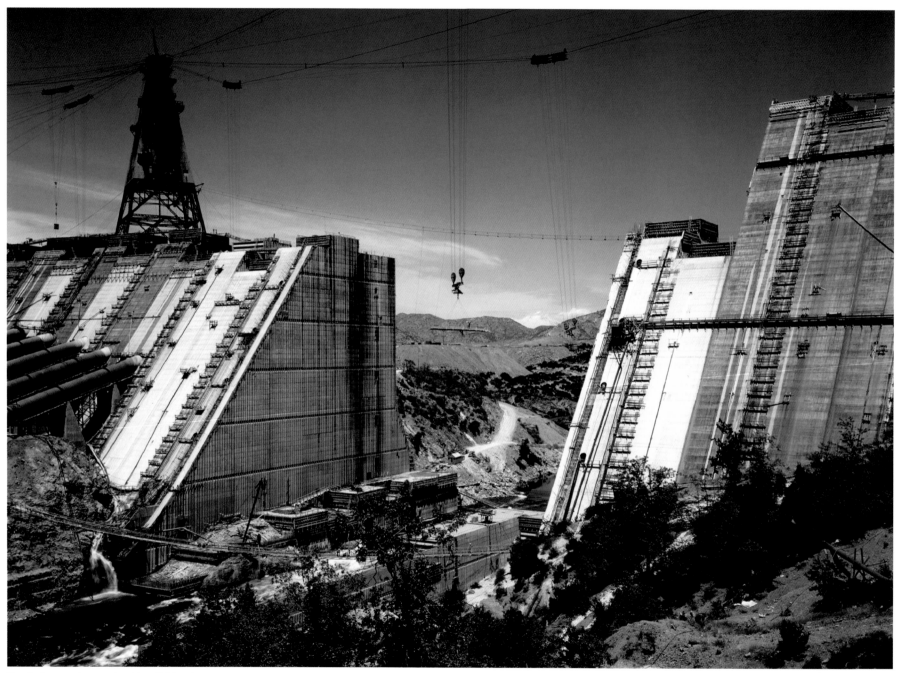

140

Shasta Dam under construction, California
Russell Lee 6/1942

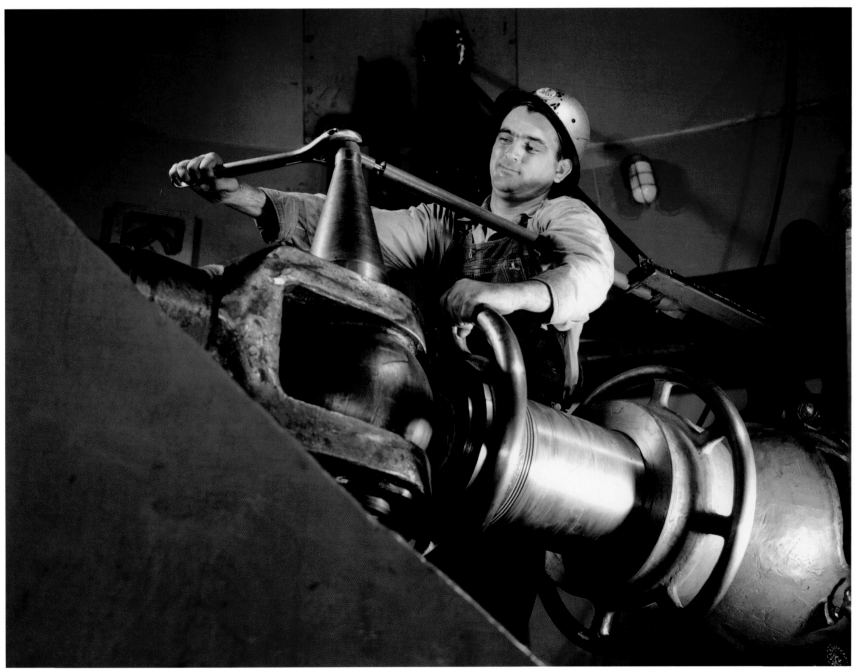

Tightening a nut in TVA's hydroelectric plant, Watts Bar Dam, Tennessee
Alfred T. Palmer 6/1942

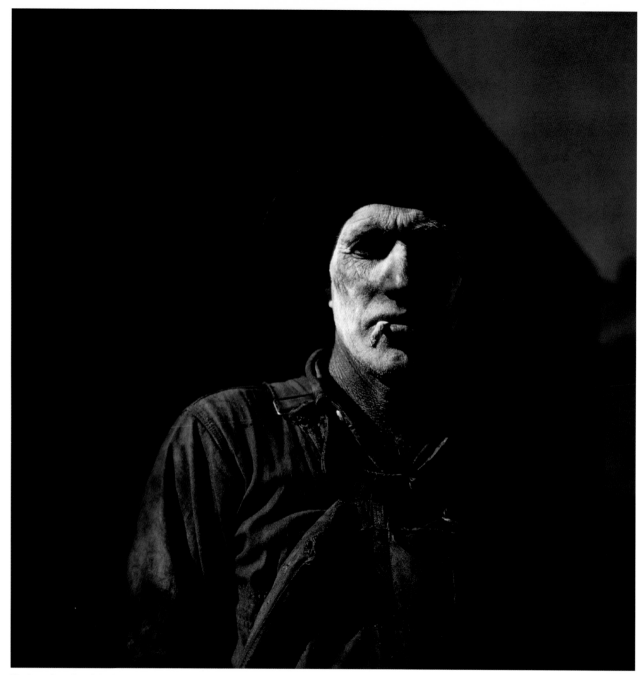

142

Worker at carbon black plant, Sunray, Texas
John Vachon 1942

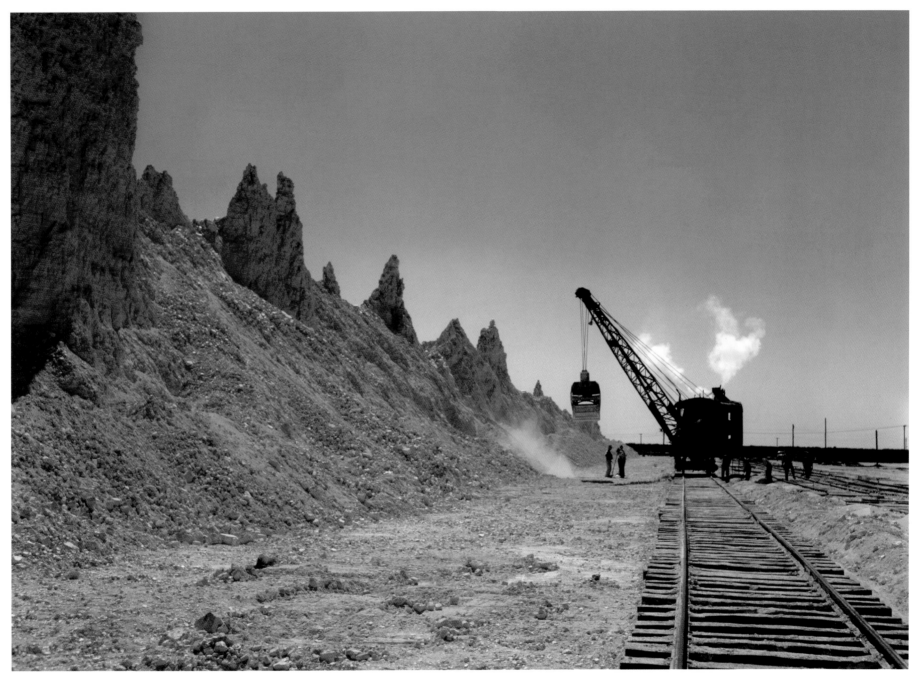

Nearly exhausted sulphur vat from which railroad cars are loaded, Freeport Sulphur Company, Hoskins Mound, Texas
John Vachon 5/1943

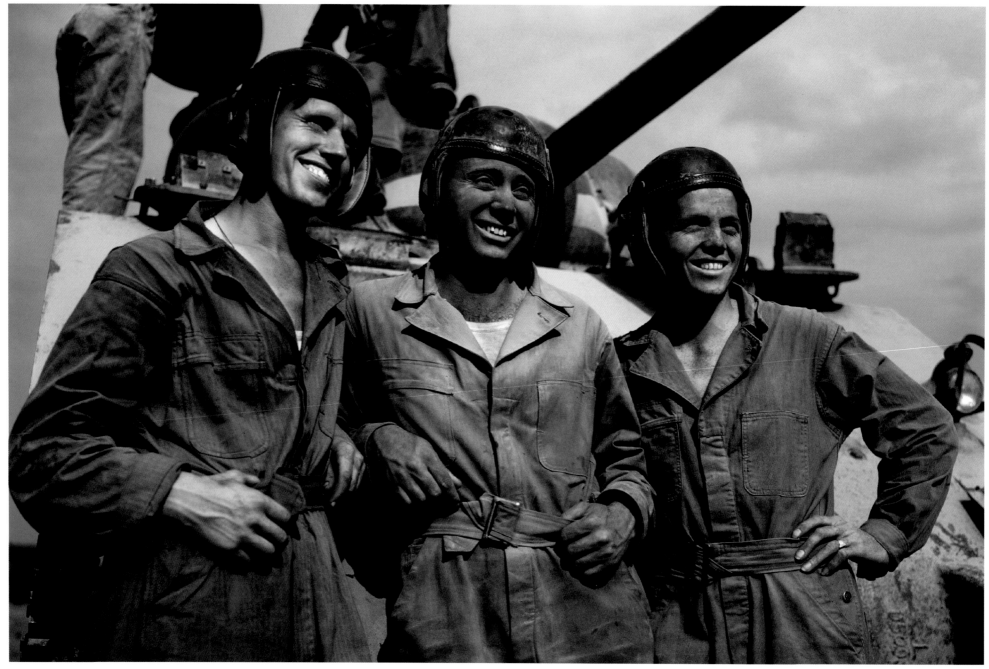

144

M-4 tank crewmen, Fort Knox, Kentucky
Alfred T. Palmer 6/1942

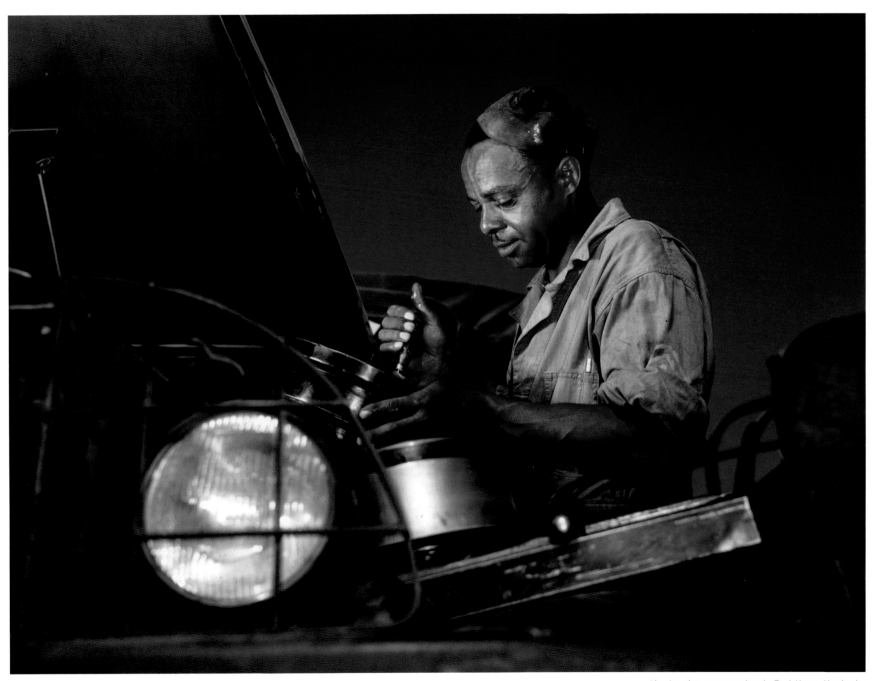

Air cleaning an army truck, Fort Knox, Kentucky
Alfred T. Palmer 6/1942

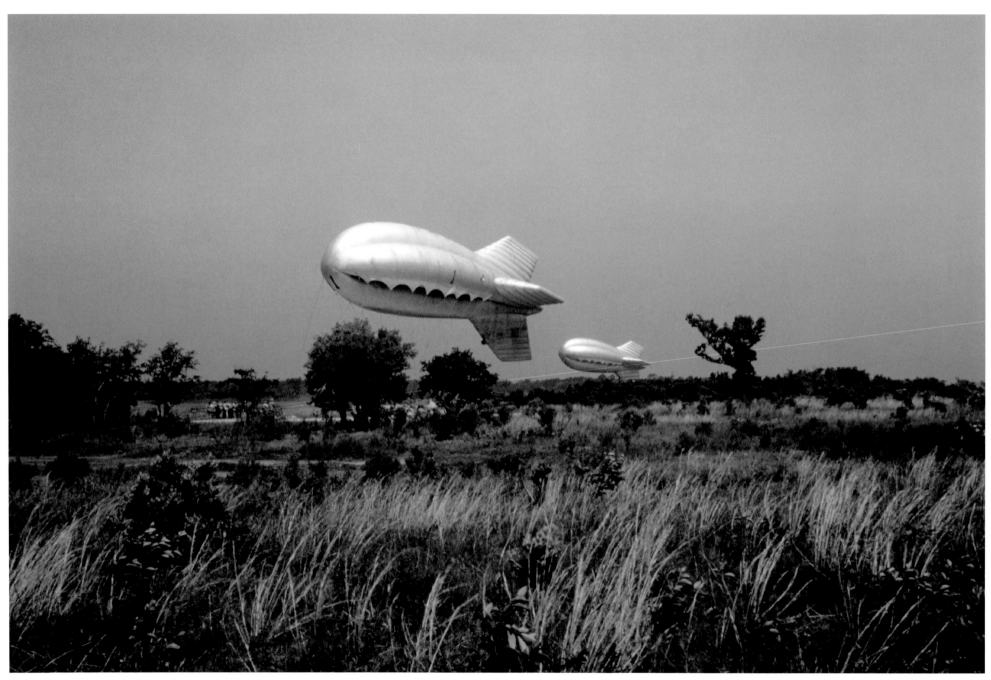

Marine Corps barrage balloons, Parris Island, South Carolina
Alfred T. Palmer 5/1942

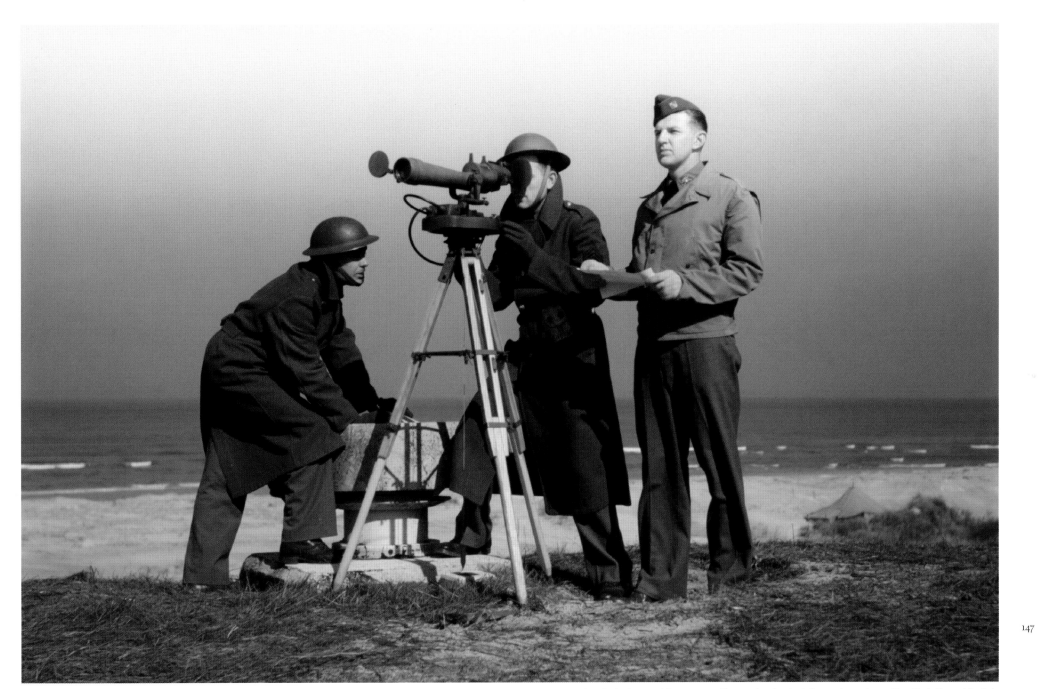

Operating an azimuth instrument to measure the angle of splash in sea-target practice, Fort Story, Virginia
Alfred T. Palmer 3/1942

Switch engine in yard near Calumet Park stockyards, Indiana Harbor Belt Railroad, Calumet City, Illinois
Jack Delano 1/1943

150

Hammering out a drawbar in the blacksmith shop, Santa Fe Railroad, Albuquerque, New Mexico
Jack Delano 3/1943

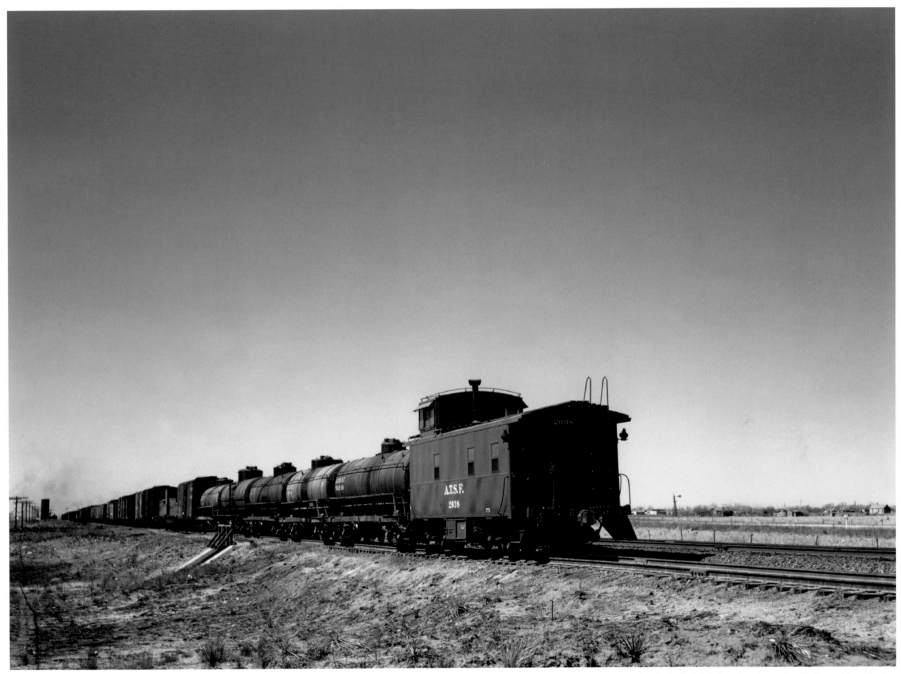

151

Westbound Santa Fe freight stopping for water, Melrose, New Mexico
Jack Delano 3/1943

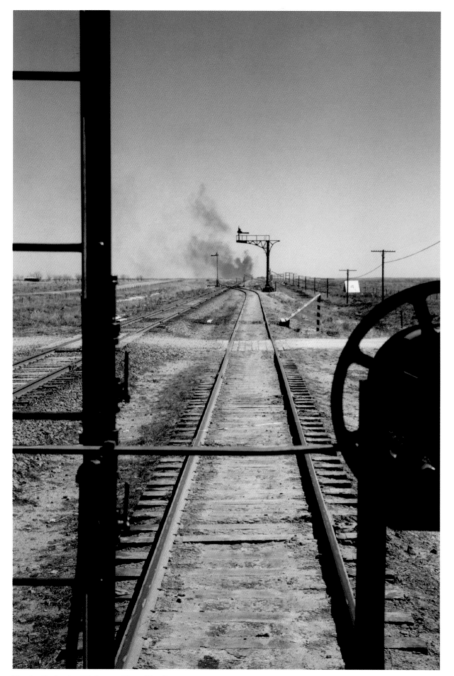

Santa Fe train, Melrose, New Mexico
Jack Delano 3/1943

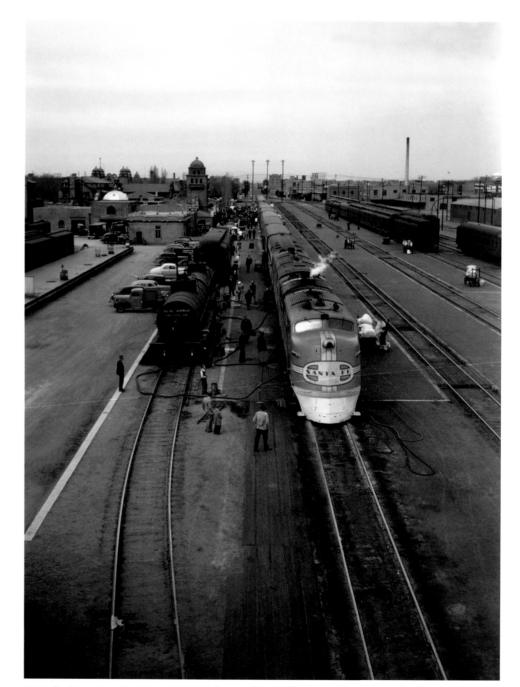

Santa Fe streamliner, the "Super Chief," being serviced at the depot, Albuquerque, New Mexico
Jack Delano 3/1943

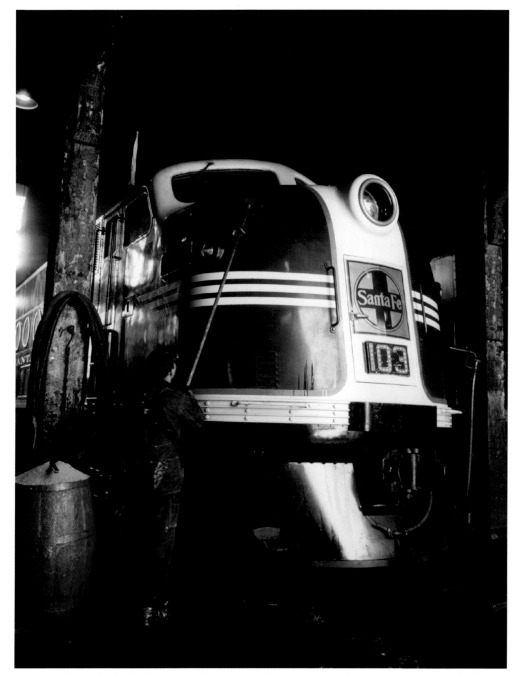

Washing a Santa Fe diesel freight locomotive in the roundhouse, Argentine yard, Kansas City, Kansas
Jack Delano 3/1943

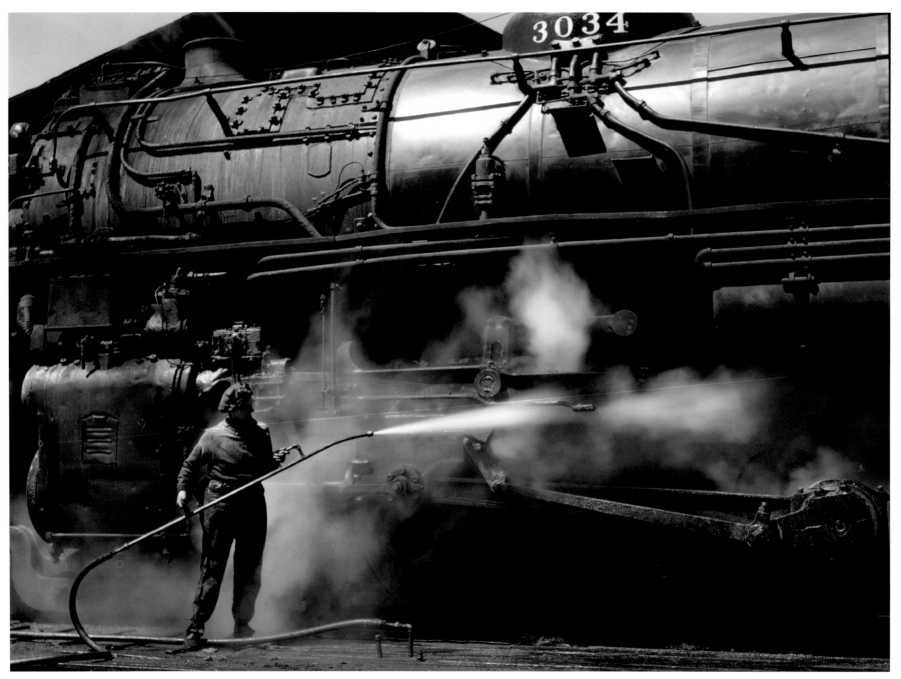

Mrs. Viola Sievers, one of the wipers at the roundhouse, giving a giant "H" class locomotive a bath of live steam, Clinton, Iowa
Jack Delano 4/1943

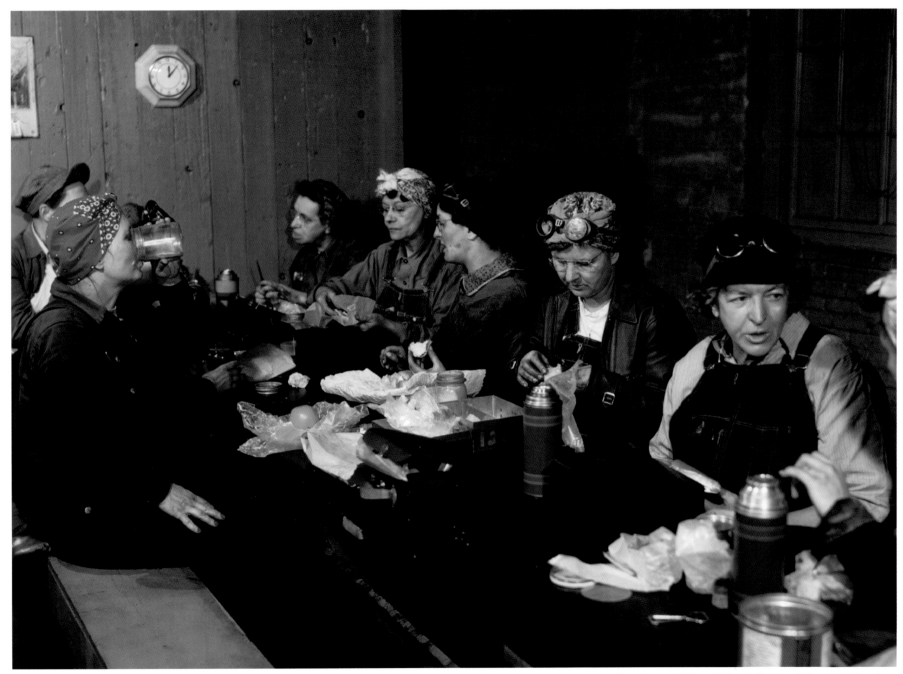

Roundhouse wipers having lunch in their rest room, Chicago & North Western Railroad, Clinton, Iowa
Jack Delano 4/1943

156

General view of part of the South Water Street freight depot of the Illinois Central Railroad, Chicago, Illinois
Jack Delano 4/1943

General view of part of the South Water Street freight depot of the Illinois Central Railroad, Chicago, Illinois
Jack Delano 5/1943

157

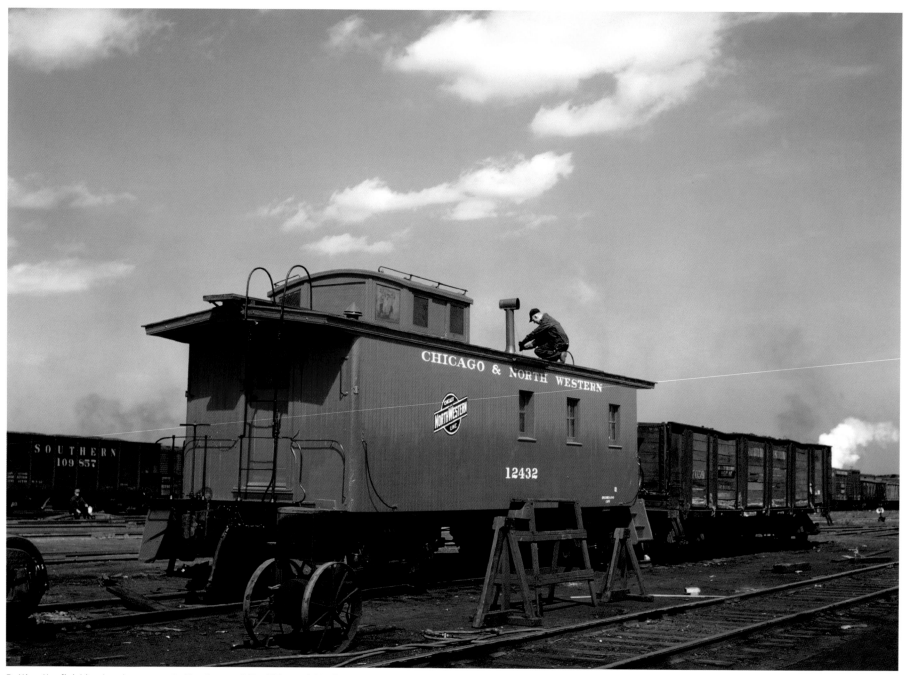

Putting the finishing touches on a rebuilt caboose at the Chicago & North Western's Proviso yard, Chicago, Illinois
Jack Delano 4/1943

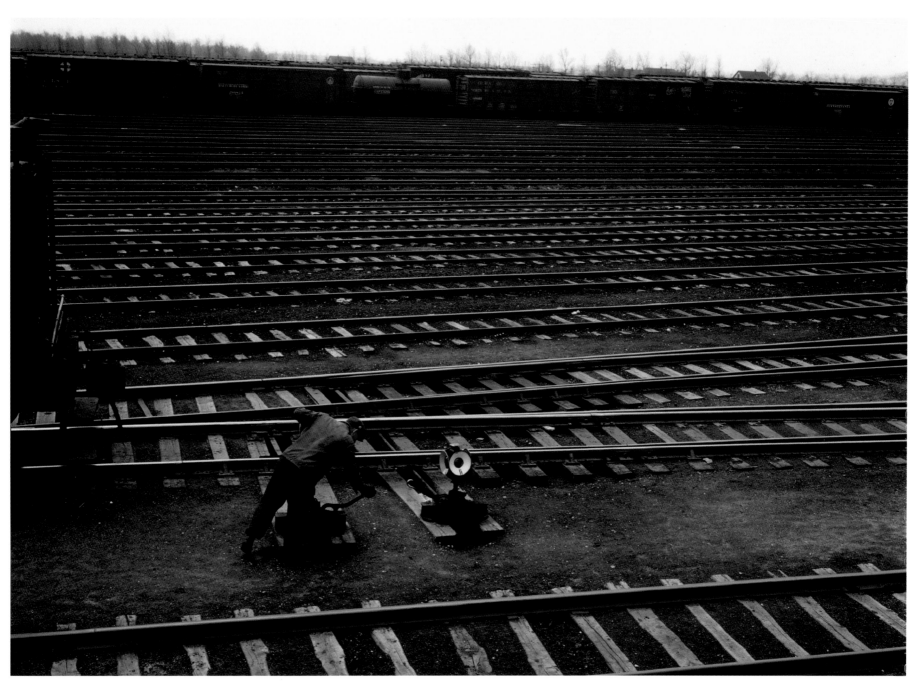

Switchman throwing a switch at the Chicago & North Western's Proviso yard, Chicago, Illinois
Jack Delano 4/1943

159

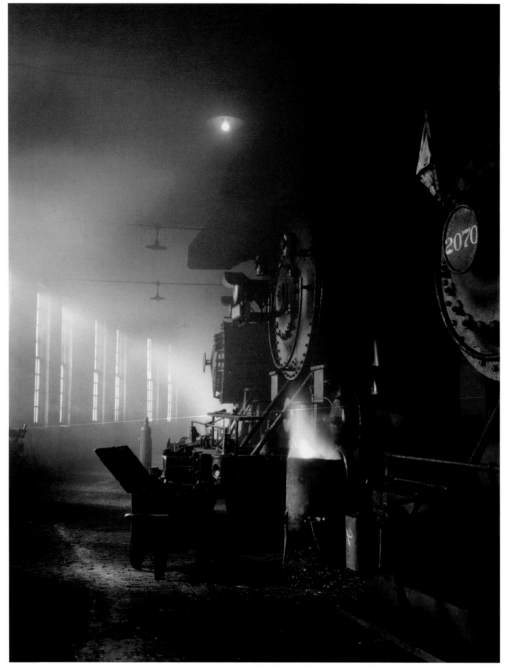

Locomotives in the roundhouse at the Chicago & North Western's Proviso yard, Chicago, Illinois
Jack Delano 12/1942

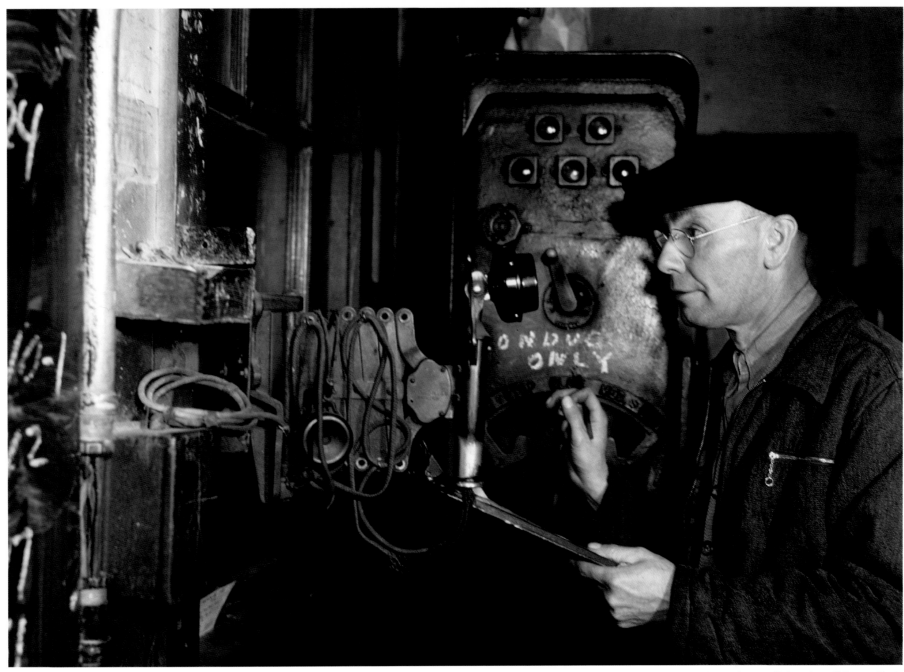

Hump master in a Chicago & North Western yard operating a signal switch system, Chicago, Illinois
Jack Delano 12/1942

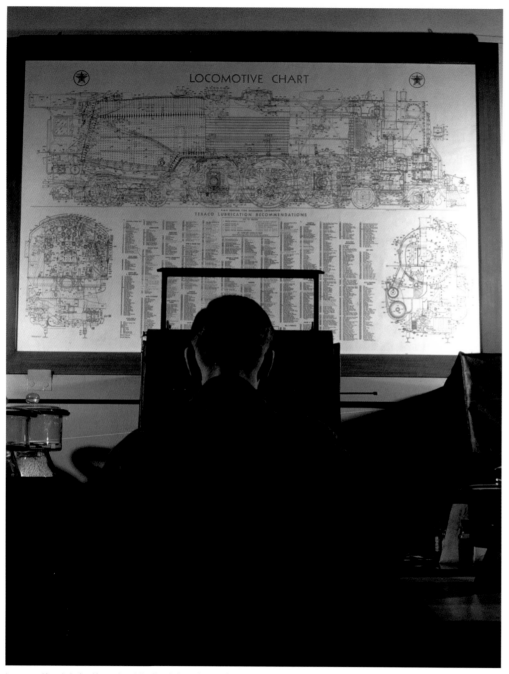

Locomotive lubrication chart in the laboratory of the Chicago & North Western Railroad, Chicago, Illinois
Jack Delano 12/1942

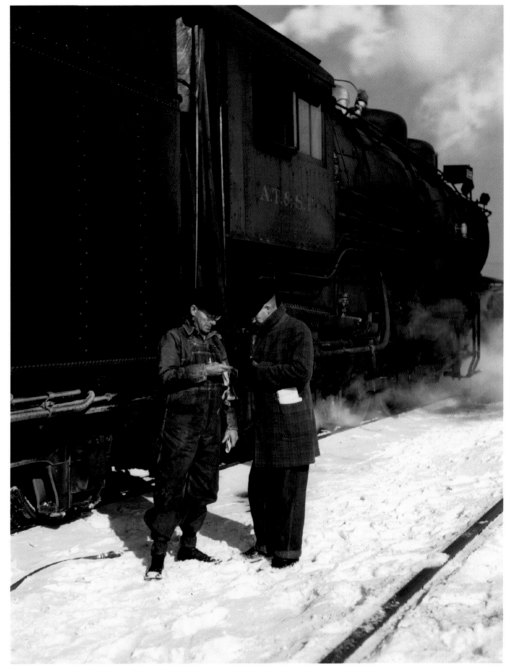

Santa Fe conductor and engineer comparing time before departing from Corwith yard, Chicago, Illinois
Jack Delano 3/1943

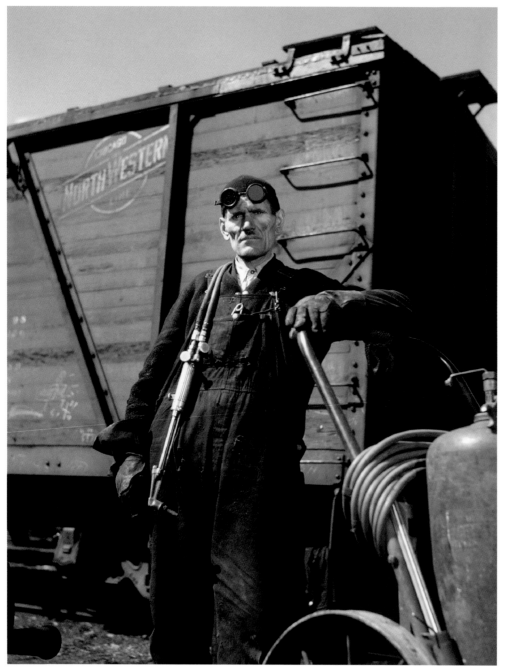

Mike Evans, a welder, at the rip tracks at the Chicago & North Western Proviso yard, Chicago, Illinois
Jack Delano 4/1943

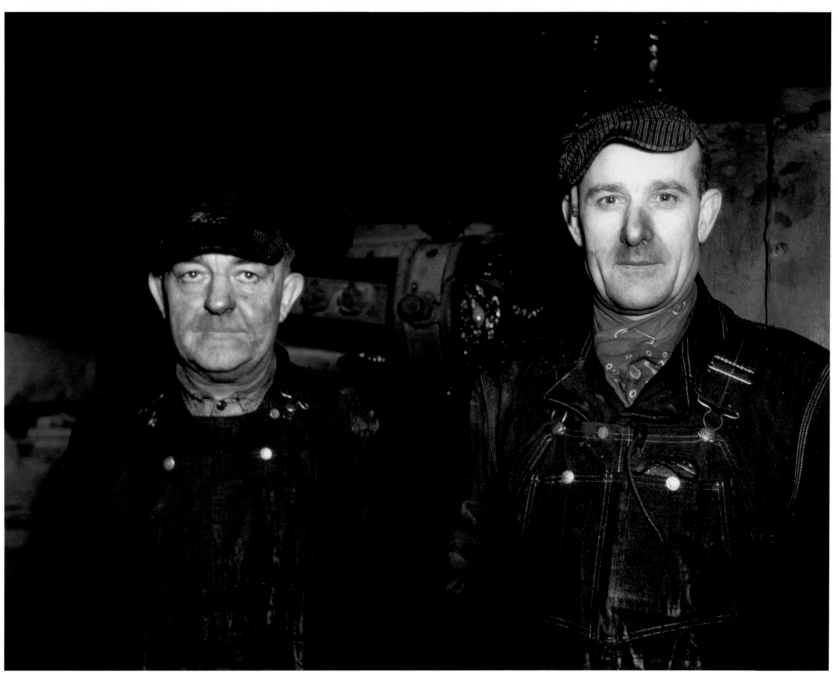

Workers at the roundhouse of the Chicago & North Western's Proviso yard, Chicago, Illinois
Jack Delano 12/1942

Roy Nelin, a box packer in the roundhouse at the Chicago & North Western's Proviso yard, Chicago, Illinois
Jack Delano 12/1942

Santa Fe freight about to leave for the West Coast from Corwith yard, Chicago, Illinois
Jack Delano 3/1943

Servicing an A-20 bomber, Langley Field, Virginia
Alfred T. Palmer 7/1942

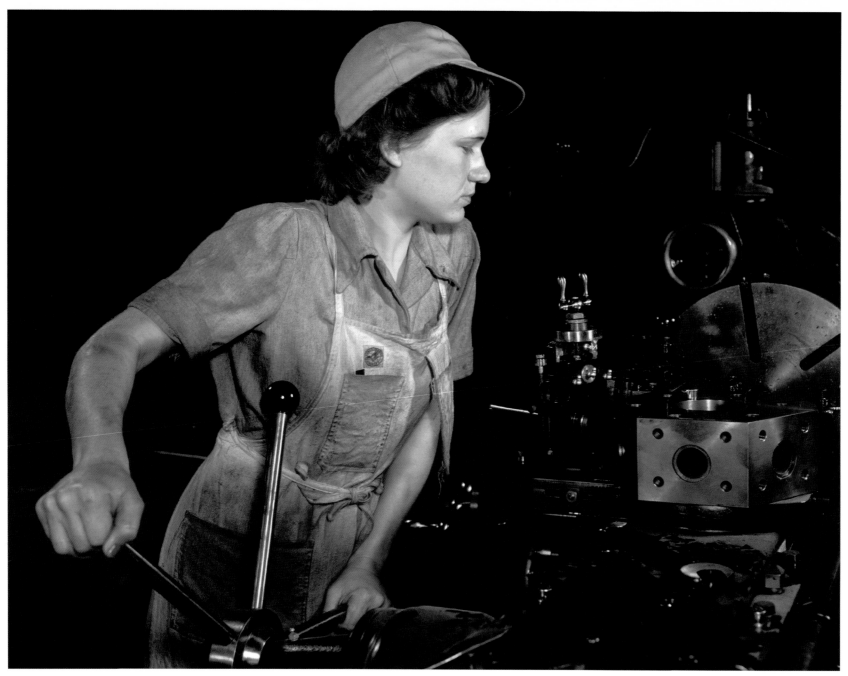

Lathe operator machining parts for transport planes, Consolidated Aircraft Corporation, Fort Worth, Texas
Howard R. Hollem 10/1942

Marine lieutenant glider pilot in training at Page Field, Parris Island, South Carolina

Alfred T. Palmer 5/1942

Aviation cadets in training at the Naval Air Base, Corpus Christi, Texas
Howard R. Hollem 8/1942

Aircraft worker, Vega Aircraft Corporation, Burbank, California
David Bransby 6/1942

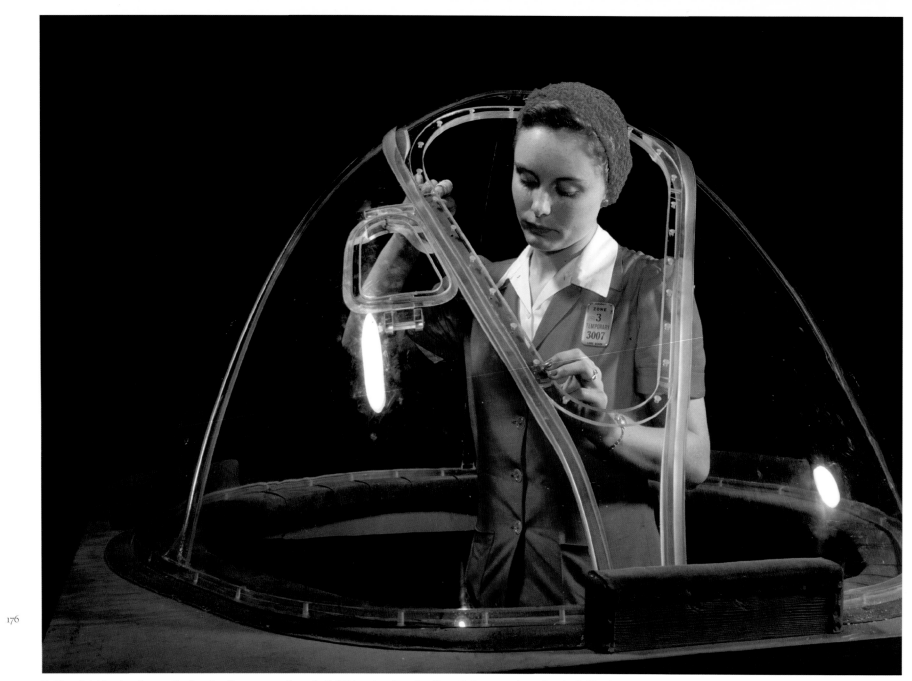

Putting finishing touches on the bombardier nose section of a B-17F bomber, Douglas Aircraft Company, Long Beach, California
Alfred T. Palmer 10/1942

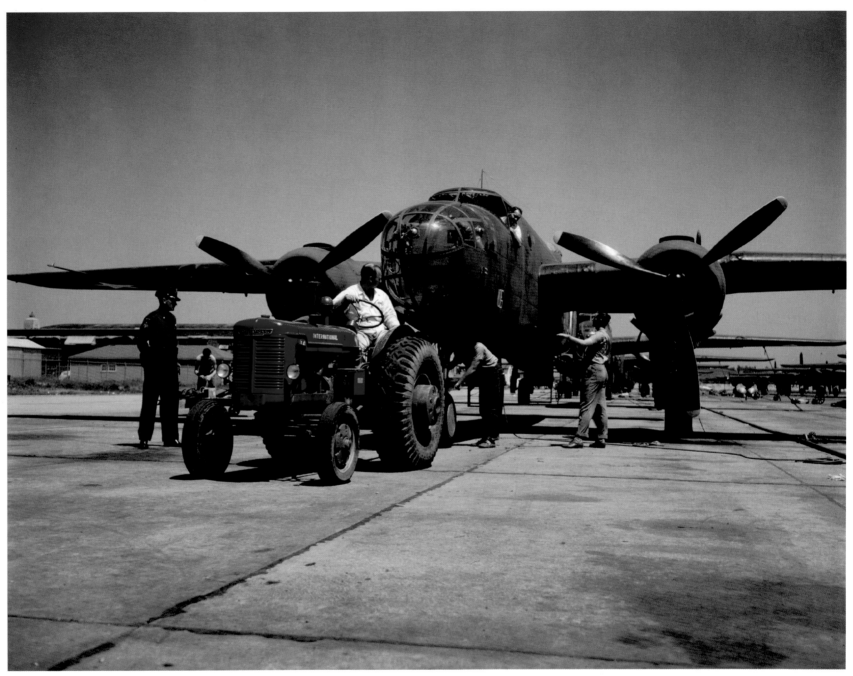

B-25 bombers being hauled along an outdoor assembly line, North American Aviation, Kansas City, Kansas
Alfred T. Palmer 10/1942

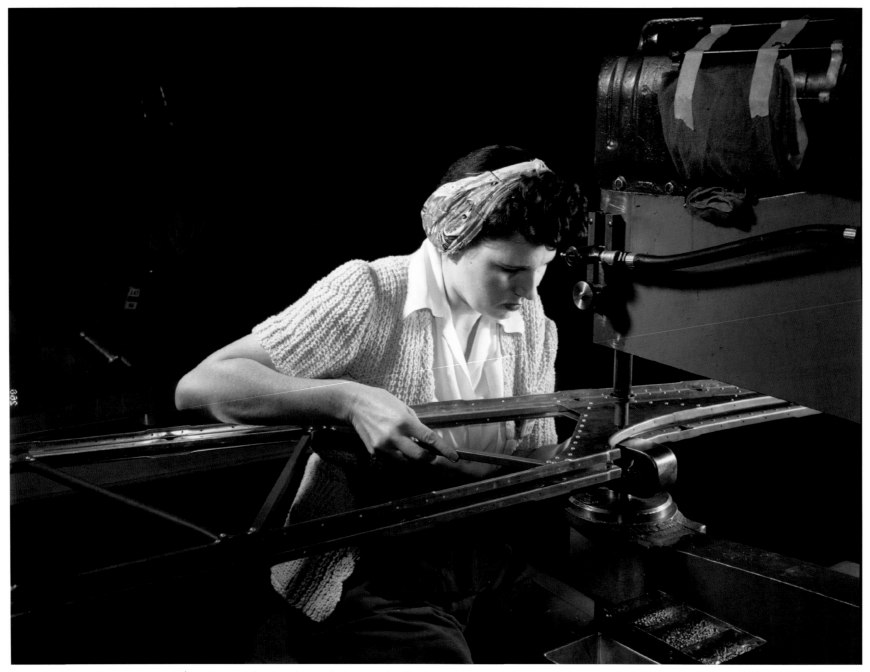

Machine operator joining sections of wing ribs to reinforce the inner wing assemblies of B-17F heavy bombers, Douglas Aircraft Company, Long Beach, California
Alfred T. Palmer 10/1942

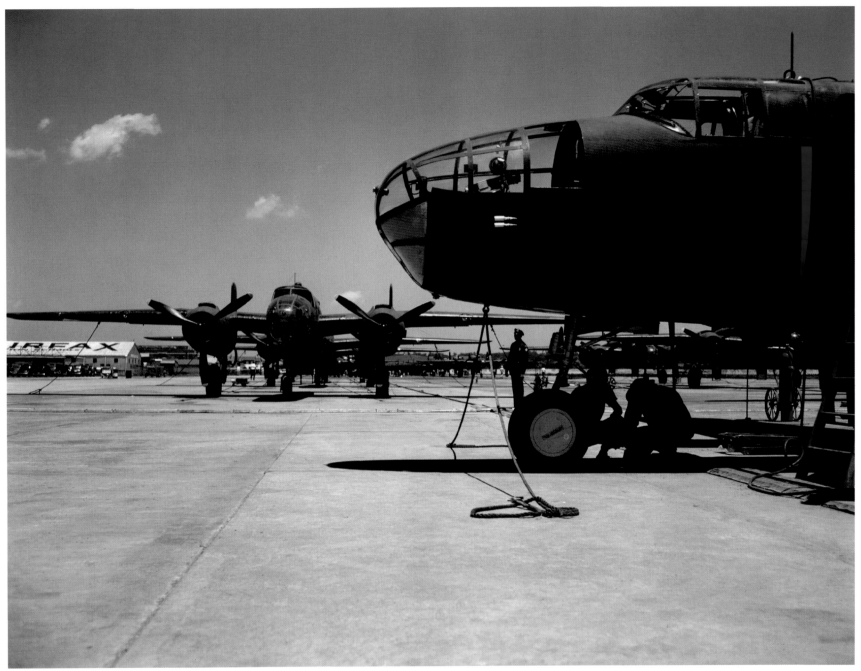

New B-25 bombers lined up for final inspection and testing, North American Aviation, Inglewood, California
Alfred T. Palmer 7/1942

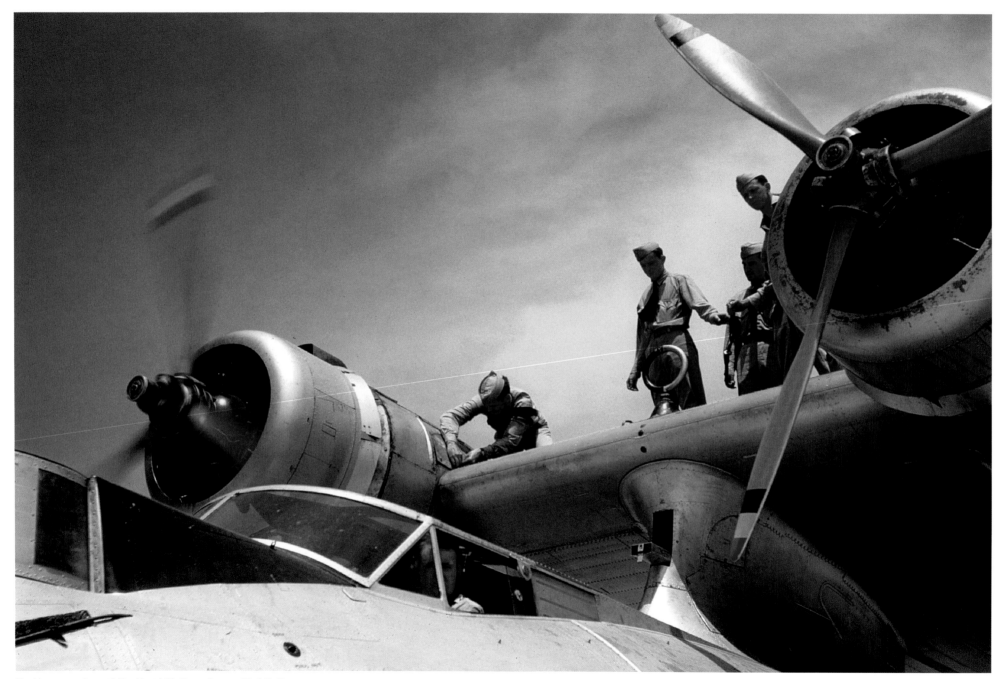

Working on a plane at the Naval Air Base, Corpus Christi, Texas
Howard R. Hollem 8/1942

Lunchtime on the assembly line, Douglas Aircraft Company, Long Beach, California
Alfred T. Palmer 10/1942

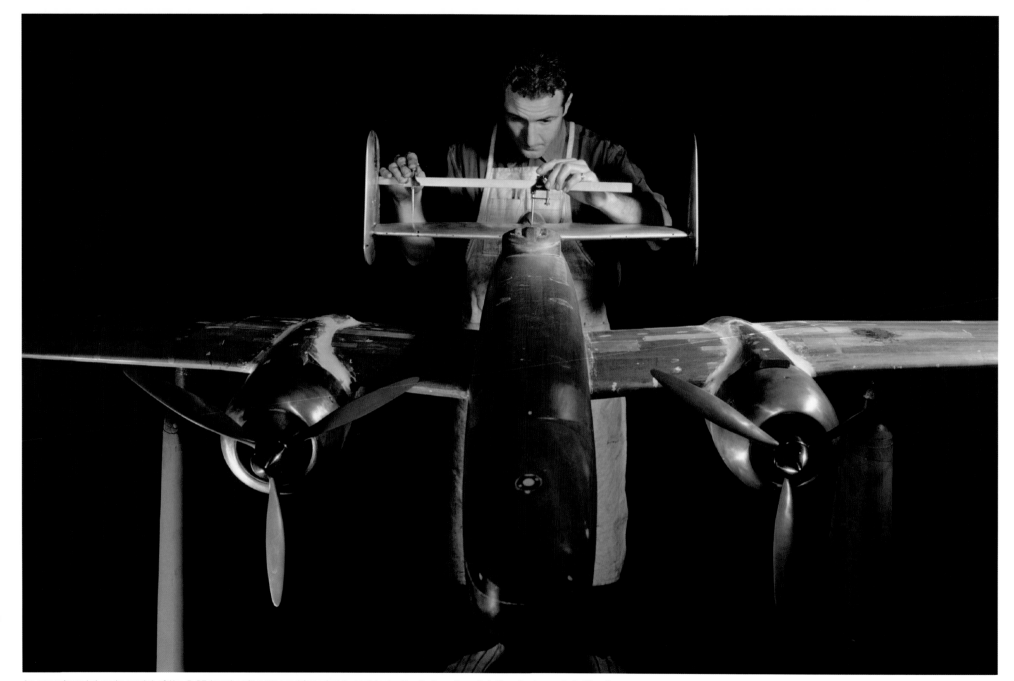

An experimental scale model of the B-25 bomber is prepared for wind tunnel tests, North American Aviation, Inglewood, California
Alfred T. Palmer 10/1942

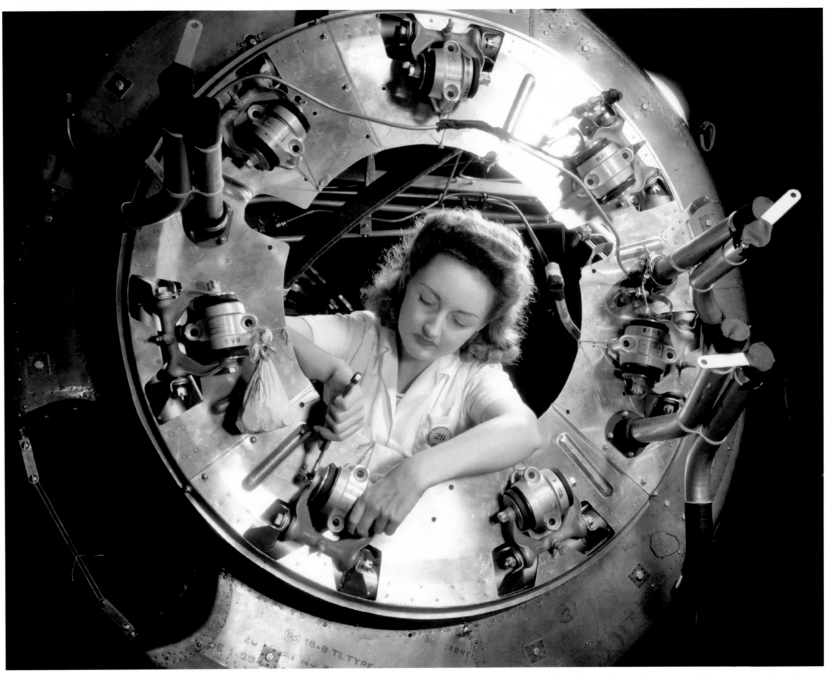

Part of the cowling for one of the motors for a B-25 bomber is assembled in the engine department, North American Aviation, Inglewood, California
Alfred T. Palmer 10/1942

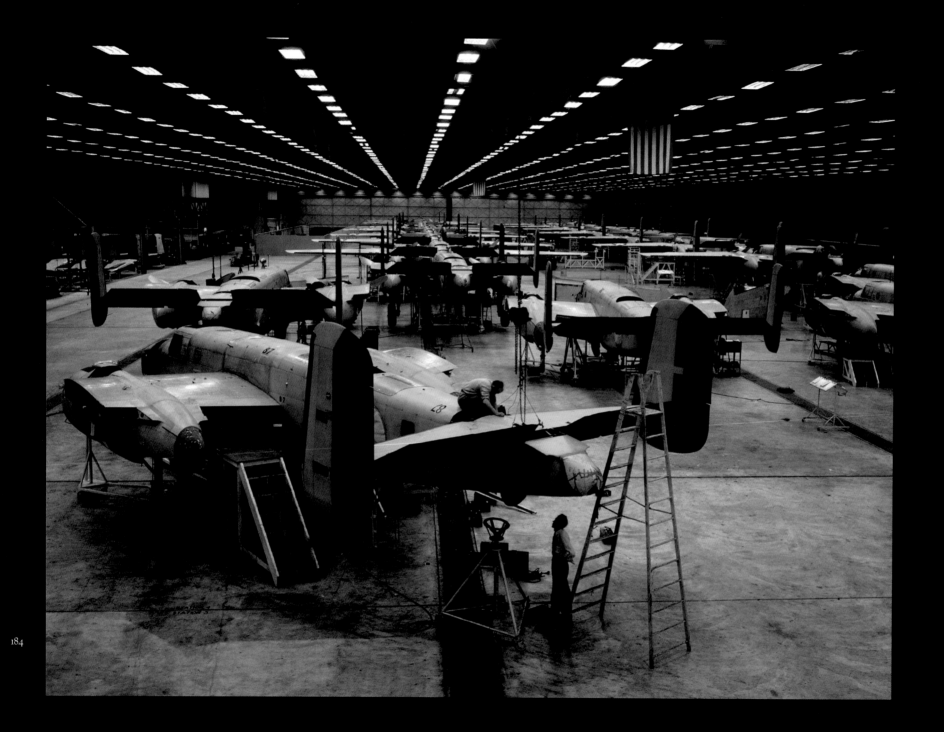

Assembling B-25 bombers at North American Aviation, Kansas City, Kansas

Alfred T. Palmer 10/1942

Marine Corps gliders in flight out of Parris Island, South Carolina
Alfred T. Palmer 5/1942

P-51 "Mustang" fighter in flight, Inglewood, California
Alfred T. Palmer 10/1942

North American Aviation's B-25 medium bomber, Inglewood, California
Mark Sherwood 10/1942

Kodachrome: The New Age of Color

IN THE MID-1930S AN UNEXPECTED ADVANCE IN photographic technology—the ability to capture on film precisely what the eye saw through the viewfinder—revolutionized the way Americans viewed their world and the way others viewed America. Convenient and easy to use, it literally triggered the dawn of a new era—the Kodachrome era—and the world would never look the same again.

All 1,616 documented color photographs in the FSA/OWI archive, transferred to the Library of Congress in 1946, were shot between 1939–42 on the Eastman Kodak Company's revolutionary new film, Kodachrome. Indeed, they are among the most significant early products of the new age. Introduced in mid-April 1935, Kodachrome was the first continuous-tone, color transparency film and was initially sold in 16mm and 8mm formats for motion picture cameras. It wasn't until August/September 1936, that, alongside its new array of cut film for professionals, Kodak began to market to the public at large its 18-exposure, "135" slide film cartridges for 35mm Retina, Leica, and Contax still cameras. The boxed rolls were priced at $3.50–$44.25 in today's money— processing included. Although expensive, the images returned from Kodak's Research Laboratory in Rochester, New York (until 1944 the only processing depot available) were, as those reproduced so magnificently in this book reveal, so astonishingly sharp and brilliantly colored that almost immediately, all previous color processes were rejected as obsolete and inconvenient.

At first, users mounted their slides in glass mounts and projected them through Kodak projectors, introduced in February 1937. The familiar press-board "ready mounts" appeared in April 1939, and thus the 553 color slides in the FSA/OWI archive—the earliest dating from 1939—are all cardboard mounted. The remainder of the photographs were shot on Kodachrome sheet film in three sizes—4 by 5 inch, 3 by 4 inch, and 2½ by 2½ inch—cut from four-foot-wide rolls of flat film in the factory and retailed for view cameras. Just how many color photographs were taken while on assignment by FSA/OWI photographers remains unknown. It's doubtful that all the Kodachromes were forwarded to the Washington offices and many were not retained in the files.

The hues of Kodak's earliest color transparency film proved unstable. Due to the original controlled-diffusion bleach method of processing, one of the three dyes residing in the gelatin emulsion—yellow (the others were cyan and magenta)—deteriorated rapidly, so that slides from the period 1936–39 are often too red or marred by a yellowish stain. In response, in 1938–39 the company greatly improved its processing by adopting the selective re-exposure method and the resulting slides—like the ones reproduced in this volume— retained their original jewel-like colors virtually unchanged. Under ideal storage conditions, the color permanence of Kodachrome is unmatched.[1]

In the late 1930s the new still camera film quickly caught on with two major groups targeted by Kodak: working photographers—photojournalists, celebrity portraitists, and advertising, fashion, and interior design photographers, plus their picture editors—and the general public. (Not until the mid-1970s did art photographers begin fully to exploit the potential of color.) Since Kodachrome could be exposed under existing light conditions at familiar snapshot speeds, and since no great expertise or special professional equipment was necessary, the new color film soon dominated the serious amateur photography market. Indeed, by 1939 sales of Kodachrome outpaced those of Kodak's black-and-white film. As a result of its sudden appearance and widespread acceptance, the company's new color film marked a historic divide in visual representation—between the monochrome world of the premodern age and the brilliant hues of the present day. Perhaps the watershed is best marked by the publication of *Life* magazine's first color cover on the July 7, 1941 issue.

As a group, the color images in the FSA/OWI archive provide a remarkable opportunity to study the early use of color transparency film as it was employed by a dedicated group of professional photographers, individuals whose practice was generally restricted to black-and-white images. As a

control group of images, the significance of the archive cannot be underestimated. As photographers such as John Collier, Jack Delano, Russell Lee, Arthur Rothstein, John Vachon, and Marion Post Wolcott switched back and forth between black and white and full-spectrum color during assignments—sometimes sequentially—in their choices of subjects, compositions, and atmospheric conditions, and in their increasing sensitivity to light and color values, one can watch them individually and collectively realize and exploit the aesthetic potential of the new medium.[2] It is fascinating and revelatory to compare the monochrome and color images taken on the same shoot, or to identify those particular landscapes or subjects that so caught the attention of the photographer's inner eye that he or she chose the new medium of color to best represent its essence. The complete collection of 170,000 FSA/OWI photographs are available online for study and review at http://lcweb.loc.gov/rr/print/. Originally, the color images were digitized in the early 1990s at a comparatively low resolution suitable for ready reference. The images selected for this publication were re-scanned at a significantly higher resolution.

— JEREMY ADAMSON
Chief, Prints and Photographs Division
Library of Congress

1 See Henry Wilhelm, "The Modern Era of Color Photography Began in 1935 with the Introduction of Kodachrome Transparency Film," in Els Rijper, ed., *Kodachrome: The American Invention of Our World, 1939–1959* (New York: Delano Greenidge Editions, 2002), 12–15. See also, Peter Krause, "50 Years of Kodachrome," *Modern Photography*, 11 (Oct., 1985), 47ff. For an early manual on the use of Kodachrome, see Fred Bond, *Kodachrome and Kodacolor From All Angles.* San Francisco: Camera Craft, 1945.

2 The entire set of digitized color images can accessed at http://lcweb2.loc.gov/pp/fsacquery.html and can be compared to black-and-white photographs shot contemporaneously by the same photographers at http://lcweb2.loc.gov/pp/fsaquery.html. For critical commentaries see Sally Stein, "FSA Color: A Forgotten Experiment," *Modern Photography* 43 (Jan. 1979), 90ff, and Andy Grundberg, "FSA Color Photography: A Forgotten Experiment," *Portfolio* (July/Aug. 1983), 53–57.

EDITOR'S NOTE: Many of the FSA/OWI photographs were given titles by the photographers, Roy Stryker, or his staff, and these titles occasionally reflected cultural biases prevalent in the 1930s and 1940s. Many others were not titled. For the present publication, all picture titles have been simplified and modernized.

PAGE 2
Road that leads to Emmett, Idaho
Russell Lee 7/1941

PAGE 4
Hauling crates of peaches, Delta County, Colorado
Russell Lee 9/1940

PAGE 5
Shepherd with his horse and dog on Gravelly Range,
Madison County, Montana
Russell Lee 8/1942

PAGE 20
Children lined up against a brick building,
probably Washington, D.C.
Photographer unknown 1941–1942

HARRY N. ABRAMS
Editor: DEBORAH AARONSON
Designers: ERIC HIMMEL WITH ARLENE LEE
Production Manager: JANE SEARLE
Production Assistant: NORMAN WATKINS

LIBRARY OF CONGRESS PUBLISHING OFFICE
Director of Publishing: W. RALPH EUBANKS
Picture Editor: BLAINE MARSHALL

LIBRARY OF CONGRESS PRINTS AND PHOTOGRAPHS DIVISION
Chief of the Prints and Photographs Division: DR. JEREMY ADAMSON
Head of the Reference Section: MARY M. ISON
Digital Conversion Coordinator: PHILIP J. MICHEL

LIBRARY OF CONGRESS PHOTODUPLICATION SERVICE
Searchers: PAMELA RUTH MILLER, DENISE HARRIS KING,
GEORGIA L. ZOLA

Library of Congress Cataloging-in-Publication Data

Bound for glory : America in color, 1939–43 / Essay by Paul Hendrickson.

 p. cm.
"FSA/OWI Collection, The Library of Congress."
Includes index.
 ISBN 0-8109-4348-4
 1. Documentary photography—United States. 2. Color photography—United States. 3. United States—Social life and customs—1918-1945—Pictorial works. 4. United States—Social conditions—1933-1945—Pictorial works. 5. United States—Rural conditions—-Pictorial works. 6. Library of Congress—Photograph collections. 7. Photograph collections—Washington (D.C.) I. Hendrickson, Paul, 1944– II. United States. Farm Security Administration. III. United States. Office of War Information. IV. FSA/OWI Collection (Library of Congress)

 TR820.5.B685 2004
 779'.9973917—dc22

 2003021336

Published in 2004 by Harry N. Abrams, Incorporated, New York

Printed and bound in China

10 9 8 7 6 5 4 3 2 1

Harry N. Abrams, Inc.
100 Fifth Avenue
New York, N.Y. 10011
www.abramsbooks.com

Abrams is a subsidiary of
LA MARTINIÈRE
GROUPE